# Stuck on the

Geert Lovink

# Stuck on the Platform

Reclaiming the Internet

Valiz, Amsterdam

# Contents

# Phantoms of the Platform or Internet's Muddy Enlightenment

Introduction

"The most revolutionary thing one
can do is always to proclaim loudly
what is happening."
Rosa Luxemburg

"I'll tell you what freedom is to me.
No fear."
Nina Simone

"I have no theory. I've only
got a story to tell."
Elizabeth Freeman

"Recent studies show that I'm tired."
@sosadtoday (Melissa Broder)

"False unconsciousness is the real
problem of our era."
Bernard Dionysius Geoghegan

"Theory is the answer.
But what is the question?"
Johan Sjerpstra

"The internet is inside us."
Patricia Lockwood

"If marxists.org had a nicer
website the revolution would
have happened by now."
Space Cowboy

"I love the smell of unruly
memes in the morning."
@jamie_jk (Jamie King)

"Being popular on Twitter is like being
popular at the mental hospital."
@rotkill

"I don't like your positive attitude."
@ofterror

9

It seems we're trapped. During the lockdown *misère* we've literally been stuck on the platform. What happens when your home office starts to feel like a call center and you're too tired to close down Facebook? "How to get rid of your phone? Wrong answers only." We wanted to use the pandemic to reset and move on. We failed. The comfort of the same old proved too strong. Instead of a radical techno-imagination focused on rolling out alternatives, we got distracted by fake news, cancel culture, and cyber warfare. Condemned to doom scrolling, we suffered through a never-ending barrage of cringy memes, bizarre conspiracy theories, and pandemic stats, including the inevitable flame wars surrounding them. Random is fun.

"We admitted we were powerless—that our lives had become unmanageable."[1] This confession is Step 1 in AA's 12 steps, and it is here that *Stuck on the Platform* also begins. As you and I are not able to resolve platform dependency, we remain glued to the same old channels, furious at others about our own inability to change. In this seventh volume of my chronicles, we're staying with the trouble called the internet, diagnosing our current phase of stagnation while also asking how to get "unstuck" and deplatform the platforms.

What happens to the psycho-cultural condition when there's nowhere to go and users are trapped in too-big-to-fail IT firms? It's not pretty. While some believe that our persistent resentment, complaints, and anger are merely part of the human condition, totally unrelated to the shape and size of the information ecology, others (like

1    www.alcohol.org/alcoholics-anonymous/.

me) are convinced that we have to take the mental poverty
of the online billions seriously. We can no longer ignore
the depression, anger, and despair, pretending they will
be gone overnight after installing another app. Addiction
is real, buried deep inside the body. Habits need to be
unlearned, awareness needs to spread. All the while Godot
just sits there, staring at the screen, waiting in the lobby
for some policy change to be announced. Yet nothing ever
happens. The resulting fallback and fatalism comes as
no surprise. "What do you do when your world starts to
fall apart?" Anna Tsing asks at the very beginning of *The
Mushroom at the End of the World*.[2] It seems we have our
answer: we stick to the platform.

# Where Are We Now?

*Waar waren we ook alweer gebleven?* Where are we now, to
say it with David Bowie. Dutch writer Geert Mak begins
each episode of his TV series with this question, and it is a
question that echoes in my head. Like Mak, I hope to catch
the platforms red-handed. I fail to remember the worrisome
circumstances the moment I closed the manuscript of *Sad
by Design* in late 2018. Thankfully Richard Seymour sums it
up for me in *Twittering Machine*. By 2019, he writes,

> techno-utopianism returned in an inverted
> form. The benefits of anonymity became the
> basis for trolling, ritualized sadism, vicious
> misogyny, racism, and alt-right cultures.
> Creative autonomy became "fake news" and
> a new form of infotainment. Multitudes
> became lynch mobs, often turning on them-
> selves. Dictators and other authoritarians
> learned how to use Twitter and master its
> seductive language games, as did the so-
> called Islamic State, whose slick online media
> professionals affect mordant and hyper-
> aware tones. The United States elected the
> world's first "Twitter president." Cyber-
> idealism became cyber-cynicism.[3]

2    Anna Lowenhaupt Tsing, *The Mushroom at the End of the World* (Princeton: Princeton University Press, 2015), p. 1.
3    Richard Seymour, *The Twittering Machine* (London: The Indigo Press, 2019), p. 27.

And we were the all-too-willing followers, unable to turn our backs against the medium and its message.

The Brexit-Trump-COVID period (2019–2021) covered here can be characterized by both stasis and crisis, with the old refusing to die and the new refusing to be born. According to Paolo Gerbaudo,

> the current political era is best understood as a "great recoil" of economic globalization. It is a moment when the coordinates of historical development seem to be inverting, upsetting many of the assumptions that dominated politics and economics over the last decades. The implosion of neoliberal globalization is not just a moment of regression, but potentially a phase of re-internalization.[4]

The lack of inverted thinking became widely felt.[5] In failing to envision the web's negative consequences, problems began to pile up. Managers preferred safety and control over change; they opted for PR spin instead of criticism. The result—to paraphrase Tyler Cowen—was internet complacency.

COVID-induced restrictions combined complacency and comfort for some with mass despair, loneliness, and a health crisis for the many, accelerating existing inequalities and fuelling the crisis of political representation. Working from holes,[6] in sanitized, gentrified areas,[7] the overall feeling was one of numbness. Escalating loss of life and the horrifying rash of infection reached a tipping point for many in the repetition of the same. Emotion, compassion, and empathy retreated into the inner sanctuary of the miserable self. During lockdown, the omnipresent internet became the stage of intense interiority. The home became the refuge of modern life. The kitchen turned into a classroom. The bedroom turned into a shopping mall, workplace, restaurant, and entertainment space, all at once.

---

4          Paolo Gerbaudo, "The Great Recoil of Neoliberal Globalization," *ROAR*, October 23, 2021, *roarmag.org/essays/gerbaudo-great-recoil/*. His 2021 book with Verso carries the same title.
5          See, for instance, Inti Tupac, "What Is Inverted Thinking," *Medium*, December 30, 2020, *medium.com/explain-this-to-me-like-im-five/what-is-inverted-thinking-81699e4066cc*, where it reads: "Instead of trying to make brilliant decisions, start by trying to avoid making stupid ones."
6          Taken from Marcus John Henry Brown's Hustetology performance, May 22, 2021, *www.youtube.com/watch?v=FSzcHCw80Ik&t=194s*.
7          "L.A increasingly feels like the dystopian vacation resort imagined in Vermilion Sands by JG Ballard but without the 'neglected virtues of the glossy, lurid, and bizarre' that made SoCal such an interesting place to begin with." Barrett, tweet from December 30, 2020.

"All revolutions are failures, but they are not all the same failure," George Orwell noticed. This is also the case for the digital revolution. The imminent datafication of the world is certain. We've reached a point where we can call out the platform as a disciplinary machine, in line with the clinic, school, factory, and jail.[8] We should no longer be surprised that this power is a repressive one—and not just depressive. By facilitating the social in a "free" and frictionless way, power relations are shaped and formatted. Yet the collective invention of explanatory concepts that make intelligible the collapse of the social remains elusive. The paradox between the promise and the reality between the empowering, decentralized vision and the ironically depressing dependency of social media—is growing unbearable. Can we be brutally honest about the social need to scale, drifting to the one and only product, preferred by all? Why doesn't diversity and difference apply here? Once the Facebooks become indistinguishable from the standard and protocol level, ordinary users, too busy minding their own business, simply do not have the energy to question the situation. The wish for interoperable global exchanges is simply too strong.

# It's All Wrong, and No One Cares

Platforms take their toll on the individual. Most of the collected evidence reinstates what we've all, intuitively or consciously known about data extraction and surveillance. As Faine Greenwood puts it,

> Facebook is very much like a cigarette company now: most people know damn well the product is bad for them and the executives selling it are evil, but it is—by design—really, really hard to quit.

What is the price we pay for a recommendation? Or, to put it more explicitly, as the artist Geraldine Juárez does:

> It's really not fair that we all have to deal with the effects of the terrible ideas and products

---

8       As Claude Lévi-Strauss noted in 1972: "In this sad century, in this sad world where we live, with the pressure of population, rapidity of communications, the uniformity of culture, we are closed, like a prison."

of tech reactionaries and anarcho-capitalists
just because the USA is an individualist
nightmare.[9]

Indeed, the Silicon Elegy heralds the destructive side
of boredom. This is not the force praised by bourgeois
coaches as the ideal precondition for creativity, but instead
more of an unspoken condition that brings on disasters.
The same applies to loneliness, that solitary state of mind
promoted as the healing force for body and soul. Under
the COVID regime, loneliness has received a significant
upgrade. *Congratulations, you're social disease number
one.* In an age defined by anxiety, paranoia, and ultimately
hate, one can enter an acute danger zone in a dazed and
confused state of mind.

And platforms take their toll on the economy and
society. Platforms do not merely monopolize markets;
they own and shape them. While the rest of the economy
stagnates and central banks fuel the stock market, Big Tech
buys back their own shares instead of doing productive
investments. We thus end up with an internet that expo-
nentially speeds up social and economic inequality. "I'm
starting to feel like a stripper dancing on this Substack
newsletter pole and everyone is cheering but so few
readers are actually making it rain," says Michelle Lhooq,
sketching out the yawning gulf between "free" culture and
a fair living wage for content creators. While the last of
the market pundits defend the status quo with consumer
choice arguments, users are coming to terms with their
servile status. We need to read the platform-user relation in
the light of Hegel's master-slave dialectic. Once the social
contract has locked in users, a combination of addiction
and social conformism makes it impossible for users to
freely leave the platform and go elsewhere. This is what
Yanis Varoufakis, in line with Jodi Dean and others, calls
techno-feudalism.[10] Similarly, Bruce Schneier spoke about
"feudal security" offered by Big Tech, in which users sur-
render their autonomy by moving into a warlord's fortress

---

9       Geraldine Juárez (@geraldi_nej) *twitter.com/geraldi_nej/status/1398266186790486017*,
posted on May 28, 2021.
10      Marc Lamont Hill, "Yanis Varoufakis: Capitalism Has Become 'Techno-Feudalism,'"
*Al Jazeera* February 19, 2021, *www.aljazeera.com/program/upfront/2021/2/19/yanis-varoufakis-
capitalism-has-become-techno.*

and in return get protection from the bandits that roam the badlands without.[11]

But if the evidence against the platform is there, the change is not. Over the past few years, through both academic studies and tech work "tell-alls," we've been provided with overwhelming proof of the manipulation of public opinion combined with psychological "behavioral modifications." The problem here is not the avalanche in internet-critical literature itself, but its limited impact and the lack of a political roadmap on how to change the internet architecture. *Internetdeutung* today is a muddy form of enlightenment. As T.S. Eliot wrote: "Humankind cannot bear very much reality." That's why they love art, cinema, literature, gaming, and creativity. To which Jean Cocteau added: "Illusion, not deception."

Captured by platforms, many no longer asked themselves why they are stuck in their own filter bubble. It is tiring to repeat the mixed feelings; we'd rather skip the topic. Techno-sentimentality exists, going back and forth between love and critique. Why are my YouTube recommendations so irresistible? Where's the vibe? There's no trace of guilt after a long swiping session, only exhaustion. Why do we continue to externalize our vulnerable mental states? Where is the embarrassment of the digital? Why do I start using the Alexa and Siri question format while chatting with friends? How to get rid of trending topics? How can we protect ourselves from algorithmic recommendations? Gone are the days of innocent surfing the Web. Today we are pulled in by powerful forces, until one day we stop thinking about them altogether. To put it in Byung-Chul Han's words, the subjugated subject is not even aware of its own subjugation.

In our pandemic period, the same pattern repeated: discontent ramped up, but then dissipated without any change. We saw a rising sentiment built on the strong online presence of the alt-right and mixed with the rocket fuel of conspiracy theories ranging from 5G radiation to Bill Gates implanting microchips. Disinformation was

11     Reference of Cory Doctorow (@doctorow), *twitter.com/doctorow/status/ 1394706771747303427*. Bruce Schneier's 2012 blog entry on the topic: *www.schneier.com/blog/archives/ 2012/12/feudal_sec.html*. Nathan Schneider points at an additional element, the pre-democratic "implicit feudalism" of mailing lists, software projects, Wikipedia and other community projects where coordinators are appointed for life: *hackernoon.com/online-communities-aint-got-nothing-on-my- mothers-garden-club-because-of-implicit-feudalism-gc2z34y4*.

a problem, and a diffuse feeling of paranoia arose, but we never received a radical makeover of the core infrastructure. In an overall suspicious and anxious atmosphere, what's the point of understanding distraction-by-design or taking digital literacy programs that just preach restraint, rationalism, and other offline morals?[12] The discursive vacuum was going to be filled one day. This is the price we pay for the hesitant attitude of a digitally indifferent ruling class that continues to downplay internet culture as momentary hype while awaiting the return of state media and corporate controlled news and entertainment.

This organized neglect to take seriously the downsides of internet culture is now boomeranging, leading to an acute conceptual poverty. This wouldn't be so bad, apart from the fact that over five billion users now depend on this infrastructure. We've so far failed to develop a language that would help us grasp the social logic of these "media."[13] For example, Casey Newton asks, "why we built a world in which so much civic discourse takes place inside a handful of giant digital shopping malls."[14] Yet the emphasis of the shopping metaphor is still on passive consumption. We've surpassed this position, yet neither interactivity of the "prosumer" nor the interface design disciplines have managed to deliver captive concepts that reached the mainstream. What would happen if the multitudes could understand and embody the grammar of the techno-social?

Critical scholarship seems to be unable to produce anything other than belated revelations without consequences. Internet theory has been destined to arrive late. Hegel once said that "the owl of Minerva takes its flight only when the shades of night are gathering." The same applies to net criticism. Only when we move to a temporary outsider position of criticism can we discover the limitations of the previous perspectives. Instead of a radical techno-imagination focused on rolling out

12    Instead of bitterly criticizing therapeutic gestures of European offline romanticism, we should better approach it with a smile and follow the attitude of Groucho Marx: "I find television very educating. Every time somebody turns on the set, I go into the other room and read a book. ... I find offline very educating. Every time somebody turns off the internet, I go into the other room and read a book."
13    This is a reference to the (rightly) unquestioned reputation of Lev Manovich's 2001 *The Language of New Media*. In his cinema-centric study, the social element simply fails. Precisely at the dawn of Web 2.0, when networks are being teleported to the level of platforms, "newness" is defined in terms of the interaction between image and user. The design question of how to visualize (and administrate) the presence of others is implicitly delegated to behavioral psychologists, IT, experts, and data scientists.
14    Casey Newton, *Platformer newsletter*, August 4, 2021.

alternatives, we get distracted by a neverending carousel of new tech developments: big data, automation, artificial intelligence, facial recognition, social credit, cyber warfare, ransomware, internet of things, drones, and robots. The ever-growing list of doom tech prevents users from collectively dreaming and deploying what matters most: their own alternative versions of the techno-social.

Lee Vinsel took this argument a step further, noticing that critical writing itself is parasitic upon hype and even inflates it.[15] The professional concern trolls of technoculture invert the messages of pundits, taking press releases from startups and turning them into hellscapes. Vinsel mentions the Netflix *Social Dilemma* documentary (watched by over 100 million viewers) and Shoshana Zuboff's *Surveillance Capitalism* as examples of "criti-hype" that "overstate the abilities of social media firms to directly influence our thoughts and provide near-zero evidence for it." Doom scrolling, subliminal liking habits, and selfie culture are social-psychological facts. With the ever-growing evidence of such manipulations that result in "behavioral modifications," we no longer have to explain the overwhelming presence of smartphone use in everyday life.

# Everyone's a Critic

The Palo Alto consensus is abhorrent but nothing has replaced it yet.[16] Leaving behind a once necessary deconstruction of the disruption paradigm, where's internet criticism today in her task to describe the fifty shades of stagnation? How long can our outrage-over-a-Tweet high last before the boredom kicks in? How much civil courage does it take before one can properly study the stagnation of one's own industry—an industry proud of its revolutionary reputation and "disruptive" innovation? The sheer cult of busyness and importance only further hides the putrefied situation. We are not talking about a counter-revolution here but about fatigue and dopamine deprivation. Is everyone ready for a round of serious confrontation and

15      Lee Vinsel, "You're Doing It Wrong: Notes on Criticism and Technology Hype," *Medium* February 1, 2021, *sts-news.medium.com/youre-doing-it-wrong-notes-on-criticism-and-technology-hype-18b08b4307e5*.

16      See Kevin Munger, "The Rise and Fall of the Palo Alto Consensus," *New York Times*, July 10, 2019, *www.nytimes.com/2019/07/10/opinion/internet-democracy.html*.

conflict? Or would it be better to take a cue from therapy and first admit we have a problem ("Yes, we're stuck")?

Let's start with some good news. Lately, both popular non-fiction and academic studies about social media, AI, big data, facial recognition, privacy, and surveillance have all exploded.

Some may see the avalanche of book titles (including my own) as a key step towards public awareness. Research is finally catching up with the disruptive tactic of moving at light-speed during the first internet decades. However, the thesis here is that the produced knowledge still arrives too late to make a difference. So while this surge of interest is welcome, critique by itself can make matters worse. "Crisis no longer produces change; negativity destroys the old but no longer produces the new."[17] As the late bell hooks warned:

> When we only name the problem, when we state complaint without a constructive focus or resolution, we take hope away. In this way critique can become merely an expression of profound cynicism, which then works to sustain dominator culture.[18]

—a motto throughout my work.

At least criticism is changing. With Trump and Brexit, the era of "mansplaining the internet" faded away. A decade earlier, internet critics were predominantly white aging males based in the United States: Andrew Keen, Nicolas Carr, Douglas Rushkoff, and Jaron Lanier. Then female technology criticism took the stage, featuring scholars like Shoshana Zuboff and the AI ethics school of Kate Crawford, Safiya Noble, Virginia Eubanks and Ruha Benjamin, brought together in the Netflix documentary *Coded Bias*.[19] However, what remained is the U.S. dominance in the field of to-the-point, one idea paperbacks. For its part, Europe still caters for the festivals and conferences like Re:publica and the Chaos Computer Congress. Yet despite the lavish overproduction of these events, they fail to elevate European technical competence and expertise to center stage.

---

17    Matt Colquhuon, "Introduction," in Mark Fisher, *Postcapitalist Desire: The Final Lectures* (London: Repeater, 2021), p. 27.
18    bell hooks, *Teaching Community: A Pedagogy of Hope* (London: Routledge, 2013), p. 14.
19    While it may be true what Adrian Daub observes in *What Tech Calls Thinking*, that "men build the structures; women fill them," (p. 49) this is not the case with AI criticism.

The reasonable knowledge of the English native speaking researcher easily prevails over the provincial resentment of the continental European coffeehouse intellectual.

Simultaneously, we witnessed the rise of American first-hand accounts of the working conditions in Silicon Valley, part journalism, part confession literature.[20] While it's tempting to summon the takeover of a "doom industry," the PR machine of U.S. tech journalism is still up and running. We need to be aware of the vested interests and general position of this industry, one deeply rooted in an odd combination of organized optimism and libertarian right-wing techno dystopian culture. The "don't be evil" anti-state pro-market ideology of past decades wasn't so easily canceled. As nothing fundamentally changed, distressed mental states fed back into the medium itself. The "scandals without consequences"—cancel culture being a prime example—kept piling in, as did "tech bashing" accounts. But these wildfires of anxiety were ultimately small and sporadic.

What makes the avalanche of tech-related studies so easy to ignore is that criticism, discussion, and debate are considered past categories. Such discourse is a remnant of the age of public opinion in which different social strata battled to gain ideological hegemony. Glenn Greenwald explains:

> The dominant strain of U.S. neoliberalism is authoritarianism. They view those who oppose them and reject their pieties not as adversaries to be engaged but as enemies, domestic terrorists, bigots, extremists and violence-inciters to be fired, censored, and silenced.[21]

This basic shift in attitude explains the absence of the open and democratic "public forum" in all platforms, the emphasis on friends and followers, and the anxious administration of "trolls" that need to be deleted, filtered, blocked, banned, re-educated, jailed, and extradited, and, ultimately, exterminated. The Other will no longer be tolerated as a diverse and different "voice," but will rather

---

20    While there are always new beginnings waiting to be (re)discovered, such as the ground-breaking work of the Bay area Bad Subjects (founded in 1992), pioneer work regarding gender politics and the right-wing libertarian politics of venture capital firms was done by PandoDaily (*pando.com*), ran by Sarah Lacy and Paul Carr (former NSFW Corp).

21    Glenn Greenwald, "The Threat of Authoritarianism in the U.S. Is Very Real, and Has Nothing to Do with Trump," *greenwald.substack.com*, December 28, 2020, *greenwald.substack.com/p/the-threat-of-authoritarianism-in*.

be forced to go away and dissolve. Out of sight, out of mind. These basic design premises have made it so hard, if not impossible, to talk about social media in relation to the principle of deliberative democracy.

How will we ever break through the cynical feedback loop of extraction, prediction, and modification? The will to optimize entropy[22] needs to go on hold. It will take a yet unknown paradigm shift to prevent treating human experience as free, raw material. Will resilience, courage, kindness, and care be enough? A declaration of digital sovereignty will not be enough. How can we ignore and overcome the chilling effect and go crazy, again?

# Journeying Out of the Valley

Recent literature doesn't help us dismantle the Silicon Valley system. It fails to provide alternatives to the stagnant monopoly model driven by venture capital. Take Anna Wiener's personal story that proudly carries the Solnit blurb "Joan Didion at a startup." Much like Jarett Kobek's *I Hate the Internet*, Wiener's achievement is to contribute to the gonzo database of Bay-area social history of the internet, built by pointless men—only this time written by a spotless Millennial, reporting from inside the trade.[23]

Wiener takes us back to the spirit of pre-2016:

> Social networks, claimed its founders, were tools for connection and the free circulation of information. Social would build communities and break down barriers, would make people kinder, fairer, more empathetic. Social was a public utility for a global economy that was rapidly becoming borderless, unbounded— or would be. Social would bring liberal democracy to the world. Social would redistribute

---

22        "To the question, then, what is entropy? a further reply comes in the shape of this apparently abstract formula: Entropy = the self-metabolizing of *différance* (spatiotemporalization [Derrida]). The tendency for entropy to increase is thus contiguous with the tendency of différance to propagate: a "repetition compulsion" (*Wiederholungszwang*)." Louis Armand, *Alienist Manifesto* 10 (June 2021), p. 18, *alienistmanifesto.wordpress.com/2021/05/31/alienist-10/*.

23        For a different overview of approximately the same books, see Tamara Kneese, "Our Silicon Valley, Ourselves," *b2o*, August 6, 2021, *www.boundary2.org/2021/08/tamara-kneese-our-silicon-valley-ourselves/*. I agree with Kneese that first-person accounts of life in tech are as political as trade union accounts that contain interviews with workers. As much as Paulina Borsook's classic *Cyberselfish* appeared after the fact, when the dotcom crash was already well underway in 2000, the Silicon Valley literature is de facto social history. Our problem is one of time, how to develop a tech critique of the present, or even better: a critical intelligence that predicts.

> power and set people free, and users would
> determine their own destinies. Deeply rooted
> authoritarian governments were no match for
> design thinkers and PHP applications.

Wiener's account starts off with the ecstatic sense of optimism when

> two hundred million people signed on to a
> micro-blogging platform that helped them feel
> close to celebrities and other strangers they'd
> loathe in real life. Artificial intelligence and
> virtual reality were coming into vogue, again.
> Self-driving cars were considered inevitable.
> Everything was moving to mobile. Everything
> was up in the cloud.

It was a year of optimism,

> of no hurdles, no bad ideas. The word "dis-
> ruption" proliferated, and everything was ripe
> for or vulnerable to it: sheet music, tuxedo
> rentals, home cooking, home buying, wedding
> planning, banking, shaving, credit lines, dry
> cleaning, the rhythm method. A website that
> allowed people to rent out their unused drive-
> ways raised four million dollars.[24]

It's surprising to see how polite Wiener is. Instead of calling out specific companies, she talks about "the millennial-friendly platform for renting strangers' bedrooms," "a search-engine giant down in Mountain View," and "the social network everyone hated," refusing to name names. While Kobek takes up the role of the angry young man who unleashes a private vendetta against the evil forces behind gentrification, Wiener documents her own *Werdegang* as a pragmatic believer, migrating from one startup to the next, before finally arriving as a "tech critic."

In the end, both office and street perspectives leave the scene, disillusioned. "The young men of Silicon Valley were doing fine," she writes. "The person with the yearning was me." At the end of her account, Wiener

24   Anna Wiener, *Uncanny Valley: A Memoir* (New York: Farrar, Strauss and Giroux, 2020), p. 3–4.

confesses that she has been repeating herself. "Working in tech provided an escape from the side of my personality that was emotional, impractical, ambivalent, and that wanted to be moved, that had no apparent market value."[25] What the boys wanted was to build systems; what Wiener wanted was the emotional narrative, the psychological and personal side of the story.

> My obsession with the spiritual, sentimental, and political possibilities of the entrepreneurial class was an ineffectual attempt to alleviate my own guilt about participating in a globally extractive project.[26]

While similar to Anna Wiener in terms of personal style, Wendy Liu's memoir *Abolish Silicon Valley: How to Liberate Technology from Capitalism* contains more explicit language and demands. A case in point is Google's cult of secrecy seeking

> to ward off leaks and mitigate security risks. The latter made sense to me, but the former had me unconvinced. Why was this company so afraid of public criticism? Developing technology in a bubble seemed like a recipe for disaster when people around the world were depending on Google's products—especially when Google's technical workforce was wildly unrepresentative of the wider population.

I would add here that all companies that grow aggressively and operate with neoliberal frameworks internalize PR and marketing as part of their personal integrity. There is no distinction between the intimate self and professional decisions. All forms of criticism, no matter how soft or harsh, are considered a direct attack on the aura of good intentions that surrounds the product.

With Trump in power and real estate expulsions at its height, Wendy Liu left the Bay area to study in London, where she reads up on critical literature. She starts to ask if there's another way to do it, to develop tech "without the role of a multinational corporation necessitating patents and

25    Wiener, *Uncanny Valley*, p. 260.
26    Ibid., p. 262.

lawyers and stock price analysts?"[27] While wishing for sites for the public good, free of ads and marketing, may be laudable or worthy, one also wonders why such goals had all but disappeared. Why had generation after generation bought into the libertarian startup logic and never even dreamed of revolting against the logic of extraction and surveillance?

Silicon Valley platforms have blurred the distinction between attitude and opposition. It's become harder to distinguish between the radical sincerity of refusal and the lifestyle choice of otherness-without-consequences. According to Caroline Busta,

> platforms reflect the countercultural demands of earlier generations: eschewing big government and vertical corporate culture while encouraging personal fulfillment and flat organizational structures. Today you can be a coder and a DJ, an Uber driver and a travel blogger, a Sand Hill Road suit and a Robot Heart Burner.[28]

To be truly countercultural, "one has to, above all, betray the platform, which may come in the form of betraying or divesting from your public online self."

First-hand accounts turn out to be powerful documents. *Bekenntnisliteratur* fascinates us because we still haven't cracked the mystery of why Good People Do Evil Things. Why didn't they notice the right-wing libertarian agenda of the venture capitalists that keep on funding startups? While evidence of wrongdoing keeps coming in by the truckload, neither neoliberal nor authoritarian political forces feel the need to come up with structural solutions.

# Everything Is Collapsing

To move beyond the capitalist realism of the Bay Area, we need to put the internet malaise into a wider—and even less comforting—perspective: the Faustian "collapsology."[29]

27      Wendy Liu, *Abolish Silicon Valley* (London: Repeater, 2020), p. 137.
28      Caroline Busta, "The Internet Didn't Kill CountercultureYou Just Won't Find It on Instagram," *Document Journal* January 14, 2021, *www.documentjournal.com/2021/01/the-internet-didnt-kill-counterculture-you-just-wont-find-it-on-instagram/*.
29      *en.wikipedia.org/wiki/Collapsology*. Bernard Stiegler organized a workshop in Paris around this topic on July 2–3, 2019, in which I participated, along with young members of the French chapter of Extinction Rebellion, in preparation of the renaming of the Ars Industrialis organization into the Association of Friends of the Thunberg Generation.

We could also call this the "stack of crises" in which
ecological, economic, financial, and digital crises all inter-
twine and bounce off of each other, resulting in a cascade
of interrelated events, a whirlwind of droughts and fires,
floods and uprisings. Let's add here the social media ques-
tion, an issue that most love to ignore. We would rather
indulge in philosophical reflections on AI intelligence that
get stuck into repairing the mess called network society.
The failed architecture of the internet is one of the many
layers in the stack of crises.[30]

It's important for me, in this context, to involve here
the work of Bernard Stiegler, who passed away in 2020
and played a key role in my thinking over the past decade,
putting the still exploding internet into perspective. In one
of his texts, he concludes that "the fact that the knowledge
necessary to combat the consequences of contemporary
technological development has been destroyed." We need
to understand social media as what Stiegler calls autom-
atisms. "This must be done at a time when general auto-
matization clearly amounts to a new age of heteronomy
bearing within it the possibility of the end."

The last thing we need is legal and sociological sys-
tems that ignore the present political moment in favor of
an invented tradition of thinking that must be preserved.
There is no media theory or digital humanities legacy here
that needs to be defended, let alone a stillborn "net critic"
profession in need of promotion. Let's not get lost in pe-
dantic exercises to define and defend academic territories
with their canons and methods. Efforts to confine the
"digital" will be in vain. Digitization is a closed chapter,
done, finito. Soon the internet will be as well, pushed aside
by even larger, urgent forces.

What we should praise is the present lack of weight,
and, for instance, enjoy the confusion amongst those that
try to map "digitization." In this sense, the conceptual and
institutional poverty concerning the internet can also be
read as freedom—the initial freedom every user once felt—
one that Hannah Arendt explained in such clear language.
Against the backdrop of a platform era defined by new
enclosures of the mind, Arendt insists on the preservation

30      "The more we can see the connection between data-based extraction and earth-based extraction,
the better off we'll be." Naomi Klein, speaking on Douglas Rushkoff's Team Human podcast, August 4, 2021.

of wonder and the lifelong pursuit of inquiring after the unknown. With Arendt, we should resist the fate of both speculative and critical thinking to become moral philosophy, "mere instruction in the art of living. A how-to instead of a questioning."[31] For Arendt (political) theory is born out of despair (which happens to be the current state of internet culture) in response to historical experiences (in our case failed networked uprisings and the fortification of digital confinements). If there is something to defend here, why not the "grandeur of the internet"?

Alarmism is not enough. In the *Inhabit-Instruction for Autonomy*, it reads:

> To hell or utopia? Either answer satisfies us. Finally, we reach the edge—we feel the danger of freedom, the embrace of living together, the miraculous and the unknown—and know this is life.[32]

This is the vitalism necessary to climb out of the abyss. The manifesto presents two paths. A: It's over. Bow your head and phone scroll through the apocalypse. B: Take a breath and get ready for a new world. The focus here is on network versus platform. *Inhabit-Instruction for Autonomy* can be read as a manual on how to go from A to B. However, decisionist gestures are not enough. It's first necessary to study why so many got stuck on the platform. "We search for the organizational power to repair the world and find only institutions full of weakness and cynicism." It all starts with the elimination of isolation and making an inventory of the collective skills, capacities, and connections. The proposed way out consists not so much in the creation of networks as such but of building meeting points (note: not platforms). Such hubs or nodes can be designed as points of aggregation, temporary centers of activity. While the platform is aimed at economic exchange and (data) extraction, the aim of the hub is to create commonality. There can be a thousand hubs but only one plateau.

---

31      These insights are part interpretation and part adaptation of Samantha Rose Hill's blog postings and tweets on Arendt's distancing of (political) philosophy, in particular Samantha Rose Hill, "Hannah Arendt's Courses on 'The History of Political Theory' and Philosophy?," *substack.com*, January 26, 2021, *samantharosehill.substack.com/p/political-theory?r=9dhve*.
32      *inhabit.global/*.

Creating a hub is the logical next step to finding each other. We need dedicated spaces to get organized and to give ourselves time together. Hubs bring together the people, resources, and shared spirit necessary to create the foundation for a life in common.

Consider *Stuck on the Platform* a relapse-resistant story about the rise of platform alternatives, built on a deep understanding of the digital slump.

1

# The Anatomy of Zoom Fatigue

"Humankind is so resilient.
For example, I have acclimated
to Microsoft Teams."
Ian Bogost

"Word of the day is
'clinomania': the excessive
desire to stay in bed."
@susie_dent (Susie Dent)

Poverty of hermeneutics today:
Post-it Notes, Miro, tag clouds,
a search bar, infinite scrolling
recommendations.

This is it. During the COVID-19 pandemic, the internet came into its own. For the first time ever, it experienced a sense of completion.[1] Glitches were common. Video calls lagged, then froze. Laptops or routers had to be restarted. In those bright early days of the first lockdown (March–April 2020), few dared to complain. Almost overnight we saw a mass migration to Zoom. And oh what freedom! To paraphrase Marx and Engels, it was now possible to teach class in the morning, attend a conference in the afternoon, and socialize after dinner—while never leaving the fucking screen. We hadn't yet arrived at the feeling of being trapped in a virtual prison. In fact, as we tweaked and improved our online personas, in-person meetings began to feel strange or secretive. Somehow, we became trapped in a *Videodrome* future, a scenario that suggested some very dark outcomes.

From mid-2020 onwards, I began collecting evidence on the trending topic of "Zoom fatigue." Needless to say, experiences of this kind are not just limited to Zoom, but extend to Microsoft Teams, Skype, Google Classrooms, GoTo Meeting, Slack, and BlueJeans—to name but a few of the major players. In our pandemic era, cloud-based video meetings became the dominant work/life environment, not just in education, finance, and health care, but also in the cultural and public sector. Every stratum of management withdrew into new enclosures of power. The same environment was adopted by high-flying business consultants and precarious freelancers. While their lives were very different, they had one thing in common: they work very long hours.

Zoom has multiplied work, expanded participation, and systemically devoured any time we might have once had for writing, thinking, leisure, and relations with family and friends. Excessive screen time takes a toll. Body Mass Index levels have increased. Affective states and mental health has taken a hammering. Spatio-motor coordination has suffered. Video vertigo is a peculiar condition that also prompts more widespread forms of disorientation. Minka Stoyanova teaches computer programming and spends 20 hours a week on Zoom: "My ability for non-work-related social-distancing encounters has gone down greatly," she

1   German "Vollendung": completion, perfection.

confessed. While some people "schedule Zoom cocktail parties and birthday meet-ups, I dread having to log back into the interface."[2]

It is a question of strategy. Should we resist this new normal and go on strike? Should we refuse to deliver online classes, hold management meetings, or offer virtual medical consultations? This is easier said than done. Paychecks are at stake. At first, staying at home felt like a privilege. We even felt a little guilty when others had to venture out into the pathogenic world. Now, many fear that video calls are here to stay. "Companies big and small, all over the world, are transforming themselves into a business that is more digital, more remote, and more nimble," observes Fast Company.[3] Expensive real estate can be sold off, expenses dramatically reduced, and discontented staff neatly isolated, preventing any communal organization.

The video dilemma is intensely personal. "If work exhausts my video call time, I intuitively cut informal video calling with allies, friends, possible collaborators," designer Silvio Lorusso observes. "This makes me sad and makes me appear rude. It's a self-preserving attitude that leads to isolation." The debate should not be about hanging out on FaceTime or Discord with friends for a game night, doing karaoke, holding a book club, or watching Netflix together. Video time is part of the advanced post-Fordist labor regime, performed by self-motivated subjects who are supposed to be doing their jobs. But then you drift off while pretending not to. Your eyes hurt, your concentration span diminishes, multi-tasking is a constant temptation, and that physically, psychically uncomfortable feeling hums in the back of your head ... You've heard it all before.

In 2014, Rawiya Kameir defined internet fatigue as the state that follows internet addiction:

> You scroll, you refresh, you read timelines compulsively and then you get really, really exhausted by it. It is an anxiety that comes along with feeling trapped in a whirlwind of other people's thoughts.[4]

2        Private email exchange after a public call on the nettime mailing list, July 3, 2020.
3        Siddarth Taparia, "This One Concept Will Transform the Future of Work Post-COVID-19," *Fast Company*, March 10, 2020, *www.fastcompany.com/90558734/this-one-concept-will-transform-the-future-of-work-post-covid.*
4        Rawiya Kameir, "Is Internet Fatigue Ruining Your Life," *Complex*, March 17, 2014, *www.complex.com/pop-culture/2014/03/is-internet-fatigue-ruining-your-life.*

Philosopher Nigel Warburton echoed this fatigue with his Twitter post that asked: "Does anyone have a plausible theory about why Zoom, Skype, and Google Hangout meetings are so draining?" He received 63 retweets, 383 likes, and a few replies. The responses closely mirrored popular diagnoses and advice now offered across the web. So what were the main drivers of this exhaustion after a Zoom meeting, this post-screen slump? Responses included the brain's attempt to compensate for the lack of full body, non-verbal communication cues; a sense of constant self-consciousness; engagement in multiple activities with no real focus; and a consistent tugging temptation to multi-task. Suggested remedies are predictable: take breaks, don't sit for too long, roll your shoulders, work your abs, hydrate regularly, and integrate plenty of "screen free time" into the day.

## Living in Videospace

Isabel Löfgren lives in Stockholm, but Zoom has become her official place of residence. Her office is now located in that sleek black rectangle in her pocket, her mobile device. "Our living rooms have become classrooms," she states.

> **Does it matter what is on display behind you? What does it say about you? If you have a bookshelf in the background, or your unfolded laundry in a pile on the chair behind you, it's on display and up for scrutiny. What is personal has become public.**

Zoom sets up shop in the private space of the home, becoming another room in the house. Which theorists or philosophers predicted this strange scenario? Gaston Bachelard certainly didn't in his *Poetics of Space*. Neither did Georges Perec in *Life: A User's Manual*, failing to include a screen in his fictitious apartment block.

Actually Czech philosopher Vilém Flusser anticipated this state of affairs, predicting "the technical image as phenomenology." Technical implies something state-of-the-art, a technology which is both smooth and sophisticated. Yet as Löfgren notes, Zoom's functionality is surprisingly simplistic or even crude. "You can raise your hand and clap like a preschooler, chat like a teenager,

and look at yourself in your own little square as if peering at a mirror."[5] In fact, in many cases, Zoom fails to work altogether. Lorusso chronicles a long litany of dysfunctions in his first days of use.

> I couldn't install Microsoft Teams, my camera wouldn't activate, and, worst of all, the internet connection had hiccups. The connection was neither up nor down; every other attempt it just became super slow. Let me help you imagine my video calls: all would be smooth for the first five minutes and then decay took over—frozen faces, fractured voices, reboots and refreshes, impatience and discouragement. A short sentence would take minutes to manifest. It was like being thrown back to the times of dial-up connection, but within today's means of online communication.[6]

Zoom was broken, but we used it anyway. All-too-quickly, it became the new normal. Video calling moved from a global experiment to a foregone conclusion. We adjusted to a new interpassive mode. That was it. Completion achieved.

"I am utterly zoomed out and exhausted," Henry Warwick writes from Toronto.

> Between watching the nation of my birth (the United States) commit a long slow political suicide and having friends die of COVID and working like a dog while on what is de-facto nine months of bio-house arrest, I'm not in a great mood.

Henry's summer was spent making video bits and preparing for the delivery of asynchronous class material, which he describes as

> not really a university education—it is a step above a YouTube playlist. Sitting in front of a Zoom window makes it difficult to forge those friendships and networks, and it's certainly

5    Private email exchange, June 26, 2020.
6    Silvio Lorusso, "Remote Work? Demand Dial-Up," *Platform BK*, posted June 12, 2020, *www.platformbk.nl/en/remote-work-demand-dail-up/*.

a buzzkill for adventure. In addition, there is
the issue of Internet Time as I have students
all over the world. It's hard for them to attend
a two-hour lecture when it's 2.00 a.m. where
they are. It's utter madness. Making these vid-
eos was a serious time drain. I refuse to give
Adobe my money, and Apple screwed Final
Cut Pro so badly that I am editing my videos
in DaVinci Resolve, which has the benefit of
being free-ish. I have never used Resolve,
so the learning curve was not insignificant.[7]

Long before the recent pandemic, philosopher Byung-Chul
Han was already observing that we no longer lived in a
disciplinary society but one defined by performance.[8] This
performance is not spectacular or intense, but a kind of
mundane repetition. Spending hours in virtual conferences
doesn't feel like being in a paranoid panopticon—but
neither is it a celebration of the self. We are not being
punished—but we also aren't feeling productive. We aren't
subjected—but we can't say we're activated either. Instead,
we are hovering, waiting, pretending to watch, trying to
stay focused, wondering when we might squeeze in a
lunch break or recharge with a caffeine hit. Much like the
seemingly endless pandemic, we are being asked to endure
never-ending sessions on Zoom. The Outlook Calendar is
the new jail warden. This is not a brief sprint, where we
emerge sweaty and uplifted, but a long-duration marathon
that leaves us drained and depleted. What's wearing us out
is the *longue durée*.

    Tired subjects perform badly. Screen time apps and
MyAnalytics summaries now tell us precisely how many
minutes of our lives are being wasted as we calibrate our
productivity and efficiency to collaborate with colleagues.
It's hard not to wonder if the IT sector isn't about to get
into bed with big pharmaceutical companies. The society
of synthetic performance enhancement is now prime for a
dramatic expansion. There is no hope that this simulacrum
of life can ever protect us from accelerating economic and
social collapse. Despite the guilt trips, we are allowed to

7    Private email exchange, October 1, 2020.
8    Byung-Chul Han, *The Burnout Society* (Redwood City: Stanford University Press, 2015).

admit that we're not achieving much.

In response, the system has turned emphatic and switched to worry-mode about our mental state. Soon after the introduction of lockdown, with quarantine in place, the authorities set about investigating whether their pitiable subjects were still coping. With society on hold, it is the waiting that tires us out. A few years ago, David Wojnarowicz tracked how another disease took its toll on the body, noting the disintegration that resulted from his encounter with the "fatality, incurability and randomness of AIDS ... so powerful and feared."[9] Now we witness our own version of disintegration, watching as our lives fray at the seams. Trapped in the waiting room, we are being asked—very kindly—to stay in survival-mode, to press on despite our burnout.

Pressing on means mastering anger and numbing intense emotion. What we experienced during the shock of lockdown was *aesthetic flattening*: a highly reductionist substitute for human interaction, as Cade Diehm and Jaz Hee-jeong Choi described our online social life in that period:

> a core source of angst in reflections on the hypermodern vulgarity inherent in the same software being used for everything from professional meetings to remote birthdays to funerals, or the absurdity of rushed, voyeuristic on-screen pedagogical endeavors, marred by limited support and buffer for failures.[10]

According to Diehm and Choi, video calling is an unsatisfactory low-resolution audio-visual interaction. This is paired with the reduction of body and identity from three dimensions to two, facilitated by universalist design thinking for smooth-surfaced dumb terminals that cannot accommodate performative or deeply immersive interactivity and self-expression.

Zoom has become the universal client, the software suite for everything. It seems to tick off a giant list of use

---

9    David Wojnarowicz, *Close to the Knives: A Memoir of Disintegration* (Edinburgh: Canongate Books, 2017). See also *blogs.ethz.ch/making-difference/2019/05/09/introduction-posthuman-bodies-judith-halberstam-and-ira-livingston/*.

10    Cade Diehm and Jaz Hee-jeong Choi, "Aesthetic Flattening," *The New Design Congress*, posted on June 30, 2021, *newdesigncongress.org/en/pub/aesthetic-flattening*.

cases: social media, work, entertainment, food orders, gaming, watching Netflix, seeing how family and friends are doing, and live streams to observe those in hospital. In the context of a global lockdown, it offers some level of telepresence, allowing us to steer clear of buses, trains, and airplanes. But what a sad form of teleportation. What happened to the future? We need to go back to early science fiction novels, to revisit those far-fetched dreams. Utopia and dystopia seemed to merge in 2020. All we want is to re(dis)cover the body. We demand instant vaccines. We want less tech. We long to go offline, to travel. We want to leave the damned cage behind.

# Zoom Doom

Some weeks into lockdown, the question arose why video conferencing was so exhausting. Zoom fatigue is "taxing the brain," people complained.[11] Why are classes and meetings on Skype, Teams, and Google Hangout so draining? This was expressed not as some sort of interface critique but as an actual existential outcry. Popular articles on Medium name it as such. Common titles include variations of "Do You Have Zoom Fatigue or Is It Existentially Crushing to Pretend Life Is Normal as the World Burns?" and "The Problem Isn't Zoom Fatigue—It's Mourning Life as We Knew It."

It took just days for the "Zoom Fatigue" trope to establish itself, a sure sign that internet discourse is no longer controlled by the "organized optimism" of the marketing lobby. Managerial positivism has been replaced by the arrival of instant doom. According to Google Trends, the term made the rounds back in September 2019 and reached its peak in late April 2020, when the BBC reported on it.[12]

> Video chats mean we need to work harder to process non-verbal cues like facial expressions, the tone and pitch of the voice, and body language; paying more attention to these consumes a lot of energy,

11    Julia Sklar, "'Zoom Fatigue' Is Taxing the Brain: Here's Why That Happens," *National Geographic*, April 24, 2020, *www.nationalgeographic.com/science/2020/04/coronavirus-zoom-fatigue-is-taxing-the-brain-here-is-why-that-happens/*.
12    *trends.google.com/trends/explore?q=zoom%20fatigue*.

stated one expert. "Our minds are together when our bodies feel we're not. That dissonance, which causes people to have conflicting feelings, is exhausting. You cannot relax into the conversation naturally." Another interviewee describes how on Zoom "everybody's looking at you; you are on stage, so there comes the social pressure and feeling like you need to perform. Being performative is nerve-wracking and more stressful."[13] Maybe Han's performance prediction was correct.

"I usually stand and move around when lecturing, sometimes making large gestures," states Michael Goldhaber,

> just sitting at a desk or wherever is sure to be fatiguing. Doing this in a non-fatiguing way will require fundamentally re-thinking the system of camera, mic and screen with respect to participants.[14]

The sad and exhausting aspect of video conferencing can be attributed to the "in-between" status of laptops and desktop screens. They are neither mobile and intimate, like the smartphone and FaceTime, nor immersive such as Oculus Rift-type virtual reality systems. Zoom fatigue arises because it is so directly related to the "bullshit job" reality of our office existences. What is supposed to be personal turns out to be social. What is supposed to be social, turns out to be formal, boring, and (most likely) unnecessary. This is only felt on those rare occasions when we experience flashes of exceptional intellectual insight and when existential vitality bursts through established technological boundaries.

As programming teacher Stoyanova noted, the ability to see oneself—even if hidden in the moment—creates a tiring reflective effect, the sensation of being surrounded by a hall of mirrors. Educators feel that they are constantly monitoring their own demeanor, while simultaneously trying to reach through the interface to their students. In a blog post, L.M. Sacasas describes the effect of paying so much attention to one's self:

---

13    Manyu Jiang, "The Reason Zoom Calls Drain Your Energy," *Remote Control*, April 22, 2020, *www.bbc.com/worklife/article/20200421-why-zoom-video-chats-are-so-exhausting*.
14    Michael Goldhaber, nettime mailing list, July 7, 2020.

> We are always to some degree internally con-
> scious of ourselves, of course, but this is the
> usual "I" in the "I-Thou" relation. Here we are
> talking about something like an "I-Me-Thou"
> relation. It would be akin to having a mirror
> of ourselves that only we could see present
> whenever we talked with others in person.
> This, too, amounts to a persistent expenditure
> of social and cognitive labour as I inadvertently
> mind my image as well as the images of the
> other participants.[15]

It is like practicing a speech in front of a mirror. When speaking to yourself, you experience a persistent cognitive dissonance. In addition, there is the lack of eye contact—even if students have activated their video—which also makes live lectures more difficult to conduct. "Without the non-verbal feedback and eye-contact one is used to, these conversations feel disjointed."[16] Curiously enough, speaking into the void nevertheless kickstarts the adrenalin glands, which certainly isn't the case when rehearsing in front of a mirror. We have entered a strange mode of performance that aligns with predictive analytics and pre-emption. Even though the audience might just as well not be there, performing on Zoom still activates biochemical responses in the body.

And yet if Zoom is a mirror, it is a delayed and distorted one. Online video artists Annie Abrahams and Daniel Pinheiro point to the rarely discussed effects of delay.

> We are never exactly in the same time-space.
> The space is awkward because we are con-
> fronted with faces in close up for long time
> spans. We first see a face framed like when we
> were a baby in a cradle as our parents looked
> down upon us. Later it became the frame of
> interactions with our lovers in bed. This makes
> it that while video-conferencing, we are always
> connected to something very intimate, even in
> professional situations.

15    L.M. Sacasas, "A Theory of Zoom Fatigue," *The Convivial Society*, April 21, 2020, *theconvivialsociety.substack.com/p/a-theory-of-zoom-fatigue*.
16    Private email exchange, July 3, 2020.

Abrahams and Pinheiro also observe that it is impossible to detect much detail in the image we see.

> Video conferencing is psychologically demanding because our brains need to process a self as body and as image. We lack the subtle bodily clues for the content of what someone tells. Our imagination fills the gaps and makes it necessary to process, to select what to ignore. In the meantime, we are continuously scanning the screen (there is no overview and no periphery). We are never sure we are "there", that the connection still exists, and so we check our own image all the time. We hear a compressed mono sound, all individual sounds are mixed into one soundscape.[17]

The result of all this compression and distortion is an impoverished interface, a crude simulacrum of social interaction. Isabel Löfgren responds that we should think of Zoom as a "cold medium," one which demands more participation from the audience, according to Marshall McLuhan's concept of cold and hot media. "The brain needs to fill in the gaps of perception, which makes our brains (and our computers) go on overdrive." In terms of camera angles, Löfgren adds that we are constantly looking at a badly framed medium-shot of other bodies.

> We have no sense of proportion in relation to other bodies ... emotional closeness to the subject on the other side of the camera is eliminated with the lack of eye contact,

leaving us with no "pheromonal connection." In this sense, "Zoom terminology is correct," she notes, "our experiences of others occur in 'gallery mode.'"[18]

# Caught in the Grid

The Zoom regime keeps the subject locked in, on task and on track. *Keep your eyes on the camera*, our digital alter-ego

17      A. Abrahams et al., "Embodiment and Social Distancing: Projects," *Journal of Embodied Research 3*, no. 2 (2020), 4 (27:52), *doi.org/10.16995/jer.67*.
18      Private email exchange, October 3, 2020.

whispers through our earphones. According to Sacasas, video conference calls are

> physically, cognitively, and emotionally taxing experience as our minds undertake the work of making sense of things under such circumstances. We might think of it as a case of ordinarily unconscious processes operating at max capacity to help us make sense of what we're experiencing.[19]

We are forced to be more attentive, we cannot merely drift off. Multi-tasking may be tempting, but it is also very obvious. The social (and sometimes even machinic) surveillance culture takes its toll. Are we being watched? Our response requires a new and sophisticated form of invisible day-dreaming, absence in a situation of permanent visual presence—impossible for students, who are not afforded their grades unless the camera stays on.

Video conferencing software keeps us at bay. Having fired up the app and inserted name, meeting number, and session password, we see ourselves appear as part of a portrait gallery of disappointing personas that constitutes the Team. Within seconds you are encapsulated by the performative self that is you. Am I moving my head, adjusting myself to a more favorable position? Does this angle flatter me? Do I look as though I'm paying attention? And this professional image is often disrupted by the distractions of "real life"—partners who walk into the room, a passing pet, needy kids, and the inevitable courier ringing the doorbell. "Thanks to my image on the screen, I'm conscious of myself not only from within but also from without," notes Sacasas. He describes the experience as a double event that the human mind experiences as if it were real.

Why do I have to be included on the screen? Don't I have the right to be invisible? I want to switch off the camera and become a ghostly half-presence. I want to be a voyeur, not an actor. I long to be frozen like an ancient marble bust, neatly standing in a row with other illustrious figures, brought to life with a click like the figures in *Night*

19    Sacasas, "A Theory of Zoom Fatigue."

*at the Museum.* But no, it's too late, I've already joined the call and appeared on stage. The software lords have decided otherwise and gifted the world with the virtue of visible participation. They demand total contribution. The set is designed to ensure that we stay focused, all of the time, making the fullest possible contribution, expending maximum mental energy. You hate dressing up for that video call (but you do it anyway). Bored and tired of the emotional labour, you change your background to a tropical beach, a paper thin paradise to inject some cheer into the situation.

> Writing for *Artforum*, Paula Burleigh observes that the most pervasive of COVID imagery has little to do with the actual disease: it is the digital grid of people congregating virtually on Zoom for "quarantini" happy hours, work meetings, and classroom instruction.[20]

The grid Burleigh describes as a hallmark of minimalist design and modernist art, "conjures associations with order, functionality, and work, its structure echoed on graph paper and in office cubicles." In his two-part *History of the Design Grid*, Alex Bigman describes how the system of intersecting vertical and horizontal lines was invented in Renaissance painting and page layout. This led to the development of graphic design. The assumption that images are more dynamic and engaging when the focus is somewhat off-center is something video conferencing designers have yet to take on board.

The grid cuts through any rational divisions between boxed-in subjects. Individuals are unable to spill-over into the space of others, except when they gossip on a backchannel. Let's commemorate the guilty pleasures of the Zoom bombers who, early on in lockdown, carried out swarm raids on open sessions they found on websites and social media.[21] For some, spraying management meetings

---

20          Paula Burleigh, "Square Roots: Paula Burleigh on Zoom and the Modernist Grid," *Artforum*, June 22, 2020, *www.artforum.com/slant/paula-burleigh-on-the-zoom-grid-83272*.
21          *en.wikipedia.org/wiki/Zoombombing*. In a private email from September 18, 2021, Donatella Della Ratta points at the pleasure of disrupting the official reality of videocasting out of the private sphere, for instance in a 2017 BBC broadcast two small children walk in (*www.youtube.com/watch?v=Mh4f9AYRCZY*). "How far we are from that cheerful atmosphere, the first time we have an incursion of 'real life' into screen life, kids playing and screaming in the background, the guy trying to be serious and professional, the interviewer laughing, and millions of people cheering while watching this. How far that cheerful atmosphere is from the incursion of real life we have to experience on a daily basis

with graffiti and workshops with porn was seen as annoying puerile male behavior. Others got the joke, understanding how this anarchist gesture disrupted the platform's regime of squared tiles and perfect order. As Burleigh concludes, "the grid is rife with contradictions between what it promises and what it delivers." Individualized squares are the post-industrial equivalent of a Le Corbusier housing nightmare: we are sentenced to live in our very own utopian prison cells. Here one finds tragic normalcy, punctuated at moments by deep despair.

We're alive, but are being slowly caught in the grid, trapped inside existential reality. Its insistence on 24/7 mindfulness can only lead to a regressive revolt, an urge to take revenge. How can we blow up the social portrait gallery, with its dreadful rectangular cut-outs? Jailed inside the video grid, you zone out, drifting away from the management meeting and entering a virtual version of Velázquez's *Las Meninas* (1656). You move on to the next room, the Kazimir Malevich 1915 Suprematist exhibition. You snap back to attention, only to realize the depressing reality: you're back inside your own sad version of *The Brady Bunch* opening credits. You're on Zoom, not roaming inside some artwork.

The body gets depleted, bored, distracted, and ultimately collapses. No more signals! Please provide less, turn the camera off. The number one piece of popular advice on combating Zoom fatigue is simply "do it less"—as though that's even an option. There is an imperative here, and it's about productivity and efficiency, not software. As one article quipped: "you don't hate Zoom, you hate capitalism."[22] Should we be designing indicators of group sentiment? In what way can we fast-forward real-time team meetings? More backchannels, perhaps, and less ongoing visual presence. But wait, isn't there already enough multi-tasking happening? If anything, we long for intense and short virtual exchanges, followed by substantial offline periods.

---

when we work, teach, do business meetings in constant fear that the cat will jump on the keyboard or someone will ring our door bell or our little kid will start screaming from the other room."
22        See, for instance, this 2021 study that compares to have cameras on and off during virtual meetings: Kristen M. Shockley et al., "The Fatiguing Effect of Camera Use in Virtual Meetings: A Within-Person Field Experiment," *APA PsycNet*, August 2021, *doi.apa.org/fulltext/2021-77825-003. html*. "Fatigue affects same-day and next-day meeting performance."

# The Zoomopticon

Zoom watches you. The video filter that adds a mask, a funny hat, a beard, or a lip color demonstrates that Zoom is watching you through face tracking technologies. Søren Pold, Danish interface design researcher, observes that Zoom only provides "a slight overview and control of the sound you're receiving and transmitting." This Zoomopticon, as Pold calls it,

> is the condition in which you cannot see if somebody or something is watching you, but it might be the case that you're being watched by both people and corporate software. Zoomopticon has taken over our meetings, teaching and institutions with a surveillance capitalistic business model without users being able to define precisely how this is being done.[23]

How can we respond to this surveillance regime and its pressure to be professional? In her *Anti-Video chat manifesto*, digital art curator Michelle Kasprzak echoes the understanding of Zoom as a surveillance tool. She calls out this eavesdropping, identifying other individuals and agencies on the call. "Hello NSA, hello Five Eyes, hello China, hello hacker who lives downstairs, hello University IT Department, hello random person joining the call." In response to this regime, Kasprzak calls on us to turn off our video cameras.

> DOWN with the tyranny of the lipstick and hairbrush ever beside the computer, to adjust your looks to fit expectations of looking "professional." DOWN with the adjustment of lighting, tweaking of backgrounds, and endless futzing to look professional, normal, composed, and in a serene environment. DOWN with not knowing where to put your eyes and then recalling you need to gaze at the camera, the dead eye in your laptop lid.[24]

23     Private email exchange, October 6, 2020.
24     Ref. in Silvio Lorusso's essay, *michelle.kasprzak.ca/blog/writing-lecturing/anti-video-chat-manifesto*.

She calls upon us to "refuse fake living in an IKEA show-room with recently-coiffed hair, refuse to download cutesy backgrounds which take up all our CPU, and refuse to fake human presence."

# Social Media as Medicine?

Zoom takes its toll on our physical and mental wellbeing. London-based cultural anthropologist and research consultant Iveta Hajdakova writes:

> Last week I had three nightmares, all related to remote work. In one, I was fired because of something I said when I thought I was offline. In the second, my colleagues and I were trying to get into an office through a tiny well. We were hanging on ropes and one of them became paralyzed, which I think was a dream version of a Zoom freeze. The third nightmare was about me losing track of my tasks. I woke up in panic, convinced I had forgotten to send an important email.

In the early days of lockdown, she struggled with head-aches and migraines. Luckily, she writes, these have gone

> perhaps due to a combination of factors, having a desk and a more ergonomic setup, being able to get out of the flat, limiting non-essential screen and headphone time, and adopting lots of small changes to my routine. The head and the ears are feeling much better now, but some-thing isn't quite right, as the nightmares signal. I've started feeling disconnected and I think this is not merely a result of social isolation but of a more profound sense of disorientation.

As a result, Hajdakova is noticing a growing sense of confusion and uncertainty. "I feel like I am losing the ability to anchor our interactions in embodied human beings and shared physical environments."

Zoom is on its way to becoming a social environment, a strange remediation of office life gone by. "In the beginning, recreating the office experience over video calls worked because all of us still had the shared reference

point," Hajdakova continues.

> But the more we're removed from the office in space and time, the more I'm forgetting what it is that we're imitating. We're creating something new, a simulacrum of the office.

And yet this simulacrum is a pale imitation, reducing a worker and her rich personality to a collection of chat handles and cutesy icons.

> I don't want to be just a face and voice on Zoom calls, an icon on Google docs, a few written sentences, I want to be a person ... Social media helps so I've been posting on social media a lot.

Friedrich Nietzsche once noted: "When we are tired, we are attacked by ideas we conquered long ago." When Facebook is experienced like a panacea, we know something must be deeply wrong. But why is this feeling of discontent so hard to pin down? The inert state is essentially regressive.

Proving our own existence is like running on a hamster wheel. "The more I try to be a real person, the more I'm getting trapped in the simulation of myself," Hajdakova says.

> I'm communicating and sharing just to remind people I exist. No, it is to remind myself that I exist ... Like McLuhan's gadget lover, like Narcissus, staring at his own image.

We are losing a sense of reality, memory and confidence, Iveta argues,

> but also losing a sense of understanding for other people. Just knowing that they feel X or Y but having no way of connecting with them through some kind of mutual understanding. In general, Zoom is traumatizing for me because of the way my mind works—I need physical things, shared environments etc., otherwise, I lose not only confidence but also memory and motivation.[25]

25     Quotes from a private email exchange, September 21, 2020. See also her text on the same issue: *thisbloodyplace.com/ill-just-never-know/*.

# No Diagnosis, No Cure

After surviving the COVID-19 siege, we've earned the right to wear the T-shirt: "I survived Zoom." Is a different kind of Zoom possible? We have found the experience we've undergone draining, yet coming together should empower. What's wrong with these smooth high-res user interfaces, accompanied by the lo-res faces due to shaky connections? It's been a delusional dream televising events and social interactions, including our private lives. Is the "live" aspect important to us or should we rather return to pre-produced, watch-them-whenever videos? In education this is not a marginal issue. There is a real, time-honored tension between the exciting "liveness" of streaming and the detached flat coolness of being "online."[26] How can we possibly reverse the Zoom turn?

Already we've seen some formulaic solutions being offered. In 2021, Stanford researchers published four causes of Zoom fatigue and proposed, in tired Silicon Valley fashion, "four simple fixes."[27] The obligations of students, teachers, and office workers to work online has been rephrased as "prolonged video chats." The required presence of many hours and even days is presented as a choice: "Just because you *can* use video doesn't mean you *have* to." To take the pressure off the eyes, the researcher recommends exiting full-screen mode, reducing the size of the window, minimizing face size, and using an external keyboard. In addition, users should employ the hide self-view button, install an external camera, give themselves audio-only breaks, and turn their bodies away from the screen. Power relations, within education and beyond, have not been taken into account. In most cases any form of "absence" from the screen will, intuitively or not, be read as disengagement and punished accordingly. Such tips tell Microsoft and Zoom how to improve their products and ultimately deliver more work to Stanford engineers. Instead of these "improvements," it is better to use a tool

---

26     See Alan Liu's definition: "Cool is information designed to resist information." (*The Laws of Cool*, Chicago: University of Chicago Press, 2004, p. 179). We could update Liu's phrase "I work here, but I'm cool" to "I hangout here, but I am cool."

27     Vignesh Ramachandran, "Stanford Researchers Identify Four Causes for 'Zoom Fatigue' and Their Simple Fixes," *Stanford News*, February 23, 2021, *news.stanford.edu/2021/02/23/four-causes-zoom-fatigue-solutions/*. The research paper can be found here: *tmb.apaopen.org/pub/nonverbal-overload/release/2*. A contextualization of the present can be found in this 1980s history of the "tired eyes": Laine Noorey, "How the Personal Computer Broke the Human Body," *Vice*, May 12, 2021, *www.vice.com/en/article/y3dda7/how-the-personal-computer-broke-the-human-body*.

like Zoomscraper that "allows you to self-sabotage your audio stream, making your presence unbearable to others."

Six months into the pandemic, online conferences on spirituality and self-awareness began to offer counter-poison to their own endless sessions. They staged three-day Zoom events, twelve hours a day. They introduced Embodiment Circles,

> a peer-led, free, online space to help us stay sane, healthy and connected in these uncertain and screen-filled times. The tried and tested 1-hour formula combines some form of gentle movement, easy meditation and sharing with others.[28]

The organizers promote

> embodied self-care for online conferences. With such an amazing array of speakers and other offerings, the conference-FOMO is real. Let's learn a few self-care practices that we can apply throughout the conference, so we arrive at the other end nourished, inspired, and well-worked ... rather than drained, overwhelmed, or with a vague sense of dread and insufficiency.[29]

Given this context, should we be talking in terms of "harm reduction"? Online wellness is the craze of the day: our days on Zoom include breaks with live music performances, short yoga routines, or body scan sessions. It is Bernard Stiegler's pharmakon in a nutshell: technology that kills us will also save us.[30] According to this stance, if Zoom is the poison, online meditation is the antidote.

But our post-digital exodus needs no Zoom vaccine. Rather than medicalizing our working conditions, let's instead put forward some concrete demands. In late October 2020, students demonstrated at the Amsterdam Museumplein, demanding "physical education." We must now fight for the right to gather, debate, and learn in person. We need a strong collective commitment to reconvene "in real

---

28     embodimentcircle.com/embodiment-circle-online/.
29     Quoted from communication related to icpr2020.net/.
30     Pharmakon: a Greek word meaning both poison and remedy. Bernard Stiegler argued that technics was a pharmakon, simultaneously curative and toxic.

life"—and soon. For it is no longer self-evident that the promise to meet again will be fulfilled.

Italian media theorist Donatella Della Ratta further opens up the debate by politicizing the online teaching situation. In her essay "Teaching into the Void," she reports about Zoom-specific face lifts and the product hype of ring lights, face upgrading technologies that made us all into influencers. In search of an exit, Della Ratta formulates a counter-politics

> that finds and forms itself in the aural rather than the visual, one that is most present (and most potent) in the "awkward moments" of lags, lapses, glitches, bandwidth failures, and frozen frames.[31]

Her focus is on subtle forms of refusal such as students who ignore their teachers warnings and turn off their cameras during their Zoom lessons. What if you don't want to share your bedroom, kitchen, or living room with strangers? What if you look tired and bored and you're fed up with jolly backgrounds? Della Ratta's essay ends by praising awkwardness, that mental state that "thrives upon the clumsiness of your well-rehearsed professional performance that stumbles on impact with bad bandwidth, frozen frames, a kid screaming in the background, the family dog's impromptu barking."

Are there better precedents out there, better blue-prints to build from? A media-archeological approach to Zoom might return to 1990s cyber fantasies of mass live castings such as Castanet. The system was designed by dotcom start-up Marimba, a group described at the time as "a small group of Java Shakespeares" by *WIRED* maga-zine.[32] The idea was to make the web act more like TV by overthrowing the browser paradigm (a goal that the app would later partially achieve). Much like Zoom, Teams, and Skype, the Castanet application had to be downloaded and installed in order to maximize bandwidth capacity.

Two decades later the basic choices are still more or less the same and the players haven't even changed that

31      Donatella Della Ratta, "Teaching Into the Void," *Institute of Network Cultures*, January 6, 2021, *networkcultures.org/longform/2021/01/06/teaching-into-the-void/*.

32      Jesse Freund, "Turning in to Marimba," *WIRED*, January 11, 1996, *www.wired.com/1996/11/es-marimba/*.

much. Microsoft, for instance, who owns Skype and Teams, is still a key competitor. Each individual webcasting technology uses its own, proprietary mix of peer-to-peer and client-server technologies. Zoom, for instance, looks smooth because it compresses and stabilizes the signal of the webinar into one stream—instead of countless peer-to-peer ones that constantly need updating. It also pushes the user into a position of "interpassivity": a passive audience mutes its audio and shuts up, much like a pupil listening to a teacher in the classroom. This is in contrast to free software peer-to-peer architectures (such as Jitsi) that go back to the free music exchange platform Kazaa. Software like Jitsi, ironically enough, is also listed as one of the inspirations of Skype, which revolves around collaborative exchanges between equal partners. So, are we watching a spectacle as an audience or working together as a team? Are we permitted to vote, intervene, freely chat?

As the "hybrid event" future gets underway, we need to keep talking and thinking through Zoom fatigue, rather than succumbing to fatalism. The era of "blended learning" aiming to merge the virtual and real has arrived. In the face of these pressures, it is even more important to get organized, demanding a ban on the use of video conferencing in work both inside and outside the institution. Access to buildings will have to be a human right. We should sabotage the real-estate mode of thinking and refuse online education as a cost-saving effort, together. Physical spaces are not "assets" but public goods.

Of course, that doesn't mean a technophobic retreat to some imagined utopia either. As always, mind the European offline romanticism trap. Instead, let's make virtual meetings exceptional again. This starts by making virtual conferencing an issue of debate and global dialog. In an age where the online population has passed the 5 billion users mark, other video conferencing platforms can become tools (one of many) to overcome closed borders, reach out, organize, come together, and listen to those who have been excluded. The muted top-down architectures of Teams and Zoom are the wrong start. It's time to go back to the drawing board, this time with an entirely different 21st-century cosmo-technical crew.

2

# Requiem for the Network

"In the final stage of his "liberation"
and emancipation through the
networks, screens and technologies,
the modern individual becomes a
fractal subject, both subdivisible
to infinity and indivisible, closed on
himself and doomed to endless
identity. In a sense, the perfect
subject, the subject without other—
whose individuation is not at all
contradictory with mass status."

Jean Baudrillard[1]

1    Jean Baudrillard, *Impossible Exchange* (London: Verso, 2015), p. 64.

This is the age of network extinction. Small is trivial. Notorious vagueness and non-commitment on the side of certain slacker members of the networks killed this cute construct. Platforms did the rest. "The collapse of centralized power that was prophesied in the 2000s never materialized," remarked Cade Diehm,

> centralized actors outmaneuvered the re-formists, shielding themselves and their own ecosystems from scrutiny. The concentrated media companies of the 2020s now dwarf their 1999 equivalents, and the innovations pioneered by decentralized infrastructure were exploited by the winners as they ascended to monopoly.[2]

Should we revive this organizational model and bring on a network renaissance or forget about it and move on? Decentralization may be the flavor of the day, but no one is talking about networks anymore as a solution for the social media mess. Where have all the networks gone?

Networks have been neatly excised from our tech vocabulary. Search for the term in books like Nick Srnicek's *Platform Capitalism*, Benjamin Bratton's *The Stack*, or Shoshana Zuboff's *The Age of Surveillance Capitalism*, and you'll come up empty. Even activist literature rarely uses the term anymore. The mathematical and social science-driven "network theory" has been dead for over a decade. The left never made an attempt to own the concept. If anyone did, it was "global civil society," a hand-picked collection of NGOs that played around with Manuel Castells' *Network Society* in an attempt to enter the realm of institutional politics at a transnational level. The distribution of power over networks turned out to be nothing but a dream. The valorization of flat hierarchies, a notion especially endorsed by "the network is the message" advocates, has been replaced by a platform system driven by influencers who are "followed" in a passive-aggressive mode without consequence. Instead of a redistribution of wealth and power, we feverishly continue to "network" under the calibrated eye of platform algorithms.

2    Cade Diehm, "This is Fine: Optimism & Emergency in the P2P Network," *The New Design Congress*, July 16, 2020, newdesigncongress.org/en/pub/this-is-fine.

In this age of the subject without a project, there seems to be no invisible "underground" anymore. Building networks as alternatives to crumbling institutions such as the church, the village, the trade union, or the political party was once a fashionable post-Cold War tactic. Back then, networks were also seen by shady agencies like RAND as stealth technologies able to infiltrate, disrupt, and penetrate rogue states or actors perceived as enemies to the U.S. world order. In the 1980s, networks were introduced in banking as "financial networks" and were later followed by the democratization of the internet. Three decades later the concept seems to have reached the status of *gesunkenes Kulturgut*, a watered down version for the masses. What killed the network? Was it their inherently "open" and informal character, or simply the lack of collective will to do anything much more than feed on click-bait?

Networks have never been so full, yet felt so vacant. For writer Romain Dillet, the term "social network" has now become meaningless. What killed the network is the never-ending push to add more "people you may know." More equals better and aligns with the capitalist imperative of perpetual growth. In the logic of social networks, accumulating more friends is equivalent to a firm demonstrating a strong capacity to expand its market reach. Yet a sad emptiness accompanies the mass individualization of the cult of personality. "Knowing someone is one thing, but having things to talk about is another." He concludes that the concept of wide networks of social ties with an element of broadcasting is dead. "Chances are you have dozens, hundreds or maybe thousands of friends and followers across multiple platforms. But those crowded places have never felt so empty."[3]

Tech companies will do whatever it takes to grow and foist more ads on the user, including delving into dark pattern design. The result? "As social networks become bigger, content becomes garbage." The diagnosis rings true. Yet what about the remedy? Instead of entering a political debate about how to break up these monopolies and build meaningful alternative tools that can replace the

---

3        Romain Dillet, "The Year Social Networks Were No Longer Social: In Praise of Private Communities," *TechCrunch+*, December 24, 2018, *techcrunch.com/2018/12/23/the-year-social-networks-were-no-longer-social/*.

platforms, Dillet turns to formulaic digital detox. "Put your phone back in your pocket and start a conversation," he suggests, "you might end up discussing for hours without even thinking about the red dots on all your app icons." Is it possible to re-imagine the social and not blame ourselves for being weak, addicted individuals? Can we resurrect some of the promises of the network?

# From Platform to Network?

One explanation for the disappearance of the network is the rise of the platform. The fourth and last part of Caroline Levine's study on form is—somewhat surprisingly—dedicated to the network. Ignoring the "short summer of internet" in 1997, the dotcom mania that followed it, and the current harsh reality of our platform capitalism, this untimely aesthetics theory from 2015 offers a fresh look at the promises that the network form has to offer. Networks are praised for their ability to transcend institutional boundaries and causality in favor of connectivity, linkages, and flows.

Levine contrasts both centralized and distributed networks with a series of local network clusters, where the hinges between small groups of nodes are often missing or broken. For Levine, the problem is not that it is too hard to organize a network, but that there are too many of them, each with its own logic, overlapping, running into one another, all working at once. What happens when there are "too many organizing patterns at work, not one of them dominating or controlling the others?"[4] The answer is that cluttered networks frustrate and obstruct wholeness. They connect yet avoid. They "work" because of their secondary status. Once networks are operational, we can no longer comprehend their totality.

Networks become daunting, too complex to adequately grasp. But just when they reach maximum complexity, the situation flips and platforms come into play. Platforms capture users in a very obvious way. Snared in this walled garden, users no longer remain at large on the network. Platforms thus remove the ambiguity and open-endedness

4        Interpretation of the network chapter of Caroline Levine, *Forms: Whole, Rhyth, Hierarchy, Network* (Princeton: Princeton University Press, 2015), pp. 112–131. Thanks to Sven Lütticken who pointed me to this book.

of the network. They erase any confusion or obfuscation and instill clarity and comfort. Platform operators attain transparency; platform users are satisfied. The trivial diversions of the past are over, the charms of these minor forms have evaporated. The platformers finally feel at home again, no longer on the run, having to pretend to hide from the powers that be. The dream to be major takes over.

# Searching for the Network

Whatever happened to the idea of the network? Can we examine the traces and prints around this scene for clues about this once-promising concept? For this investigation, I made the rounds, visiting different continents to see how fellow activists, artists, and researchers estimate the sorry status of networks today.

I started off with Dutch post-digital art critic Nadine Roestenburg who believes that millennials and Gen-Z see networks as a given.

> An underlying structure that no longer takes a fixed shape. Everybody and everything is always connected to each other, there is no longer a white space between the nodes. The network has exploded into a void; a hyper-object too big, too complex for our understanding. Meaning is lost in meaningfulness and therefore we are desperately searching for a starting point, a single node that can reconnect us. This explains the popularity of digital detoxes, mindfulness, and meditation.[5]

Nadine suggested I get in touch with Jenny Odell, author of *How to Do Nothing*. She wrote back:

> One thing that hasn't changed is that we require certain contexts in order for speech and action to be meaningful. There is such a big difference between 1) saying things in a group where you are recognized, and which has convened (physically or digitally) around a specific purpose, and 2) shouting into an

5    Email exchange with Nadine Roestenburg, July 25, 2019.

anonymous void, having to package your
expressions in a way that will grab the atten-
tion of strangers who have no context for who
you are and what you're saying. Both in group
chats and in-person meetings, I'm amazed at
how things actually get *done* rather than just
*said*, with people being able to build off of the
expertise of others in an atmosphere of mutual
respect. Social media, through the process
of context collapse, makes this kind of thing
impossible by design.[6]

Odell believes it is worth revisiting and defending ideas of
decentralized federation "because the model preserves the
aspects of sociality that make the most of the individual
and the group. Looking back at the history of activism, the
decentralized form shows up over and over again. The den-
sity of the nodes allows people to form real relationships,
and the connections between the nodes allow them to
share knowledge quickly. To me, this represents the possi-
bility of innovating new ideas and solutions—rather than
one-off, mic-drop statements and a bunch of 'connected'
individuals simply spinning their wheels."

Let's get unfashionable, dig up an Adorno quote
from *Critical Models*, and recast it for the social media age:
    The old established authorities decayed and
    were toppled, while the people psychologically
    were not ready for self-determination. They
    proved to be unequal to the freedom that fell
    into their laps.[7]

This is what networks require: an active form of self-deter-
mination. Self-organization from below is the exact opposite
of smooth interfaces, seamless address book importing, and
the algorithmic "governance" of your news and updates.
Self-determination is not something you download and
install for free. During the turbulent 1990s, centralized
information systems lost their power and legitimacy. Instead
of smaller networks that claimed to be more democratic

6     Email exchange with Jenny Odell, August 7, 2019.
7     Theodor W. Adorno, *Critical Models: Interventions and Catchwords* (New York: Columbia
University Press, 2005), p. 191.

and—in theory—promote autonomy and people's sovereignty, all we got were even larger, more manipulative monopoly platforms. Self-determination is an act, a political event, and, above all, it is not a software feature.

Like any form of social organization, networks need to be set-up, built, and maintained. Unlike mapping software seems to suggest, networks are not just generated on the spot, as if they were machine-generated entities. We're not talking here about automated correlations. Forget the visual snapshots. Networks are structured by protocols and their underlying infrastructures; they are not free-floating entities. Especially in these times of depression and despair, what should be of interest is the network's vitalism, not just its birth or death. Once networks start to grow on their own, they may develop in unexpected directions, flourish but then stagnate. They can also fork, forming new networks. It is often just as easy to abandon them as it was to create them. Unlike other forms of organization, the political charm of networks lies in their ability to create new beginnings, much in the same spirit as Hannah Arendt writes about the miraculous energy that is unleashed when we are beginning anew.[8] Rethinking networks as tools to create new beginnings can lure us away from "collapsology"[9] and push aside the never-ending obsession with the finality of this world.

The informal character of networks may invite unknown outsiders to join them. Yet this often leads to hierarchies and power-plays by active members on the one hand, and a culture of non-commitment on the other. What are we supposed to do? Respond? Like? Retweet? This uncertainty is part of the network architecture when you cannot rely on pseudo-activity from likes, clicks, and views. Networks are easy to join and even easier to abandon. They do not require formal membership, nor the creation of a profile (usually the creation of a random username and password is all that's required).

On platforms this fuzzy uncertainty disappears, "solved" by a constant stream of messages. Instead of

8    See Oliver Marchart, *Neu beginnen* (Vienna: Verlag Turia + Kant, 2005), pp. 18–19.
9    "Collapsology is the study of the collapse of industrial civilization and what could succeed it." The concept was developed by Pablo Servigne and Raphaël Stevens in their essay "Comment tout tout collombrer: Collapsology" (2015), *www.archeos.eu/collapsologie/*. See also *www.collapsologie.fr* that "keeps track of the scientific literature on ecological collapse, limits to growth and existential risks."

inviting us to act, social media platforms ensure that we spend most of our time keeping up-to-date. In a state of mild-panic, we work through the massive backlog of notifications missed or ignored over the past few days. Depleted and too wiped out to do anything else, we're left contemplating in a near-comatose condition the now well-known feeling of the void. Emptiness amplified with nothing better to do. That's one of the primary affective consequences of the mass training program for an auto-mated future. Platforms impose a psychic blockade (to put it in Mark Fisher's terms), preventing us from thinking or acting. Their "service design" is such that we're no longer positioned into taking action. Instead, we're lured into expressing outrage or concern. These are the "networks without a cause" that invite us to respond to each and every event with a stripped-down, ill-informed opinion, a basic response or reaction.

In Italy, a country where the term "social networks" is still circulating, the debate about the current state of the so-cial is as lively as ever. Writing in response to my hypothesis on the death of the network in the age of platform capitalism, Tiziana Terranova, author of *Network Cultures*, believes that

if we can look back at the network age it would be possible only because we seem to be at the highest point of the network wave—a mathematical abstraction derived from and implemented into communication technol-ogies which still completely dominates and organizes the epistemic space of contempo-rary societies. What we probably can look back on, and many of us are, is the hopeful time of networks, when it was still possible to see new possibilities in the network *topos*, rather than just the reorganization of power. It might be possible to perceive, even now, what networks might eventually give in to, something emerg-ing at the very limits of hyperconnectedness and the proliferation of correlations that have displaced modern notions of causality. If I had to place a bet on what this something might be, I would put it on technologies that employ quantum-theoretical models of entanglement (rather than connectedness) and "spooky"

models of causality. It might be possible that this is where new technologies of power and struggles for emancipation from the grip of economic, social and cultural relations might have to unfold.[10]

Translating this to my own framework, I have to think of "unlikely networks." These wouldn't be populated by family, colleagues, or high-school friends, but instead seemingly random strangers, in a much weirder and radical way than algorithms are now selecting partners on dating apps. Event-driven entanglements are important here.

## Escaping or Stagnating?

How do we escape corporate social media networks—and just as importantly, do we even want to? In his interview collection *Facebook entkommen*, the Austrian researcher Raimund Minichbauer neatly sums up the stagnation that artists, activists, and researchers find themselves in since 2011, when the last renaissance of social movements and "indy" social networking attempts were made before the final lock-in. Much to the surprise of insiders, most autonomous groups and social centers still use Facebook to announce their activities. Minichbauer's book resonates with the "Unlike Us" network, founded by the Institute of Network Cultures in 2011, that aimed to combine social media critique with the promotion of alternatives.[11] The network never really took off. After a few conferences, a reader, debates and campaigns the email list was the only channel that remained, until the initiative was folded in 2020.

Despite two waves of public interest—in 2013 after the Snowden revelations and in 2018 after the Cambridge Analytica scandal—nothing has fundamentally changed. Even though we know a lot more about "behavior modifications" and the "abuse" of user data, these insights have not led to a significant change in platform dependencies. So while the list of alternative apps steadily grows, how can activists be so openly cynical about their own alternatives? And what does this say about the level of regression

10    Email exchange with Tiziana Terranova, August 8, 2019.
11    *networkcultures.org/unlikeus/.*

in Western societies, when even the most engaged activists are so laissez-faire about Facebook? Is it laziness? Is the fear of being isolated justified?

Minichbauer points at another sensitive issue where activists, geeks, and technology designers have not made any progress: the "community" question. Mark Zuckerberg's systematic abuse of the term is on full display when he is talking about "his" 2.4 billion Facebook users as if there were one "global community."[12] As Minichbauer suggests, it is easy to dismiss the appropriation of the term—and we should certainly continue to deconstruct such shallow corporate definitions—but this should not lead us into a position in which we reject any form of mutual aid and (free) cooperation with others out of fear that all our social interaction might be tracked, mapped, and commodified. As Donna Haraway stated: we should stay with the trouble. So we're faced with a clear choice about the term "community." Either we accept it as a living entity, something that exists based on sharing something in common—or we dismiss it as a dead entity that should no longer be invoked, searching instead for other forms of the social. Many people are glad to escape the strains of close-knit living, as Jon Lawrence notes:

> If we abandon vague aspirations to rediscover an idealized vision of community that never existed and focus instead on small-scale, practical initiatives to foster social connection and understanding, we stand a chance of weathering the present crisis with our social fabric intact.[13]

> Whether we acknowledge it or not, the world is placing its bets on which system will survive the coming era of destabilizing non-linear change: inflexible, opaque Central Planning or flexible, self-organizing networks of decentralized autonomy and capital.[14]

This is the choice that we have presented ourselves with over the past decades. A diverse coalition consisting of

12    www.facebook.com/notes/mark-zuckerberg/building-global-community/10154544292806634.
13    Jon Lawrence, "The Good Old Days? Look Deeper and the Myth of Ideal Communities Fades," *The Guardian*, August 11, 2019, www.theguardian.com/commentisfree/2019/aug/11/good-old-days-look-deeper-and-myths-of-ideal-communities-fades.
14    Charles Hugh Smith, "Which One Wins: Central Planning or Adaptive Networks?", *Of Two Minds*, February 19, 2019, www.oftwominds.com/blogfeb19/evolution-wins2-19.html.

liberal business elites, geek entrepreneurs, and activists have systematically overlooked the possibility that the internet as a platform would one day be the Central Planning Committee. Silicon Valley used the network logic in order to advance a ruthless process of hypergrowth at all costs—and then promptly proceeded to dump the network logic altogether. Once the address books were copied and the networks were properly "mapped," their diffuse and "rhizomatic" structure became a nuisance in favor of clearly defined, profile-centric "graphs" in which users are afforded to interact with products and "friends."

## From Network to Herd?

Strangely enough, the demise of the network logic has not yet been properly theorized. Networks have become a secondary invisible layer in "the stack."[15] A "remediation" effect has come into play: the content of the platform is the network, a variation of McLuhan's thesis that the content of the new medium is the old one. However, this can only happen if my list of "friends" or "followers" actually constitutes an active network. Platforms are worthless if they consist of fake or dead networks. Platforms only come into being—and generate their desired extractive value—if there are actual exchanges and interactions happening. Automated exchanges between machines can simulate the social (as bots do), but such fake traffic only works if it augments something real—by itself it is soon noticed as worthless. Without humans such as system administrators, moderators, software developers, and network maintainers, any platform immediately stops functioning. One forgotten patch and the system breaks down. Anyone can set up a website, run an app, or host a network, but only very few can vacuum it all up and bring it all together onto a meta-level.

In Shoshana Zuboff's *The Age of Surveillance Capitalism*, networks aren't even mentioned. Perhaps it is too much of a technological term? Instead of networks, Zuboff uses terms developed by behavioral scientists such as Skinner and Pentland to describe animal group behavior such as "hives" and "herds." Zuboff then contrasts these

15      I have described the re-arrangement between the key terms "media," "network," "platform," and "stack" earlier in a chapter of my 2019 book *Sad by Design* (London: Pluto Press, 2019).

zoological terms with the human need for the "sanctuary" of the home. The new frontier of power is data extraction of the "behavioral surplus," with the aim to resell this data in the form of prediction products. As Zuboff puts it: "Surveillance capitalism has *human* nature in its sight."[16] The surveillance capitalist logic is one where we go from extraction to prediction and modification. Contrary to what artists, theorists, and activists once feared, it was not the precious informal social relations that were being appropriated by machines (and thus compromised). The prime target is the mind, brain, and behavior, not the "social noise." So despite using the label "social media," there is neither a social nor mediating element in Zuboff's universe.

The network form embodies a constructivist view of society in which the social is not merely a technical protocol and a given but is utilized as a vital element that needs to be created, maintained, and taken care of. Without human care, networks immediately fall into disrepair. To be sure, this position is in stark contrast with the instrumental view of Silicon Valley. Yet more subtly, it also goes against many science and technology scholars, who fawn over autopoietic automation while ignoring the cranky wetware (humans) who might spoil the party. Networks embody the "all too human" aspects: they are vulnerable, moody, unpredictable, sometimes boring or rather excessive, and yes, sometimes out of control. These characteristics can all be "managed" through moderation, filtering, censorship and algorithmic governance, but cannot simply be eliminated.

What happens when we start to look at social media from an instrumentalist point of view and apply this Skinner dogma to today's platforms? "A person does not act upon the world, the world acts upon him." Against most cultural studies approaches that emphasize the neoliberal subjectivity of the competitive self, for Zuboff there is no individuality anymore. As part of the herd, we're programmed to do what our digital instinct tells us to do. In her classic sociological view, informed by Durkheim, there is little room left for agency. These days weakened neoliberal subjects are no longer considered self-confident actors.

16   Shoshana Zuboff, *The Age of Surveillance Capitalism* (London: Profile Books, 2019), p. 346.

The good old days when British cultural studies discovered subversive appropriation hidden in passive consumers are over. We urgently need agency, yet we don't have it. The online billions are frowned upon as busy bees working for the Valley or seen as (addicted) victims of the latest conspiracy.

# Forgetting the Network

How did this *Netzvergessenheit* occur? Once a network becomes too big, the network is supposed to disintegrate and then regroup, shifting its structure to a higher level and creating a "network of networks." Whereas some of these dynamics were literally on display for those around in the emerging 1990s, these days, the foundational network principles—decentralization, distribution, federation—sound magnificent but idealistic and totally unfeasible. As usual, the trouble started right at the height of its influence. When the internet population started to grow exponentially in the late 1990s/early 2000s, diversification reached a critical point. Users started to flock to the same websites. Conceptually speaking, the beginning of Web 2.0 started off with the "scale-free networks" that exhibited a power-law degree of distribution. This term implied a paradigm shift, ending the old assumption that networks had an upper limit, after which they would fall apart and almost naturally create new nodes.[17] The step from scale-free networks to the platform concept was a small one, but it took almost a decade, until 2010, when Tarleton Gillespie formulated the first rules of what was going to become the internet platform economy.

Mathematics-based "network science" has had its day and remains silent about "the law of scale-free bullshit." Engineers who built networks all remain silent and claim innocence. At least 8chan founder Fredrick Brennan expresses second thoughts:

> There's this idea that if we have unbridled freedom of speech that the best ideas will fall out. But I don't really think that's true anymore. I mean, I've looked at 8chan and I've been its

17    See also danah boyd's recollection of how her term "context collapse" emerged in the early Web 2.0 period: "How 'Context Collapse' Was Coined: My Recollection," *Apophenia*, December 8, 2013, *www.zephoria.org/thoughts/archives/2013/12/08/coining-context-collapse.html.*

admin, and what happens is the most rage-inducing memes are what win out.[18]

In a variation of Eugene Thacker, we could say that the pinnacle of humanity lies in its ability to disgust the other.

There is a similar case with Actor-Network theory, which simply could not compute the ugly side of social media platforms. This was all not supposed to happen and the political economy blind-spot of the "mapping without a cause" Latour school became blatantly evident. At some point, from the late 1990s onwards, academics and theorists were no longer capable of keeping up with Silicon Valley's hypergrowth strategy and its venture capitalists that quietly financed the move from neoliberal markets to the creation of monopolies by "moving fast and breaking stuff." Wisdom for the few told us that competition is for losers. The once remarkable insight that bots are also actors no longer mattered.

Sepp Eckenhaussen, former student activist and now Institute of Network Cultures researcher, stresses the role of the network as a business model.

> Networks generate data and data equals money. Needless to say, these are not ordinary users. In this model surplus-value is constantly taken out of the network. This is known to be the case with social media but also happens in self-organized solidarity networks. These mechanisms seem to work best where the isolation of precarious subjects is worse, but also felt most, such as in the art scene. The longing for community makes us easy prey. The willingness to share freely and build up sincere connections can easily lead to an "enclosure of the commons." Like how academics ran into the business trap of academia.edu, after they uploaded all their work, in full confidence that they were sharing it amongst their own network and that it would not be exploited.[19]

18    Nicky Woolf, "Destroyer of Worlds," *Tortoise*, June 29, 2019, *members.tortoisemedia.com/2019/06/29/8chan/content.html*. See also the work of Alberto Brandolini, originator of the bullshit asymmetry principle; Brandolini's law emphasizes the difficulty of debunking bullshit and, development of the "intellectual denial of service" concept and "bad infinitum," "a tendency for non-experts to overwhelm experts with repetitive costly, and often unproductive demands for evidence or counter-argument to oft-debunked or misleading claims" (*techiavellian.com/intellectual-denial-of-service-attacks*).
19    See Ico Maly, "The End of Academia.edu: How Business Takes Over, Again," *diggit magazine*, February 22, 2018, *www.diggitmagazine.com/column/end-academiaedu-how-business-takes-over-again*.

Niels ten Oever, data activist and researcher, emphasizes the invisible aspect of networks:

> They provide orderings to our lives, societies, machines, and cities. When networks make themselves known, they become visible in an almost burlesque manner: we want to see them, we know they are there, and yet they always remain at least partially covered. They evade total capture. Whatever we build on top of networks to make them seem interconnected, centralized, and uniform. Underlying networks show themselves at times of change, rupture, and crisis.

For Niels, networks still exist and thrive best underground:

> The network is a complex assemblage, a multiplicity, that has raw and fuzzy edges, and never really works as expected. It can never be completely seen or understood. After wreaking havoc on the world, the networks cede back to where they belong: underground. Movements that are built on top of networks can have two fates: either they dissipate back into the distributed nature of the network (where they still travel!) or they centralize and get shed by the network itself, where they flow to the logic of institutionalization. Our plans should be big, but our expectations should be low. There is nothing wrong with being underground.[20]

Brian Holmes, long-time Euro-American cultural critic, has this to say:

> Here's the thing about the contemporary communications network: each of its human nodes is a socialized individual emerging from deep collective time, whether centuries or millennia. Network theorist Manuel Castells was spectacularly wrong: the Net and the Self are not ontologically opposed, but instead, they're continually intertwined at all levels. This means that if you want a network to

20   Email exchange with Niels ten Oever, August 5, 2019.

successfully self-organize, its members have to develop both an explicit ethics and a shared cultural horizon, as to overcome the inherited frameworks of belief and behavior. Anarchists already knew this in practice, since their communities typically involve some kind of overarching philosophical dimension, as well as carefully articulated codes for daily collective life. At the opposite end of the political spectrum, Islamist radicals knew it too: they called on ancient religious beliefs and updated sharia laws to knit their networks together. That's why such groups could successfully take the lead during the early rounds of networked politics, beginning in 1999 and 2001 respectively. Meanwhile, media theorists including myself were projecting the idea that as long as you built it with free software, the computer-linked media system represented a clean break with the past: a sudden liberation from the manipulated corporate channels that had blocked spontaneous self-organization for so long. And here's the other thing: it just wasn't true.

## Rethinking the Network

What do networks look like today and how might we rethink them? Holmes believes we still live in networked societies.

I still spend a lot of time working on technological platforms for self-organizing nets, such as the map/geoblog I'm currently making for the Anthropocene River network. What's clear, however, is that networked cultures aren't born from technological inventions such as the microprocessor or TCP/IP. Instead, they are made, by individuals working collectively to transform, not just their technological tools, but also their cultural horizons, and above all their day-to-day codes of ethical conduct. How to accomplish such profound cultural and philosophical work while still attending to the complex technologies on which most everyday social interactions now depend? That's where

the political question is coalescing right now.[21]

Amsterdam-based Migrant-to-Migrant activist Jo van der Spek has been involved from day one in the local "We Are Here" movement, working together with illegalized migrants. He suggests we look at criminal, migrant and family networks, the dark web, and other social forms of internet culture "as they explicitly oppose the pleasures and pains of platforms. Possibly they are characterized by their preserving analogue features that make them immune from algorithms and corporate data sharks."[22]

Precarity theorist Alex Foti believes that "the distinction technical/social network has now blurred as the political and ethical aspects of algorithmic technology have come to the fore." He urges us to do our own platform parties and organizations, because

> isolated individuals on social media are less powerful than party cabals that resort to bot armies and constant media manipulation. Online platforms are the only way to grow fast in membership and power. Federalism was once at the heart of the European Union, but that doesn't equate with horizontalism. We need to have a federal republic of Europe, federated hackers of the Union, federated collectives of xenofeminists etc. It's time for effectiveness over righteousness. Anti-systemic forces need intellectual debate but also a shared line, and especially disciplined local cadres ready to fight for the planet against fossil capitalism. This means developing a green anti-capitalist ideology that gives meaning to the struggles of people and an organization that embodies it and implements it, especially if civil wars break out after ecological catastrophe.[23]

What emerges out of the patchwork of experiences from the past decades is a new notion of network-driven techno-voluntarism. Forget automated processes, updates without

21    Email exchange with Brian Holmes, August 7, 2019.
22    Email exchange with Jo van der Spek, August 10, 2019.
23    Email exchange with Alex Foti, August 28, 2019.

a choice. The strength of a network is not to inform their participants. Information does not lead to action. This takes us back to the core issue: organizing like-minded souls so they can come together and take action. This already assumes so much that needs to be taken apart. How do such "cells" come into being? Can we overcome paranoia and a lack of trust in strangers? Can we start to act with the Other in ways that blow up all possible filter bubbles in order to establish cosmopolitan platforms that facilitate local networks? We know how to exchange information and how to communicate, but we now need to utilize both in cause-based contexts. We don't need no updates.

Sandeep Mertia from Delhi offers another position from the Global South:

> Theory can benefit from looking at the vast majority of the world that is only now beginning to get proper access to digital media. The infrastructures of data and capital in this space are owned and managed by both the state and privately-owned platforms. In India, there is a broad sense of having a certain "latecomer advantage," bypassing earlier models of digital literacy and capacity-building towards more accessible forms of vernacular, visual and smartphone-centered digital media. It would be fatal to assume that hundreds of millions of new users will simply align with presently dominant practices of media consumption and circulation. Perhaps an anthropology of what is emergent might offer new ways to inquire and theorize networks beyond taxonomic models of control and decentralization.

The networks Mertia refers to are inside the platform logic. "Both the state's Aadhaar from one side and quasi-monopolistic Reliance Jio on the other are operating as platforms at large." According to Mertia, there are many everyday practices of use and circulation that defy or skirt platformed logics. For example, creating

> WhatsApp networks for local tiffin delivery … can be said to be a part of the platform logic, but they challenge formal food-delivery apps such as Zomato and Uber Eats. These

users may not aspire for decentralization per se—most likely not—but they challenge centralization in ways that can be useful in rethinking networks.[24]

The European counter meme collective Clusterduck comes up with a list of tactics in defense of networks.

Our digital communities constantly undergo forms of intrusion, pollution, and appropriation. Networks are not dead and yet they are buried. The right to network is not granted and must be claimed through practices of analysis, hijacking, and re-appropriation. From the BBS frontiers to Web 2.0, the human capacity for cooperation has constantly evolved, defying easy definitions. Surviving as a network today requires an increasingly complex toolkit of practices: creating a movement based on a Twitter hashtag to convey a sense of a constant URL activity; hijacking the YouTube RetroPlayer-algorithm to make sure that right-wing commentators' videos are followed by debunking videos capable of bringing radicalized users out of the so-called "alt-right funnel"; organizing moments where the networks can meet IRL to coordinate, celebrate and strengthen the ties between users; founding and administrating thematic groups on mainstream social platforms such as Facebook and Reddit, to lure users and communities away from there and redirect them to fringe social platforms such as Mastodon, Discord, or Telegram; analyzing the history of web communities and subcultures, to learn their networking techniques and proceed backwards, in order to understand the processes of hostile appropriation, co-optation and hijacking they had to endure; breaking the cycles of hatred, triggered by bots and sponsored trolls, through white hat trolling and debunking activities, to turn the quarrel and noise of "reverse censorship"

24     Email exchange with Sandeep Mertia, August 9, 2019.

into something meaningful; using "top of the pop" design and codes to carry our messages, and create memes and memetic narratives that can propagate through filter bubbles, in order to bring together communities that would never meet otherwise; exploring new narratives, highlighting the importance of interspecies cooperation and the significance of symbiotic and parasitic relationships in shaping our capacity to co-evolve. "None of us is stronger than all of us" has never been so alive.[25]

# Toward Organized Networks

All this leaves me with the question of how I look (back) at networks myself. Am I ready to salvage the name of my research institute to make a statement? Is this a requiem for the network without consequences, a sing-along-song that sticks with you for a while and then gets forgotten? Should I let go or do I have some emotional attachment to the term? If the concept no longer works, then drop it. It is true that over the past decade our Institute of Network Cultures did not start a "platform" (maybe we should have?).

What I *have* tried to do is to strengthen the network concept from within, buttressing some of its flimsier definitions and scaffolding its indecisive properties. Since 2005 I've worked together with Ned Rossiter on the idea of "organized networks." In 2018 our book *Organization after Social Media* came out, bringing together our writings.[26] Our proposal was to move from "weak links" to "strong links," leaving behind diffuse networks and instead work-ing with much smaller, dedicated online groups. Is this an effective way to salvage the term and elegantly reintroduce the concept? What we deliberately did not address was how to accelerate and scale up networks. These days we want to go from zero to hero in a day, on a network with five billion users (the Internet). Rather than always aiming to reach critical mass in the shortest time possible, we suggested the idea of an avant-garde, cell, or think tank that sticks to the

25      Statement of the Clusterduck collective, August 17, 2019.
26      Geert Lovink and Ned Rossiter, *Organization after Social Media* (Colchester: Minor Compositions, 2018).

issue. The shift here is one towards forms of organization that need certain tools in order to get things done.

Organized networks invent new institutional forms whose dynamics, properties, and practices are internal to the operational logic of communication media and digital technologies. Their emergence is prompted, in part, by wider social fatigue and increasing distrust of institutions such as the church, political party, firm, and labor union, which maintain hierarchical modes of organization. While not without hierarchical tendencies (founders, technical architectures, centralized infrastructures, personality cults), organized networks tend to gravitate more strongly toward horizontal modes of communication, practice, and planning. Organized networks emerge at a time of intense crisis (social, economic, environmental), when dominant institutions fail in their core task: decision-making. As experiments in collective practice conjoined with digital communication technologies, organized networks are testbeds for networked forms of governance that strives to address a world rapidly spiraling into a planetary abyss.

In the roaring 1990s it was believed that the "network effect" would do the job. Like-minded users were supposed to come together, bring in friends and cause a multiplying effect, rapidly growing a particular community. Two decades later, Bernard Stiegler described this dynamic, observing that in the automatic society, digital networks referred to as "social" make individuals bend to mandatory protocols because they are drawn to do so by the automated herd effect that constitutes a new form of the artificial crowd, a phrase developed by Freud. In line with this term we can see social networking as a historical follow-up of the church and the army.[27] The task of the twenty-first century *Massenpsychologie* is to describe exactly where social media platforms differ from earlier social formations. The task of sociology will then be (after losing its corporate-institutional preoccupation with big data and related *Methodenzwang*), to understand the design dimension of today's techno-social. Such work would attempt to design beyond the current confinements of the platform, playing with artificial crowds and degrees-of-freedom.

27    Bernard Stiegler, *Nanjing Lectures 2016–2019*, edited and translated by Daniel Ross, (London: Open Humanities Press, 2020), p. 32.

Only then might we begin to consider a possible renaissance of network theory.

Is the platform the necessary next step of History or rather an anomaly? If tech ubiquity will be a given for the foreseeable future, how should we read 1990s network nostalgia? Is a renaissance of decentralized infrastructure, actively owned and defended by communities, a viable option? What happens when we decide to put in a massive effort to dismantle "free" platforms, including their culture of subconscious comfort, and spread actual tools—including the knowledge of how to use and maintain them? Tech has become a vital part of our social life and should not be outsourced. This can only be done when priority is given to "digital literacy" (which has gone down the drain over the past decade). Society pays a high price for the ease of smartphones.

Soon, few will be able to afford the built-in vagueness of the network logic. Coordination is required, and debates with consequences. What social media have grossly neglected is democratic decision-making software for how to get things done (which further development is based on actual experiences). Roaming around aimlessly, in rhizomatic circles, will soon be an activity few will find exciting. The ultimate critique of social media will be that they are boring. We're not there yet, but every day the call of the exodus gets louder. There will be more urgent and more exciting things to be done. Which tools bring us closer to the bliss of action?

Networks are not destined to remain inward-looking autopoietic mechanisms. Once situations are on the move, we can no longer distinguish networks from events. What was there first, the network or the event? Such a question should no longer bother us. This is something for data analysts (aka historians) to figure out. But we've moved on. In *The Mushroom at the End of the World*, Anna Lowenhaupt Tsing asks:

> How does a gathering become a "happening," that is greater than a sum of its parts? One answer is contamination, make way for others. As contamination changes world-making projects, mutual worlds—and new directions—may emerge.[28]

28    Anna Lowenhaupt Tsing, *The Mushroom at the End of the World* (Princeton: Princeton University Press, 2017), p. 27.

# 3

# Exhaustion of the Networked Psyche

## Probes into Online Hyper-Sensibilities

"Anyone else having a resurgence
of intense anxiety mixed with rage?"
@magicbeans (Maggie Vail)

"Don't hope, cope."
Tomi Ungerer

"Just forgot that life is pain and
then remembered again."
Tweet

"Truth is like poetry, and most people
fucking hate poetry."
Lotte Lentes

"I don't need you, I have wifi."
Addie Wagenknecht

"Quitting is a strength,
not a weakness."
Ingeborg Bachmann

"Trigger warnings trigger me."
Johannes Grenzfurthner

"Going to become a cam girl and create an army of shitbots to raise my profile in the community."
dark pill

"When we can't dream any longer we die."
Emma Goldman

"Existenz heißt Nervenexistenz. Leben heißt provoziertes Leben."
Gottfried Benn

"I'm easy but too busy for you."
Millennial WhatsApp saying

"We'll Look Back at Our Smartphones Like Cigarettes"
Cal Newport

"With an Iron Fist, We Will Chase Humanity into Happiness."
Bolshevist motto

Let's embrace our digital fates. We, Online Billions, are stuck on the platform. The growing imbalance of digital enchantment is neither causing a revolution or revolt, nor does it fade out. Welcome to the Great Stagnation.

We are exhausted. There are numerous ethical, political, and poetic questions staring at us from the digital abyss. Can exhaustion—a state of being which by its very definition suggests only despair, defeat, and despondency—be transmuted from within? Our individual exhaustion seems like a towering rock face, hard as flint. No matter how much we chip at it with clues and codes, it fails to yield. Can we overcome exhaustion and reclaim the very energies which depleted us towards exhilaration and action? Is there a poetry of exhaustion? A poetry *in* exhaustion? What would the politics of claiming exhaustion propose? How do we recover from collective resignation?

Let's dive into social media weariness, the cause of our tired eyes. What are the techniques of resignation that we are exposed to? The blissful ignorance after browsing an entire ecosystem of narratives is not surprising.[1] Distraction = Exhaustion. Culture is a pendulum, and the pendulum is swaying. Organized optimism, hardcoded in online advertisements and other forms of algorithmic advice, turned out to merely be producing anxiety. As Caroline Cowles Richards says: "What can't be cured, must be endured." The suffering, sorrow, and misery is getting tagged and filtered by our own self-censorship. We've been captured and feel frozen. There's no escape from this traumascape. The Internet is the cemetery of the soul. To adapt a phrase from Cioran, we could say that no one finds in social media that which was lost in life. Unfulfilled desires, in order not to die, extinguish themselves in the messages. There is nowhere to run, no place to freely surf and wander. We're stuck in place, forced to bear the brunt of the Online Other's anger.

You're enraged, feel engaged, but still retreat into your safe rabbit hole. When you're feeling tired and nothing seems helpful, you've reached the end of the

---

1    See Aaron Z. Lewis, "You Can Handle the Post-Truth: A Pocket-Guide to the Surreal Internet," May 29, 2019, *aaronzlewis.com/blog/2019/05/29/you-can-handle-the-post-truth/*. In a positive affirmation of post-truth, Lewis writes that there is no consensus history. "To go meta is to study the way history has been (and is) written. It's trying to understand the story of the stories we've told about ourselves. There's no *one* narrative that rules them all, no *one* way to connect the dots from the past to the present."

downward spiral. You ignore the signs and will pay dearly—but for now nothing matters much. What happens when you forget to like and follow and no longer respond to texts? What's next when your social graph falls flat and you have nothing to talk about? The networks around you collapse but you feel incapable of acting. Is this the joy of missing out? The epic shit of others no longer impresses. Perfectionism has killed you and you're now faced with an empty bucket list. Bored with Reddit, Facebook, and Insta, but with nowhere else to go, you're damn sure you've lost interest in everything you were once passionate about.

In *The New Inquiry*, Indiana Seresin discusses Lauren Berlant's remarks on contemporary tectonic shifts in social power.

> As we are living now, when privilege unravels it goes out kicking and screaming, and people lose confidence in how to be together, uncertain about how to read each other, and incompetent about even their own desire.[2]

This uncertainty on the level of social interaction can easily be noticed on the platforms and is produced by the technical arrangements in which social relationships are produced online. There's a cultivated fear of directly contacting others. The carousel of causes and effects is accelerating the culture of uncertainty Berlant talks about. Is social media to blame? Or should we stress that social media is merely a mirror of society? What happens to our ability to act when the two can no longer be separated? We've lost confidence in how to be together. What might the long-term impact of this be for the online networks? How can we claim to build up communities in a time of ongoing uncertainty? Seresin ends by contemplating why we "remain secretly attached to the continuity of the very things we (sincerely) decry as toxic, boring, broken. Faced with the possibility of disappointment, anesthesia can feel like a balm."

Whatever happened to the collective and communal? As Jodi Dean points out, the rise of individuality has coincid-

2     Quoted from Indiana Seresin, "On Heteropessimism: Heterosexuality Is Nobody's Personal Problem," *The New Inquiry*, October 9, 2019, *thenewinquiry.com/on-heteropessimism/*.

ed with a decline in the organizational power needed to create change. The unlimited possibilities to expand the self crippled our possibility to organize effective resistance. Much of the

> vague, inchoate contemporary left of social media, university campuses, NGOs, and socially engaged art, appeals to protect individual identity, and vigilance against suspected threats to individual identity displace efforts to build collectivity.[3]

Instead, Dean wants to remind leftists "of another figure of politics, one that was prominent in the twentieth century as a figure for all united in emancipatory egalitarian struggle against racism, sexism, capitalism, and imperialism."

Once we're locked-in, the path to infinity has been blocked. Instead, we're caught in a *Truman Show*-like repetition of the perpetual now, toiling around in the micro-mess of online Others that try to do their best, masking their failures and despair—like everyone else. Franco Berardi observes the mental state of today's students:

> I see them from my window: lonely, watching the screens of their smartphones, nervously rushing to classes, sadly going back to the expensive rooms that their families are renting for them. I feel their gloom, I feel the aggressiveness latent in their depression.[4]

In the social media era, the Oblomov position is not an option—especially for those who cannot afford to get stuck in the abyss. Elegant designs force faux-choices on us: engage, click, agree, respond. If only we were capable of taking action and making decisions. We experience the sadness of online existentialism minus the absurdity. If only Robert Pfaller's "interpassivity" was ever really implemented in code (instead of being yet another Austrian idea), we could indulge in a permanent state of apathy. But there's nothing passive about human-machine interactions. We,

3        Interview with Jodi Dean on her 2019 book *Comrade*, in *The Chronical of Higher Education* by Maximillian Alvarez, October 11, 2019, *www.chronicle.com/interactives/20191011-ComradelyProf.*
4        Franco Berardi, *The Second Coming* (Cambridge: Polity Press, 2019), p. 10.

the streaming egos, scroll and swipe, obsessed with self-creation. Facebook, the sociological constant of our times, equals the unbearable lightness of nothing. Surrounded by this massive bubble of light matter, we literally see no alternative options. No multiverses for you. Jailed in the digital monad, you are free to dream about as many worlds as you like. On social media, the Zen status of detachment is an ontological impossibility. We're never really lurking—our presence is always noted—and we can therefore never truly enjoy the secretive voyeur status. Interaction is our tragic existence. Instead, we're constantly asked to upgrade, fill in forms, and rank our rideshare drivers.

Borja Moya warns us not to outsource your identity and reality to social media platforms. While traveling, Borja noticed that a lot of people were traveling alone and showed symptoms of depression.

> Something interesting happens when you disconnect from your phone and focus on the real world. You start to observe. It hit me pretty clearly: Social media is transforming our identities and making us delusional with the way we perceive reality.[5]

Moya uses a game metaphor, suggesting that you are the player: "You prove that you're better than the people around you. It doesn't matter if you're feeling depressed, what matters is how you look to others." Writing in a self-confessional style, Moya admits that sticking with reality is painful.

> Facing one's reality can be one of the toughest challenges anyone can face. And this is why these platforms come in handy. Deep down, people don't want to acknowledge things about themselves. They just don't. It's easier to play the status game and feel great in the short-term.

Social media is a vital tool to maintain dignity for the impoverished white middle classes in the West. Time to

---

5          Borja Moya, "Depression, Self-Identity and Reality: Living in a Fictional Story Created by Social Media," *Medium*, December 19, 2018, *medium.com/privateid/depression-self-identity-and-reality-living-in-a-fictional-story-created-by-social-media-38f230ab9bf7*.

introduce Sybil Prentice. @nightcoregirl's writings deal with "a future entirely subsumed by 'sharing' economies and platforms, where all paid labor has been reduced to the service-industry's mise-en-abyme."[6] She exposes the rough underbelly of fashion and make-up brands. Here it is no longer relevant to distinguish fact from fiction. We're all encouraged to blur the line between real and fake. She's living the "princess lifestyle" in "posh poverty,"

> not to be confused with faux bourgeoisie because … I *was* raised in wealth, albeit fluctuating wealth. Peak posh was father as Vice Chairman for a bank I will not disclose. Faux bourgeoisie is Michael Kors or like a Hilton downgraded to three stars because it hasn't been renovated since 1996, or wearing red-bottomed heels that aren't Louboutins. Ghetto fabulous is a better existence. The doc diagnosed me as manic depressive and, more importantly, I *need* to sustain this lifestyle. Luxurious by nurture, cutthroat by nature.

If you catch her on the phone, she's exclusively communicating via WhatsApp,

> sending mini audio clips to friends. This involves more engagement than texting but less commitment than a regular phone conversation. When everything is mediated via voice memos, I'm in boss mode.

During the entirety of her "disgraceful" 45 minute period she was on Tinder, "I had men PayPal-ing me €20 per audio message, generally me recording variations of: *You're such a fucking loser.*"

We've arrived at the stage Bernard Stiegler characterized as "symbolic misery." Driven by cognitive downgrading, this is a condition that, according to Stiegler, can be traced back to the launch of the Web in 1993. This condition led to a new stage of "proletarianization," which he also describes as an era of "symbolic stupidity" due to "automated deci-

6    Sybil Prentice, "Posh Poverty (01)," *New Models*, May 8, 2019, *newmodels.io/proprietary/posh-poverty-01-sybil-prentice.*

sion making." The resulting "stupor" is caused by a series of technological shocks brought on by the four GAFA horsemen of the Apocalypse, shocks aiming to disintegrate the societies that emerged from the Aufklärung. This is my reading of the second in his series of Nanjing lectures.

The result is "net blues," a form of disenchantment "suffered by those who believed in the promises of the digital era (including my friends at Ars Industrialis and myself)."[7] This condition results in a growing inability to retain insights and a loss in the capacity to theorize. Instead, we turn to externally stored, data-driven knowledge, a stage in which "understanding (Verstand) has been automated as analytical power that has been delegated to algorithms."

This is the process of outsourcing "objective memory" or what Stiegler called "tertiary retention." In the nineteenth century, early craftsmen were gradually reduced to factory workers, losing their skills. The same fate will eventually be experienced by all professions: the destruction of all knowledge that results from exteriorization. For Stiegler, this is not a given but a fatal development. The turn is provided by his idea of the pharmakon: the digital is both poison and medicine, leading to a new episteme or epistemology, which Stiegler calls "digital studies"—the sphere I am trying to contribute to here, holding onto the promise of a new epoch.

How to reverse the depletion of resources? From a strategic point of view, the question becomes how to create an alternative to the "automated herds" and "artificial crowds." What forms of the social can take up the task of care? This is the "organized network" question that's on the table. How can we escape the pitiful misery of the individualized fate, overcome the compulsive defense mechanism of the subject as monade? How can we break out of the jail of identity and instead design new ways of being together—cooperation and forms of the social that are truly twenty-first century?

Netflix knows about the poor mental state of its users: decision fatigue. "Audiences are under assault, besieged not only by too many shows but, now, too many platforms

    7    Bernard Stiegler, *Nanjing Lectures 2016–2019* (London: Open Humanities Press, 2020), p. 12.

on which to watch them," the New York *Vulture* blog
observed.[8] We've come full circle, with many choices but
little (quality) content. As early as 1992, Bruce Springsteen
was singing about this paradox:

> Man came by to hook up my cable TV. We
> settled in for the night, my baby and me. We
> switched 'round and 'round 'til half-past dawn.
> There was fifty-seven channels and nothin' on.[9]

In the midst of the lockdown, Netflix figured out users
were ready to zap again: "Not sure what to watch? Choose
Play Something." We could also call it recommendation
inflation, the tendency to go in circles, despite the ever-
growing content on offer, despite the 2500 engineers
that fine-tune Netflix's algorithm. Can deep exhaustion
be overcome by a funky design of the next generation
discovery tool? Netflix thinks so and presents the dialectics
of channel surfing as a brand new experience, which in
fact repeats the same old mantra of a "personalized chan-
nel playing something the algorithm thought you might
enjoy"—just branded differently. Netflix exemplifies the
Internet's real existing stagnation. The medium itself has
become boring.

Browsing a few minutes through the German media
theory galaxy quickly provides us with fundamentally
different reference systems and shows how limited today's
techno imagination is. For instance, we might warp back
to *Switching—Zapping*, a book by German media theorist
Hartmut Winkler that I reviewed nearly thirty years ago.[10]
Restlessness prevents a real sense of diversion. Despite
the desire to switch off and be entertained, the lack of
concentration is all too real and pushes you further into
the database. Initially, Netflix got associated with binge
watching series. However, even this excessive media
consumption got boring and users regressed back into the
primal layer of relentlessly swiping content. While Neil
Postman and Jerry Mander rejected distraction as a sign

8       Josef Adalian, "Inside Netflix's Quest to End Scrolling: How the Company Is Working to Solve One of Its Biggest Threats: Decision Fatigue," *Vulture*, April 28, 2021, *www.vulture.com/article/netflix-play-something-decision-fatigue.html*.
9       Ibid.
10      Hartmut Winkler, *Switching—Zapping: Ein Text zum Thema und ein parallellaufendes Unterhaltungsprogramm* (Darmstadt: Verlag Jürgen Häusser, 1991). My review of the book appeared here: *www.mediamatic.net/en/page/12827/winkler/*.

of decay, Siegfried Kracauer regarded it as a compensation for the daily pressures of work. Walking in the footsteps of Walter Benjamin, we could see today's swiper as an "examiner," someone kept pleasantly occupied.

It's important here to not fall into the cultural pessimist trap that cultural industries such as Netflix set up for themselves. We take the side of the amoral user that abandons the series midway into the second season without any sense of treason. We're dancing along with the content—as long as it lasts. No more binge watching, we've switched to crude channel surfing. We're in charge of our own clicks and swipes, much like in the olden days of the remote control. We're running from the platform profile, running from ads, trying to stay one step ahead of the pedagogic storyline. After all, we're interactive watchers, in charge of making our own meaning. This is media sovereignty.

Random switching is revenge against the storytellers and their pedagogical teachings. It sabotages the requirement to contemplate the work, dig into the narrative, and uncover its layers of meaning. From early film, Dada, and surrealism to Joyce, there has been a strong counter movement against the Enlightenment ideal to dive deep into the artwork (and claim this journey as "real culture") in favor of multiple voices. For Benjamin, distraction was not just a deficit or disease, but provided a legitimate way to enjoy and interpret art works. In the spirit of Kracauer, we need to further cultivate the digital feel of database watching and go beyond the behavioral boundaries. We need to reject the predictable platform approach and reinvent the media realm once more as a possibility space, one driven by hyper-sensual curiosity.

Silicon Valley's command, so dominant over the past decades, is slipping. The Palo Alto consensus, as Kevin Munger terms it, is slowly but steadily losing its legitimacy. People no longer believe governments should be discouraged from restricting speech online. "Everyone seems to have underestimated the demand for information about how white nationalism is good and vaccines are bad."[11] Munger notices a lack of diversity. If the government would have "supplied

11    Kevin Munger, "The Rise and Fall of the Palo Alto Consensus," *New York Times*, July 10, 2019.

basic internet technology and allowed local, domestic competition, social media would be more diverse and more culturally sensitive than it is today." States need to take charge, actively curating what their citizens see. Munger suggests they should "integrate information technology into existing institutional structures rather than subverting them in the fantastical belief that free information flows will always produce positive outcomes."

It is said that Millennials, caught in their perpetual "social" jail, surround themselves with good advice. Endless tips suggest they should stop multitasking, obsessively checking headlines, and compulsively consuming comfort food. One of the zillion recommendations is to join "Team Human" in order to break free from the toxic temptation to compare:

> You need to audit your social media feeds. That means deleting anyone whose posts make you feel envious. If you find that you're comparing yourself to a particular friend, then it might be smart to mute them.[12]

Gen Z, on the other hand, are supposed to be cynical as they have learned to expect less than earlier generations. According to Joshua Citarella, they adopted irony as a cultural strategy. Citarella proposes a materialist reading of online culture. "*Why* are young people virtue signaling toward the Right? Underlying the emergence of youth reactionary culture is the glaring failure of neoliberal capitalism to deliver on its promises."[13] For Citarella, TikTok trolling is an example of a backlash to diminishing expectations in American life. He explains: "Reactionary politics flourish most when it is difficult to imagine a better future." And pushback is important.

> Left-wing counter-narrative YouTubers like Chaun, ContraPoints, Zero Books and others, as well as Twitch streamers like Destiny and Hasan Piker, are on the frontline in this battle for young people's hearts and minds.

12       Tara Swart, "These 4 'Harmless' Habits Are Sapping Your Brain Power," *Fast Company*, July 5, 2019, *www.fastcompany.com/90372808/these-4-harmless-habits-are-sapping-your-brain-power*.
13       Joshua Citarella, "Irony Politics & Gen Z," *New Models*, April 2019, *newmodels.io/proprietary/irony-politics-gen-z-2019-citarella*.

According to Joana Ramiro, "real proximity, real human connection, is becoming anathema to the post-millennial. Our sense of community is being replaced by its generic version, administered via a screen and high-definition speakers." The deficit of intimacy and affection is being replaced by ASMR. Autonomous Sensory Meridian Response

> is the alleged pleasure, even possible tingling sensation, triggered by a series of auditory queues, especially the distinct hearing of usually very quiet noises like the light smacking of lips when someone whispers, the scratch of a pencil on paper, or the sound of hair being combed.

What can the deprived user do? "Rest assured that the perverse inventiveness of the capitalist system will provide," writes Ramiro. "Wholesome asexual videos on porn websites and ASMR YouTubers are just two examples of the commodification of intimacy and its mediated consumption by our starved souls."[14]

Browsing through Sarah Frier's corporate Instagram biography *No Filter*, we read that initially the startup was about creativity, design, experiences, and even honesty. It wanted brands to come across as honest and genuine. It wasn't opposed to people selling products. It just wanted them to do it in a way that masked their financial incentives. Over time users began aligning themselves with the addictive "blue check" validation of self-promotion culture.

> Teens revealed that they managed their feeds to make a good impression. They kept track of their own follow ratio, and didn't want to follow more people than were following them back. They wanted more than eleven likes on each photo, so the list of names turned into a number. They sent selfies to their friends over group chats to get feedback before determining whether they were good enough for Instagram. They would also meticulously curate. While older users typically kept all their photos up forever, younger people would regularly

14    Joana Ramiro, "Capitalism Killed Intimacy and Replaced It With PornHub," February 14, 2019, *jacobinmag.com/2019/02/intimacy-social-reproduction-love-asmr-pornhub*.

delete all of their posts or get entirely new accounts to reinvent themselves. If they wanted to be themselves, that was what a "finsta" or fake Instagram account was for, shared only with best friends, where they could say what they thought and post unedited pictures.[15]

In *Spinoza: Practical Philosophy*, Gilles Deleuze writes that we need to denounce values that separate us from life.

What poisons life is hatred, including the hatred that is turned back against oneself in the form of guilt. Spinoza traces, step by step, the dreadful concatenation of sad passions: first, sadness itself, then hatred, aversion, mockery, fear, despair, pity, indignation, envy, humility, repentance, self-abasement, shame, regret, anger, vengeance, cruelty.

In Deleuze's reading, "Spinoza's analysis goes so far that, even in hatred and security, he is able to find that grain of sadness that suffices to make these the feelings of slaves." The question whether smart phones and their apps take us away from life and enslave us should be easy to answer. "We do not live, we only lead a semblance of life; we can only think of how to keep from dying, and our whole life is a death worship." After Deleuze and Spinoza, we could say that Facebook needs broken spirits, much in the same way as broken spirits need Facebook. Spinoza's remedy: "Only joy is worthwhile, joy remains, bringing us near to action, and to the bliss of action. The sad passions always amount to impotence."[16] While this analysis is unequivocally clear, we rarely hear Deleuzians making a stand. Sadly, the affirmative doctrine has blocked political initiatives in this domain.

"Smithereens" is an episode of *Black Mirror* that addresses the distraction and addiction of trivial social media content through conscious algorithmic manipulation. The story

15    Sarah Frier, *No Filter: The Inside Story of How Instagram Transformed Business, Celebrity and our Culture* (London: Random House Business, 2020), p. 182. "The teens explained that in their high school, if they didn't comment on one of their friends' selfies within ten minutes, those friends would question the entire nature of their budding relationship" (p. 188).

16    Gilles Deleuze, *Spinoza: Practical Philosophy* (San Francisco: City Lights Publishers, 2001), pp. 26–28.

is about Chris, a rideshare driver that caused the death of his girlfriend in a car crash after being distracted by a dog picture on his smartphone while driving. This tragic detail eats him up. But before succumbing to guilt and committing suicide, he decides to kidnap a Smithereen employee and use them to contact its CEO, Billy Bauer, confronting him with the horrible secret. According to the Bustle website, "Smithereen is a not-so-subtle conflation of Facebook and Twitter, and that Billy is a stand-in for tech execs like Facebook CEO Mark Zuckerberg and Twitter CEO Jack Dorsey."[17] At the end of the episode, there is a glimmer of hope, or insight, when Billy Bauer admits that even he, the "God" of the network, is being manipulated by his staff and shareholders in favor of silly content. "I heard you built it that way, addictive. So that you can't take your eyes off them. Well, job done."

Then it is time for eternal adolescent CEO Billy, talking through a satellite phone, to make his own confession. Standing outside a remote meditation retreat in the Nevada desert, he tells the rideshare driver: "I am so sorry about your girl. It wasn't supposed to be like this. It was one thing when I started it. It just became this whole other fucking thing. It got there by degrees, you know, they said:

> Bill, you gotta keep optimizing, you gotta keep people engaged. Until it was more like a crack pipe. It was some kind of fucking Vegas casino. We sealed off all the fucking doors. They've got a department ... All they do is tweak it like that on purpose. They've got dopamine targets and there's nothing I can do to stop it. I'm like some kind of ... fucking bullshit front-man now. I swear to God, I've been on this retreat, supposed to be for ten days, after day two I decided, fuck it, I quit Smithereen, I am out.

See here the public perception of the social media mess we find ourselves in: an ultimately powerless CEO puppet, steered by his corporate board and optimization teams, who in turn are driven by cold profit targets. After the

17        Gretchen Smail, "This 'Black Mirror' Episode Is the Show's Condemnation of the Tech World Yet," *Bustle*, June 5, 2019, *www.bustle.com/p/is-billy-bauer-based-on-a-real-person-topher-graces-black-mirror-character-skewers-tech-ceos-17943141*.

phone conversation, Chris releases the hostage and gets shot by the police. For Billy, it is back to business as usual.

The Humane Technology agenda:

> There are folks exploring mindfulness, bodywork, psychedelics. Personal growth can take many forms. Ultimately, if a handful of people have this much power—if they can, simply by making more ethical decisions, cause billions of users to be less addicted and isolated and confused and miserable—then, isn't that worth a shot?[18]

In *Unthought,* Katherine Hayles theorizes nonconscious cognitive processes inaccessible to conscious introspection. We badly need these building blocks for a theory of social media. Hayles calls for a rethinking of cognition from the ground up—but do we have time for that in this age of immediacy? Theory is in such a sad state, precisely because it has lost the time battle against science-turned-code. Regardless of whether we call our efforts research, analysis, deconstruction, or critique, the insights that result are merely describing yesterday's smoke clouds. It is behavioral scientists that map the working of what Hayles calls the cognitive unconscious. This knowledge is then sold to programmers and designers that work for marketing departments, who attempt to alter the patterns of user behavior, opinion, and value systems. Systems for Hayles are limited to material hardware. Social media platforms with their buttons, friends, likes, and recommendations are not explicitly mentioned. "When a person turns on her cell phone, she becomes part of a nonconscious cognitive assemblage that includes relay towers, fiber optic cables, and/or wireless routers."

One day, Nina Power got herself into trouble online and was attacked on social media for siding with the "wrong" people. However, when reflecting on these attacks, she developed a feeling of liberation. She started to become interested in

18    Andrew Marantz, "Silicon Valley's Crisis of Conscience," *The New Yorker,* August 19, 2019, *www.newyorker.com/magazine/2019/08/26/silicon-valleys-crisis-of-conscience.*

what it means to live as freely and honestly as possible, to coincide with oneself as much as possible, to not feel anxious or guilty, or ashamed, to not dwell in negative feelings, or, at least, to recognize them for what they are, to live freely, to not be manipulated as much as possible, and to recognize when someone is trying to do this to you.

...

There is, I must tell you, an absolutely unbelievable freedom in no longer worrying about what people say about you, and a glorious release in no longer feeling guilt-tripped or manipulated into holding a particular line. There is profound joy in realizing that the internet is just one tiny sliver of "reality," and even then this reality is pretty questionable, and might be just a weird blip in the long history of humanity.

...

It is possible to have a life that is so vastly, unimaginably different from one in which you fear being denounced, this life where you are anxious all the time, this life where you feel bullied and coerced and told not, at any costs, to know your own mind. The internet is not the world![19]

We're told that games are *the* way kids communicate with their friends today.

> Hanging out on a basketball court was never only about the game. It was about spending time with your friends and socializing. Having an activity to gather around. In 2019, the same thing happens virtually. The activity is *Fortnite*, *Roblox*, and a little bit of *Minecraft*.[20]

Games are the evolution of the basketball court. A virtual gathering place for kids these days. An activity to form friendships around. *Roblox* and *Fortnite* are true virtual

19     ninapower.net/2019/03/14/248/.
20     blog.readyplayer.me/fortnite-and-roblox-are-changing-social-media-as-we-know-it/.

worlds. More like physical places to hang out than tradition-
al games. Unlike the breakneck pace of traditional shooters,
there's a lot of idle time built into *Roblox* and *Fortnite*.
Most of the time is spent on exploring the world, collecting
weapons, supplies, and so on. The best social platforms
find a good balance between content creation and content
consumption and teach you how to form squads.

It's difficult to see kids "graduating" from *Fortnite*
and *Roblox* and moving on to traditional social media. A
2D scrollable feed of Instagram doesn't sound so exciting
after having grown up in a 3D virtual world.

> There is something missing in conventional
> social media right now. We have social net-
> works like Facebook, KakaoTalk, Twitter, and
> Naver for communication. But they're all based
> on text, pictures, and movies. I think the next
> step is going to be having social experiences
> where you can get together with your friends in
> a virtual world, wherever you are,

says Tim Sweeney, founder of Epic Games, who make
*Fortnite.* This is one of the biggest opportunities today:
building the virtual worlds and related tech people will use
for everyday online communication in the future.

How can we redesign the "social" in such a way that will
become impossible—even unthinkable—for trolls and bots
that try to permanently disrupt our thinking and behavior?
We cannot spend all our time and energy reinventing so-
ciety without taking freedom into account. By "freedom,"
we're not talking about liberty as defined by right-wing
Libertarians, but the freedom that Arendt and Berlin speak
of. This is not just freedom from addictive and manipula-
tive software. Can we rethink bots and algorithms in such
a way that they become pets or toys—tools that work for us
rather than oppressive systems that deceive and "educate"
us? Technological freedom means the ability to set them
aside, to turn them off. We long for tools that assist us
instead of colonizing our inner life. Our sadness will not be
overcome with anger.

The dawn of the digital network era was both exhilarating
and exhausting. The ability of these new spaces to accom-

modate self expression, even if it was empty, resounded in the words of Fernando Pessoa:

> In these random impressions, and with no desire to be other than random, I indifferently narrate my fact-less autobiography, my lifeless history. These are my confessions, and if in them I say nothing, it's because I have nothing to say.[21]

The digital dawn provided the freedom to become something, anything, even if that something didn't make sense. As Whitman so arrogantly announced: "Do I contradict myself? Very well then I contradict myself, (I am large, I contain multitudes)."[22]

The seduction of the digital lies somewhere between these two poles, between succumbing to exhaustion and embracing multiple possibilities. In a moment, we can split into our multiplicities, which inherently challenge the authoritarian regimes we govern ourselves with. And in these multiplicities we can voice, even without a keen listener, our loudest, unsaid despairs. But then, slowly, the exhaustion of the digital seeps into us—first haptically, then socially, and finally at a fundamentally philosophical level. The exhaustion is not borne out of the multiplicities we can claim, nor is it the eternal Other lurking around, ready to humiliate, tame, and dismiss us. The exhaustion is cemented, brick by brick, by the question of the memories of the multiplicities we claim on the Internet.

At first, losing the memory-of-the-many is liberating. We can be silly, flirty, and aggressive all at once. We can send fragments of poetry, radical political manifestos, and unattended theory into the abyss, never worrying about the chagrin of a discerning archivist. We exhilarate in the moments of memories which are expunged from within the archives of our own selves.

But moments later, we become aware of the datasets we have become—our lives, loves, emotions, anger, despair, despondency, and also defeat. We are no longer the archivists, and thus the anarchists, of our own selves.

21    Fernando Pessoa, *The Book of Disquiet* (London: Allen Lane, 2001), p. 49.
22    Walt Whitman, "Song of Myself, 51," in *Leaves of Grass* (Oxford: Oxford University Press, 2005), *poets.org/poem/song-myself-51*.

We can kid ourselves, pretending that we have the techno-logical freedoms to turn the gadgets off—but we cannot. These lost memories of our multiplicities are whispers of something that was lost, murmurs of exhaustion echoing across the digital world.

How do we reclaim the freedoms that we so willing-ly wished away? Retreating from the algorithm regimes we are bound within is not an option. We have to embrace the dense and dark reality of the datasets we indeed are. We need to dig deep into these datasets of being, multiplicities, and the archives-of-the-self. We need to embrace the revolutionary irrationality of the self—its multiplicities and memories. An authoritarian, algorithmic structure cannot be challenged by internalizing the authoritarian, al-gorithmic impulse. And in any case, this algorithmic logic is populated by a multiplicity of memories that we cannot (and should not) reclaim. Only through such an excavation can we draw out a poetics and politics of exhaustion. This is the only toolkit that will rupture the algorithm logics which have come to define not only the way we live, but also the way we think. Let us turn the logic against itself and let our data-selves be exhausted, together.

4

# Stuck on the Platform

Notes on the Networked Regression

"I can't believe video games are real."
Sarah Hagi

"Men build the structures, women fill them."
Tech saying

"Go down into the underground, and pass
from the hyper-virtual, fleshless world to
the suffering flesh of the poor."
Pope Francis

"We are not afraid of ruins. We
who ploughed the prairies and
built the cities can build again,
only better next time. We carry a
new world, here in our hearts."
Malatesta

"It is easier to imagine Facebook causing
the end of the world than it is to imagine
the end of Facebook."
@libshipwreck (Librarianshipwreck)

"All science begins with fiction."
Speaking Truth to the Platform

"Every time I think I've sorted out my life,
capitalism collapses."
@zinovievletter (Juliet Jacques)

"Anyway, it's always the others who die."
Marcel Duchamp

"I thought the dystopic future would be more exciting."
@sosadtoday (Melissa Broder)

"The internet is a metaphysical horror game, not a representational machine."
@bognamk (Bogna Konior)

"You read one email, you've read them all."
Andrew Weatherhead

"Once I was mine. Now I am theirs."
Shoshana Zuboff

"Bring up irrelevant issues as frequently as possible."
CIA manual

"All this time I thought I was a nomad, now I'm just a runaway."
Sybil Prentice

"Recession is when your neighbour loses their job. Depression is when you lose yours."
Nicolas LePan

"Internet is the God that failed."
Johan Sjerpstra

"Repress yourself."
Mark Dery

"We're Not Bored. We're Boring."
Snapchat saying

In this social media age, the dream of many students is to start their own platform.[1] This widely spread ideal already presumes an entrepreneurial aspiration many are not even aware of. Platform has become a meta concept, a flexible container filled with promises and dreams. This isn't just about followers, it's a mindset, an aspirational building project. Forget scarcity.[2] Get ready to boost your "platformativity." Competition is for suckers. Don't be satisfied with a few crumbs. The crumbs are for the losers further down in the food chain. This is the neoliberal version of the 1980's demand: "We do not wait to have a piece of the cake; we want to own the whole bloody bakery."

How did the "platform potential" become such a desired object? The dream is to ride the speculative wave and be where the money is made. Turning the dream into reality means owning the nodes and exchanges. This is how artists, activists, designers, and geeks envision reaching their audiences—while meanwhile becoming rich and famous. Why strive to become an influencer when you could also become the owner? Welcome to platform fetishism, where social relationships are defined by the values created in social interaction itself. In this outgoing neoliberal age, the prime directive is to look down on the poor suckers that can only buy and sell. The trick is to persuade others to play according to the rules that you, the owner (aka designer) of the market, set.

The platform a-priori is the widespread belief in the goodness of sharing. Platform = society.[3] While users are encouraged to share their profiles, comments, preferences and likes, they are kept in the dark that they share not just with friends and family (and the company that facilitates all this), but primarily with third parties. In an internal email, Mark Zuckerberg explained the mechanism:

> We're trying to enable people to share
> everything they want and do it on Facebook.
> Sometimes the best way to enable people to

1    Download the platform design toolkit and there you go: *platformdesigntoolkit.com/*.
2    Sarah Rexford, "Platform Starts with Your Mindset," *Almost An Author*, October 18, 2020, *www.almostanauthor.com/platform-starts-with-your-mindset/*.
3    Angela Xiao Wu criticizes the tendency of many researchers, policy makers, and journalists to see platform data as a true mirror of society. "Platform data do not provide a direct window into human behaviour. Rather, they are direct records of how we behave under platforms' influence." This is the all too obvious that is not obvious that characterizes the platform era. See Angela Xiao Wu, "How Not to Know Ourselves," *Points Data & Society*, July 28, 2020, *points.datasociety.net/how-not-to-know-ourselves-5227c185569*.

share something is to have a developer build a special purpose app or network for that type of content and make that app social by having Facebook plug into it. However, that may be good for the world but it's not good for us unless people share back to Facebook and that content increases the value of our network. So ultimately, I think the purpose of the platform ... is to increase sharing back into Facebook.[4]

Here we see the building of new enclosures at work. Far from contributing to their personal networks, users and third parties ultimately serve the purpose of platform fortification.

None of this seems to hamper the rise and rise of the platform. In fact, the term's sheer ubiquity led it to be added to the Banished Words 2019 list.[5] The promise of the platform is simple and alluring: everyone benefits, from producers and customers to founders. Everyone is included. Everyone plays along. It's a win, win, win. The platform has become a *Kulturideal*, long ago dislodging the website, the blog, and, in turn, the web design studio as a startup model. At the same time, a ballooning social media definition established itself. Social media apps enlarged to include stories, short-form video, live streaming, and shopping. Single apps expanded—*Inception*-like—to feature platforms inside platforms. Platforms seem to be eating the world.

# Properties of Platforms

Platforms always come back to capital. There is a longing to harness value instead of losing ourselves in the messiness of the rhizomatic network. The platform dream has further consolidated the venture capital mode that seeks hypergrowth in the shortest amount of time, setting its sights on "unicorn" market domination and a monopoly position. While very few will become billionaires, the lottery aspect of the ruthless Darwinist strategy still attracts many. It's hegemonic, as they say. Elon Musk's

4        Internal Facebook email, November 19, 2012, quoted in Steven Levy, *Facebook: The Inside Story* (London: Penguin Business, 2020), p. 173.
5        *www.lssu.edu/traditions/banishedwords/year/#toggle-id-37*. "People use it as an excuse to rant. Facebook, Instagram, Twitter have become platforms. Even athletes call a post-game interview a 'platform.' Step down from the platform, already." Michael, Alameda, California.

appeal has not yet faded. The celebrity obsession is such that the pop critique of capitalism will not really question the right to become a billionaire. We all want to run our own platform—regardless of what we are longing for.

Platforms create proprietary marketplaces, connectors of supply and demand that bear little—if any—cost of production, yet are rarely neutral.[6] They are not mere "service providers." In many cases the platforms themselves are also significant players in those markets. Revenue-wise, these are advertising giants rather than just "technology" companies.[7] So platforms do not merely stage, organize, and regulate markets, they also command outsized influence over neighboring businesses and the wider ecology. Think of the road congestion and air pollution caused by all those Uber taxis just idling. Consider the environmental impact of a million e-commerce packages being delivered, rather than purchasing them all at once from a mall or shopping street. The core of the capitalist rationale remains socializing costs while privatizing profits under the banner of personal choice and convenience. Unintended consequences are a feature, not a bug.

There never was such a thing as the "passage to the platform." The ideology of creative destruction and disruption may be properly deconstructed by now. Yet the overnight migration of millions of users to different apps remains a mystery. Can the herd swell so suddenly? Can "social contagion" spread that fast? The fact is, ever since their arrival in the early 2010s, platforms simply are. In fact, this inevitability, this seemingly natural presence, is part of their appeal. The internet itself is rarely mentioned anymore. Most people use the terms social media or platforms when they speak about the internet. Invisible wireless connectivity turns the platform into another part of the landscape. Like electricity, the platform is infrastructure that is always there, on call and available.

6      In his review, "A Tale of Two Platforms," Tim O'Reilly writes about platforms as market-places, "connecting and enabling both buyers and sellers. One of the big problems in these hyper-scaled marketplaces is building up both sides of the market at the same time. Uber and Lyft demonstrate just how expensive it is. They invested billions of dollars in marketing, and even today arguably sell their services for less than it costs to provide them in order to acquire more passengers." O'Reilly notices that it's a lot easier if you only have to build one side of the market. "When Amazon launched in 1995 as 'the world's biggest bookstore', It didn't have to spend money assembling a critical mass of books, publishers, and authors. Ingram had already done that," *www.linkedin.com/pulse/tale-two-platforms-tim-o-reilly/*.
7      Quotes and summary of Ana Milicevic, "The Trouble with Platforms," *pando.com*, June 29, 2020, *pando.com/2020/06/29/trouble-platforms-google-amazon-facebook-apple-market-cap/*.

The platform is the message: content is tired, "platform" is wired. According to Marc Steinberg, platforms have become universal translation devices: they are the place where money, people, and commodities meet and transactions happen. See them as abstract mega-nodes. "Almost anything can become a platform, if one merely calls it such."[8] We move away from the framing of new media, with its emphasis on static archives and databases, and toward a more frenetic mode of never-ending, ever-changing feeds and pages. The platform splices together liveness with transactions ("only one room left!").[9] Notifications snowball, microscopic customizations aim to elicit your attention, to make you an offer you can't refuse. Yet while this surface appears to be an ever-changing, personalized semiotic spectacle, the platform—like capitalism—is dead inside. According to Mariana Mazzucato, "platforms operate in two-sided markets developing the supply and demand sites of the market, as the lynchpin, connector or gatekeeper between them." She concludes that

> consumers accept being tracked and surrendering their personal data, even if ideally they would prefer not to, not because they have happily embraced the quid pro quo, but out of resignation and frustration.[10]

The platforms that we inhabit are aspirational media for the users that go there in search of something. I'm here—now what do I want again? The search engines developed by IT engineers and library scientists were rational and cold, empty tools that obeyed your command. In contrast, today's platforms are fuzzier and more accommodating, offering personalized information for the swiping dazed and confused. The search engine had us search through the dank corridors of the archive; the platform gives us the feeling of being on top of the world. This is why Ana Milicevic proposes we speak about platform oases and no longer use the walled garden metaphor. "There's still life outside of a walled garden; outside of an oasis the air is

8    Marc Steinberg, *The Platform Economy* (Minneapolis: University of Minnesota Press, 2019), pp. 1, 92 and 115.
9    Kevin Brasler, "Travel Websites Mislead by Falsely Declaring Few Rooms Remain," *Consumers' Checkbook*, August 2019, *www.checkbook.org/boston-area/travel-websites-mislead-by-falsely-declaring-few-rooms-remain/*.
10   Mariana Mazzucato, *The Value of Everything* (London: Penguin, 2019), pp. 216 and 219.

arid and you're lucky if you run into a tumbleweed here and there."[11]

Platforms know us intimately, serving up comforting content. They recommend media according to our tastes, preferences, previous orders, search history, and likes. This digital memory allows platforms to both comfort us and trigger us. We messy humans hate starting from scratch. "Dear cookie, please save the settings for me." After all, we're not cold scientists, interested in objective knowledge. We like to save time and take shortcuts. We appreciate the machine for supplementing our weaknesses and remembering things for us. We love it for talking to us, telling us exactly how close the Uber driver is, what comparable products cost elsewhere, and what this user that just showed up is sharing with others. We break down easily as our busy multitasking lives are always on the brink of collapse. This is why we find comfort on the platform, our new virtual domicile.

For David Golumbia, it is obvious what should happen to platforms: "They should not exist."[12] But what does it mean to say that social media should not exist? Are extractive platforms like nuclear weapons—once invented, built, and deployed, they simply become part of the human story? This is the question Günther Anders struggled with, writing in the shadow of Hiroshima. Can these platforms be crippled by regulation, be broken up, or simply taken off the net? Or perhaps, more idealistically, might they get collectively cancelled or become unfashionable and disappear for good? At first, we Web 2.0 critics thought they would simply fade away after they had gone through their hype cycle. Two decades later, we know better. How can billions get rid of something they do not even like, are addicted to, and do not know how to get rid of? The conclusion can only be that the "aesthetics of disappearance" has never been properly taught. Please share the art of the collective quit. The neoliberal consumerist mindset taught us to focus on the new—on becoming, founding, and incorporating—while never giving a thought to terminating. As Neil Sedaka noted: "breaking up is hard to do."

11      pando.com/2020/06/29/trouble-platforms-google-amazon-facebook-apple-market-cap/.
12      David Golumbia (@dgolumbia), November 11, 2020, twitter.com/dgolumbia/
status/1326521004160655365.

# Platform Stagnation

Let's dig deeper into platform stagnation. Venkatesh Rao has given us the concept of "premium mediocre," associating the term with cruise ships, artisan pizza, Game of Thrones, and The Bellagio. Premium mediocre is anything that is branded "signature." It is "food that Instagrams better than it tastes."[13] How does this apply to the internet? Post-democratic internet culture is increasingly less trashy. Platforms are becoming smoother, allowing us to swipe faster in a safe but highly constrained environment. These environments are slightly upbeat but never resort to yelling. This is my reading of Rao's concept.

It's "premium" to pay for a service while constantly telling ourselves that one day we'll be the ones getting paid. Premium lifts us out of the trash heap of everyday existence, away from the petty commoners that can only afford what is free. In preparation for your future success, you surf the internet, scanning for your next partner, your next project, your next wardrobe item. In exchange, you temporarily suspend your deep cynicism. Sincerity in a fake world means staying true to one's profile, neatly summarized in the Venkatesh Rao for dummies formula: "Great minds discuss ideas; mediocre minds discuss events; small minds discuss people. Premium mediocre minds discuss bitcoin." It is the "premium mediocre" label that we want platforms to become. This is their historical, emancipatory drive—and one of the reasons why they're so hard to leave, as we'll first have to confront and overcome the premium mediocre desires in ourselves.

Most folk theory in the age of regressive populism merely reproduces the status quo. This is to be expected: further replication is only making things worse. Yet there are exceptions, gems that seem to perfectly pinpoint our current condition. In the "Platform is the Enemy," Daniel Markham states: "Technology's goal is to make us better, not dumber. Wait one second. Is that true?"[14] Let's give him the ample space he deserves in a sea of complicit literature.

**Each piece of technology we deploy can have the goal of helping us do what we've already**

13    Venkatesh Rao, "Medium Mediocre Life of Maya Millennial," *Ribbonfarm*, August 17, 2017, *www.ribbonfarm.com/2017/08/17/the-premium-mediocre-life-of-maya-millennial/*.
14    *danielbmarkham.com/the-platform-is-the-enemy/*.

> decided to do or helping us decide what to
> do. The first option leaves the thinking up to
> us. The second option "helps" us think ... The
> minute we create a platform for something,
> whether it's rating movies, tracking projects,
> or chatting with friends about work, as that
> platform takes over mindshare, *the assump-*
> *tion becomes that this is a solved problem.*

Implicitly, Markham calls for a theory of "interreactivity."
Platforms are designed for users to react.[15] They are not call-
ing for interactive engagement—let alone interpassivity as
Pfaller once described. "With the phone," Markham writes,

> I know who I want to call and why. I push buttons
> and we are connected. The tech helps me do
> what I've already decided to do. With Facebook,
> on the other hand, they get paid to show me
> things in a certain order. The premise is that I'm
> waiting (or "exploring" if you prefer) until I find
> something to interact with. The phone is a tool
> for me to use. I am the tool Facebook is using.
> I am no longer acting. I am reacting.

Many do not use the internet; the internet uses them.
"Platforms, by their very nature, constantly send out
the subtle message: *This is a solved problem. No further*
*effort on your part is required here. No thinking needed.*"
The logic here is one of brain efficiency that enables us
to focus on more important issues, or have a break and
relax. "Let the platform decide. Energy not needed. Dump
those neurons." For Markham, platforms are the enemy
because "they resist analysis in the areas they dominate.
Platforms turn into settled fact things that should be open
for debate." They do the work of deciding what categories
various things go into. Popular platforms aren't just a
danger economically because they control commerce.

> They're an extinction-level, existential danger
> to humans because they prevent people from
> seriously considering what kinds of categories

---

15      As Benjamin Bratton writes: "Platforms are generative mechanisms—engines that set the
terms of participation according to fixed protocols (e.g., technical, discursive, formal protocols). They
gain size and strength by mediating unplanned and unplannable interactions." *The Stack: On Software*
*and Sovereignty* (Cambridge: MIT Press, 2016), p. 44.

are important in each of their lives. They resist
their own analysis and over time make people
dumber.

In an interview, Zadie Smith once said: "My novels are
about the challenge of actually being human and not
avoiding the responsibility of being human, which is very
heavy."[16] This is precisely what we project onto platforms:
they should not be detached tools or cold systems, but
rather act like soulmates that we carry with us, like pets.
The platform should be a safe place, a dreamy wannabe
world that prefers fluid comfort over dragging complexity.
"Please," I tell my phone, "limit my choices, whisper to me
what I want." Think, for instance, of Facebook's childish
interface design that is destined to stay the same (while
superficially changing every few seconds, without us no-
ticing). The problem here is that there is nothing to think
about or remember. Billions of us spend hours a day on
Facebook, but would fail if we were asked to reconstruct
what this "webpage" looks like. Something vaguely blue,
with a newsfeed, updates, and some random friends?
    Aspirational life is an endless succession of proto-
types, versions, halfway attempts that later get aborted
and forgotten. The numbness in the digital state of affairs
reflects this. It is never real or material, but rather hovers
between proposal and the point after which things expire.
We resent the objects that are unable to simply be in the
world. High tech is unable to merely exist, it is always
on the verge of "notworking"—your battery dies, your
internet connection fails, your software-as-a-service sub-
scription runs out. In the meanwhile, any critical internet
theory that can offer escape has all but disappeared,
vanished into the grey zone of paywalled journal articles
and exorbitantly expensive books (available, of course, on
Amazon). The ritual use of the correct academic references
sits at the very opposite spectrum of the "toxoplasma of
rage" pole, where the more controversial the information
that is being marketed, the more it gets talked about.

---

16    Deborah Dundas, "Zadie Smith on Fighting the Algoritm: 'If you are under 30, and you are
able to think for yourself right now, God bless you,'" *The Star*, November 8, 2019, *www.thestar.com/
entertainment/books/2019/11/08/zadie-smith-on-fighting-the-algorithm-if-you-are-under-30-and-you-
are-able-to-think-for-yourself-right-now-god-bless-you.html.*

# Platform Realism

When it comes to platforms, we seem to be stuck or stagnated. What might we call this condition? Net artist Ben Grosser proposes the term platform realism. Grosser's term builds on Mark Fisher's articulation of capitalism realism,

> the idea that we don't imagine or build alternatives to capitalism because we can no longer envision a world without it. Big tech, in a few short years, has managed to instill within the public a similar state of *platform realism*. So many are unable to imagine how global communication, media, search, etc. could ever function without the platforms. Despite a growing platform malaise, it has become difficult for many to consider a world without big tech platforms as a viable conception of the future.[17]

Platforms are political and platforms constrain political thought. Michael Seemann's *Die Macht der Plattformen* could serve as an example of this tendency. In his PhD thesis, he argues that we should see platforms as political decision-making arenas. Seemann stressed that "we need to understand platforms as something inherently political, as new political institutions, political battlegrounds instead of depoliticizing them through technical means." He came to realize that the decentralist rejection of power leads nowhere.

> The upheavals of the past years—from the rise of right wing populisms to hate speech and disinformation—were not caused by the power of platforms but by unchecked empowerment of users. There was a lack of enforcement, a lack of moderation that caused most of the harm.[18]

How might we surface and critique this politics? According to Grosser, platforms are "encodings of tech bro entrepreneurial ideology, agential systems that enact and amplify their beliefs in the importance of scale, the imperative of

17    From a private email exchange, June 28, 2021, then reworked and published here: Geert Lovink, "Ben Grosser: Planning the Exodus from Plaform Realism," *Institute of Network Cultures*, June 29, 2021, *networkcultures.org/blog/2021/06/29/platform-realism/*.
18    Quotes from a private email exchange with Michael Seemann, November 20, 2021.

growth, and the superiority of the quantitative." Grosser's own projects include *Go Rando*, *Facebook Demetricator*, *Order of Magnitude* and *The Endless Doomscroller*. These projects all operate with existing platforms, obfuscating your feelings, hiding metrics, confusing algorithmic profiling, and generally making their central manipulation mechanisms visible.[19] Grosser also mentions projects by artists such as Joana Moll and Disnovation, as well as essential critiques by thinkers in media and software studies such as Wendy Chun, Safiya Noble, Matthew Fuller, and Søren Pold. Grosser concludes: "The more we can illuminate existing connections between wider societal ills and the ways that big tech models, reifies, and amplifies them, the easier any exodus will be."

Besides building alternatives, Grosser also argues that we also need to engage the world where they are. With over 3 billion people already signed up, that means we also need to agitate inside Big Tech's platforms themselves.

This isn't as bad as it sounds because platforms can be fruitful spaces for cultivating criticality. Whether covertly subversive or overtly confrontational, platform manipulations such as those that can be enacted via browser extensions or online performance projects can prompt users to reconsider the role of these systems they currently see as inevitable parts of the 21st century landscape. By exposing the hidden and hiding the visible, hacktivist art, tactical media, and other related practices can help users question the role of platforms in everyday life. Why are they built this way? Who benefits? Who is made most vulnerable? How could it be different?

# Flocks and Herds

I like to compare the platform condition with the way Michel Foucault described pastoral power. Particularly interesting in this context is what he calls the paradox of the shepherd.

19     *bengrosser.com/projects/*.

The duty of the pastor (to the point of self-sac-
rifice) was the salvation of the flock; and finally,
it was an individualizing power, in that the
pastor must care for each and every member
of the flock singly. Because the pastor must
care for the multiplicity as a whole while at the
same time providing for the particular salva-
tion of each, there must necessarily be both a
"sacrifice of one for all, and the sacrifice of all
for one, which will be at the absolute heart of
the Christian problematic of the pastorate."[20]

The flock is still there, including its times of grazing, rest,
and erratic movements—but the pastor is nowhere to be seen.

Power today in the West has shifted from the church
and the state to corporations. The aim is no longer to redeem
people. What happens is the outsourcing of tasks the state
previously understood as theirs: the gathering of knowledge
of both the population at large and that of users, formerly
known as individuals. Both are taken care of, in the shape
of markets, on the platform. We should read this as a design
challenge and see geeks, admins, designers, marketers,
tech entrepreneurs, and behavioral scientists as today's
shepherds. However, their explicit task is to remain invisible
and thus unaccountable. Their guidance is felt as abstract
"algorithmic governance," the rule of AI and big data.

So one approach to this question is to point at the
theological foundations of today's political power of social
media platforms. Mark Zuckerberg's repetitive referencing
of the Judeo-Christian term "community" would be an
ideal political theology reference here. Another would be
the "subject formation" through the addictive repetition of
numbness, going back time and again, without purpose.
We are part of that electronic herd and need that reaffir-
mation. Yet, why is this interrogation of the present so
difficult for us?

Platforms are dynamic systems for millions of users,
a transient space for the multitude who act and interact.
We could freeze-dry Uber or Tinder, but that doesn't help
us much to get a better understanding. If we return the

20    Quote from Ben Golder, "Foucault and the Genealogy of Pastoral Power," *Radical Philosophy
Review 10*, no. 2 (2007), p. 165, *eportfolios.macaulay.cuny.edu/biogeo/files/2009/10/ben-Golder-essay.pdf.*

next day, or within the next five minutes, the site looks different, offering other products and prices, blackmailing users with non-existing urgencies and scarcities. We're nervous, in a rush, and so are the platforms that have been designed to exploit these human conditions. This view breaks with the "remediation" thesis as we're no longer dealing with digitized versions of heavy, static media objects such as photographs, paintings, film roles, paper books, and newspapers, but with tiny, fragile data trails that pop up, leave a trace (likes, transactions, page views) and then disappear again. Rapid changes on the platform pulverize the fixed status of the file and the very idea of a static site with "pages."

What happens to the notion of liminality when people are stuck midway in the digitization rite of passage and are not supposed to change anymore, frozen, pinned down by limited technical options and polarized conversations, in a regressive era that rules out metamorphosis?[21] The closing of Yahoo! Groups in 2020 was yet another sign of dominant platform players actively scaling down community tools in favor of profile-centric liking and sharing. Besides going completely offline, the most effective critique still remains empowerment with autonomous tools.

# From Neofeudalism to Self-Organization

Both what Europeans call regression and Americans call neo-feudalism describe the return to earlier stages of psycho-capitalist development. In her review of McKenzie Wark's *Capital is Dead*, Jodi Dean compares digital platforms with the role of water mills in agrarian societies.

> Platforms are doubly extractive. Unlike the water mill, peasants had no choice but to use, platforms not only position themselves so that their use is basically necessary (like banks, credit cards, phones, and roads) but that their use generates data for their owners. Users not only pay for the service but the platform collects the data generated by the use of the

---

21    "The idea that Facebook is here to stay and we might as well get used to it is climate doomerism but for platforms—platform doomerism. And this mentality undermines all attempts to finally reign it in." Joanne McNeil (@jomc), *twitter.com/jomc/status/1378330631164289024*.

service. The cloud platform extracts rents and data, like land squared.[22]

Jodi Dean describes the neo-feudal tendency as "becoming-peasant, that is, to becoming one who owns means of production but whose labour increases the capital of the platform owner." Here, platforms are seen as meta-industrial infrastructural networks, parasitic in nature, driven by higher forms of exploitation and extraction.

Both platform workers and users are regressive eighteenth-century pre-industrial figures, almost-proletarians, the "entreprecariat" (as Silvio Lorusso called them) stuck in stressful, depressive pseudo-work that neither feels productive nor satisfactory. The platform mentality, which spread over the past decade, is in fact a meta-market mentality (a term used in response to economist Von Mises). The trickle-down effect of wealth and power is not happening—and this somehow comes as a surprise to the neocon libertarians that still believe in "the market" and do not understand why some rich millennials are "plotting the end of civilization."[23] The monopoly is a fact. An anonymous Amazon worker stated that the company is an opportunistic corporation:

> It invests in businesses where we think we have a competitive advantage. In general, Amazon thinks of itself as a technology company. So we put the technology first, whatever the product is that we're selling. And we believe that because we have so much talent and so much capital, we should be able to use our technology advantage to dominate any market that we decide to enter.[24]

In this situation, is all we can hope for sporadic peasant revolts? Where is the twenty-first-century equivalent of the skilled, self-educated, and most of all, self-conscious worker that understands the need to get organized? All aspects of work have now been digitized. Instead of conspiratorial,

22      See Jodi Dean, "Neofeudalism: The End of Capitalism?" *Los Angeles Review of Books*, May 12, 2020, *lareviewofbooks.org/article/neofeudalism-the-end-of-capitalism/*.
23      Doug French, "Rich Millennials Plot the End of Civilization," *Mises Wire*, December 22, 2020, *mises.org/wire/rich-millennials-plot-end-civilization*. More on this in the debate between Slavoj Žižek and Yanis Varoufakis, Ljubljana, October 21, 2021, *www.youtube.com/watch?v=Ghx0sq_gXK4*.
24      *logicmag.io/commons/inside-the-whale-an-interview-with-an-anonymous-amazonian/*.

professional revolutionaries, we're left with do-gooder NGO workers on temporary contracts. This leaves us with the desire to leave behind the neo-feudal stage and fast forward to a series of early twentieth-century questions to do with strategy. Revolution and reform, rejection or adaptation, abolition or "civilization" of the platform-as-form? Should platforms be dismantled or appropriated? According to the accelerationists, platforms are the technological expression of "planetary computation," constructs that can be reprogrammed for post-capitalist purposes. Instead of being questioned, the platform is embraced as a bastion of efficiency, smoothness, and scale: Everyman Their Own Platform.[25] Such concepts seem to be byproducts of a lost decade, when we failed to discuss alternatives and mindlessly installed every app. Critical discussion about platforms has yet to start.

Let's come together and plan the exodus. In 1961, James Baldwin told an audience at a forum on US nationalism and colonialism: "Time passed, and now, whether I like it or not, I can not only describe myself but, what is much more horrifying, I can describe you!" This is the original promise of alternative media. Victims or minority groups do not need to be represented and can speak for themselves, thank you very much. The question is whether current social media platforms still can be used for this purpose. "How do you call the Multitude tamed by the platforms? The Platitude," Morozov once tweeted. So key to getting out is finding forms of self-organization that work. How to organize in the shadow of the perpetual present, without being bothered by filters, trolls, secret services, algorithms, and other automated authorities? How can we communicate and come together without having to entirely depend on offline encounters?

An important source of inspiration in this respect can be the federated Twitter alternative Mastodon. "Twitter has only two discoverability layers: your network and the whole world. Either a small group of contacts, or everybody in the whole world. That's crazy," Carlos Fenollosa explains.[26] Mastodon, instead, has an extra layer between your network and the whole world: messages from people

25    Reference to *en.wikipedia.org/wiki/Jedermann_sein_eigner_Fussball.*
26    *cfenollosa.com/blog/you-may-be-using-mastodon-wrong.html.*

on your server, called the local timeline. The Mastodon idea is to show how exciting it is to log into the unknown and realize that there are people who share your interests.

Call it organized networks or a network union.[27] Connected cells of organizational units, post-platform coops with a purpose that consist of strong links, operating in opposition to the extractive "weak links" logic of the "friend of a friend" platforms. Organized networks focus on common tasks that need to be done, not on "updating" solitary users. Not *What's New* or *What's Happening* but *What's to be Done*. Please liberate us, lonely, desperate souls. Refuse, walk away. If the network is the memory of the event, and the platform the memory of the network, what's next?

27    See Geert Lovink and Ned Rossiter, *Organization after Social Media* (Colchester: Minor Compositions, 2018), *www.minorcompositions.info/?p=857*.

# 5
# Minima Digitalia

"Never again is now."
Aprica

"I am not interested in discourse. I am right."
@jackies_backie (j*ckie)

"On earth, we're briefly gorgeous."
Thessaly La Force

"I am too pretty to text first."
Eraser

"It's nobody's business what
anybody does when they're alone."
Frank O'Hara

"Most of you don't even know you're
just one click away from chaos."
@brb_irl (Katherine Frazer)

"Watching Tech is a bit like watching
children let loose in a sweetie factory.
You know they are going to puke."
Bill Blain

"All is visible and all elusive, all
is near and can't be touched."
Octavio Paz

"I was listening to this song and the demon under my bed asked me why I was playing his mixtape."
The Kantaral

"The only thing they request is something to numb the pain with, until there's nothing human left."
Father John Misty

"Nothing will kill you more than your own thoughts."
PoemPorns

"I have been deliriously tired and in a brain fog all day. With mind and body broken, the struggle for options is on."
Tweet

"We're doing the Lord's work."
Click-Farm Maintainer

"I wanted to cut myself off from the past and instead I cut myself."
email

"find what you love then get distracted"
@melissabroder (Melissa Broder)

What the world needs now are temporary disciplines. As all science begins with fiction, there is a historical task here for poets and other irregulars. One urgent field would be stagnation studies, researching the aesthetics of impasse and procrastination. These scholars-of-stasis might team up with their collapsology colleagues across the hallway. The organized network has been working on a Horizon Europe grant application in a consortium with Austrian regression experts, Finnish silence researchers, and the Misogyny Prevention Center (MPC) in Zagreb.

Angelicism01 notices that he is over it, and longs to go extinct. He's in favor of invisible abolition,

> at an intimate and molecular level in their lives: for example in not working at all, disengaging from everything, deleting themselves, not offering labor in tweets, messages, emails, poems, films, theorization, organization and even love.

His motto: "Write as if you're going extinct."

Angelicism01's punk-existential diary notes, posted on Substack and an email newsletter, represent the doubt of the online multitudes and their struggle with our current condition. His theory on the Great Digital Transformation centers around the motif of the end of the universe, a termination point that is technical in nature. We all sense the finite. "We would rather go extinct than go offline."

Angelicism01 recognizes the figure of Simone Weil within the urgent speeches of Greta Thunberg. We may be confused, but there is no confusion. To address this situation, we need to bring Hegel's totality, Weil's absolute, and the internet state of mind together.

> If the absolute is that which completes thought via its urgency, in the sense of being what the Tibetans call the greatest intelligence, then why distract from it at all? Now the internet itself is the greatest distraction so that what we have is the sunsetting of the greatest intelligence right inside the beauty of the greatest distraction. That is basically our situation, and to outshine it, it seems a degree of abstinence

(in a final text of Derrida this is called "incredible abstinence") from the internet is essential. Online beauty is only fully thinkable and seeable, one might say, from the offline point of view of pure repetition.

Angelicism01 is not the first to make the claim of the absolute in the internet context. Think of Erik Davis' *Cybergnosis* from 1997. These were speculative considerations about the conceptual potentials of the virtual. Nearly three decades into the network of networks the no-sphere is real. Humanity's synapses are intimately interconnected—and the result is informational and emotional poverty. The absolute is there, right in our face, on the screen, inseparable from the trivial. "My claim on the absolute makes intelligible an absolute that is close, near enough to touch, compelling in an immediate sense, logically sensuous, more than apocalyptic, totally non-serious ('lol')." The absolute should here be read from a materialist perspective as a secular, titanic force, grounded in infrastructure.

On his return from one of the world's largest crypto-game rabbit holes, Amir Taaki reported:

> After years spent indulging his pleasures, the worldly man feels a hole which he tries to fill with the admiration of others. But even the other has its limits, as society can be corrupt. Falling victim to infinite regression, he escapes, emerging as the religious knight.

Amir's Twitter motto: "The society that separates its scholars from its warriors will have its thinking done by cowards and its fighting by fools."

I am struggling with a question posed by Johan
Sjerpstra: "What happens when a spectacular growth
of techno-magic is paired with a similar explosion of
misery at the level of mental economics?"

Hypothesis: It's time to downplay the media & com-
munication aspect of "social media" and start to see
platforms as technical compensation for the loss of
the social and the destruction of the self. Social media
has become "the social" itself. There are no non-digital
social relations anymore. Any attempt under the banner
of European offline romanticism to "reset" the virtual
and forcefully expropriate youngsters by confiscating
their phones is bound to backfire. Punishment will turn
to resentment and regressive, violent revolt. They will
bite back and fight back.

According to former Kickstarter CEO Yancey Strickler,
the internet is becoming a dark forest at night.

> It's deathly quiet. Nothing moves. Nothing
> stirs. This could lead one to assume that the
> forest is devoid of life. But of course, it's not.
> The dark forest is full of life. It's quiet because
> the night is when the predators come out. To
> survive, the animals stay silent.

In Part II of his blog post, Strickler develops a variation
of the social cooling theory: "Like oil leads to global
warming, data leads to social cooling." He states that
"in response to the ads, the tracking, the trolling, the
hype, and other predatory behavior, we're retreating
to our dark forests of the internet, and away from the
mainstream." People can only be themselves on private

channels "where depressurized conversation is possible because of their non-indexed, non-optimized, and non-gamified environments."

Strickler mentions examples of dark forests such as newsletters and podcasts, Slack channels, private Instagram accounts, invite-only message boards, text groups, Snapchat and WeChat. However, Strickler also stresses that we shouldn't underestimate how powerful the mainstream channels continue to be. He thus presents his Bowling Alley Theory of the Internet: "People are online purely to meet each other, and in the long run the venues where we congregate are an unimportant background compared to the interactions themselves." He warns that if we join the platform exodus movement, our void will be taken over by others, primarily dark forces.

> Should a significant percentage of the population abandon these spaces, that will leave nearly as many eyeballs for those who are left to influence, and limit the influence of those who departed on the larger world they still live in.

*The Dark Forest Theory of the Internet* by Shanghai-based Polish essayist Bogna Konior circles around a well-known "Deep Europe" metaphor. In the dark forest "the roots grow upwards, the crown reaches downwards: wrapped around the planet, the internet circulates." Konior uses the forest motif to describe the tragedy of communication, "its compulsion, necessity, futility and risk." Traditionally, the forest is linked to the unknown and the supernatural, a realm shrouded in mystery that spirits inhabit. The forest is an enchanted and dangerous space. It offers guidance, help, and cover—but it can also be deadly. In popular Central European mythologies, heroes and heroines confront the monsters of the forest—wolves and bears—and later transform into them. Not in the case of Konior's parable. The dark forest is no longer a transformative space. Numbed by uncertainty, the internet tribe members are tamed. Unable to act

decisively, their metamorphosis never arrives. Instead of a flash of light and a transformation, they kill time clicking, swiping, and chattering. Users do not even have the option anymore to be turned into the Kafkaesque insect. Communication and interaction are their sole destiny. "The forest-system needs to be able to read us, as do the other users. What's on your mind?"

Darkness as a strategy is a motif of the Chinese sci-fi writer Cixin Liu's 2008 *Dark Forest*, the second volume of his *Trisolaris* trilogy. The novel deals with the planetary anxiety for an upcoming invasion of extra-terrestrial aliens. For Liu, as for Konior, entropy is inevitable. Things tend to dissolve into chaos and confusion. Disorder is the prime direction. If there is a slim chance to survive, the internet must rid itself of its own excesses.

In *Crowds and Power*, Elias Canetti lists the common or shared symbols for an array of countries. For Germans, the symbol is the marching forest.

> In no other modern country has the forest-feeling remained as alive as it has in Germany. The parallel rigidity of the upright trees and their destiny and number fill the heart of the German with a deep and mysterious delight. To this day he loves to go deep into the forest where his forefathers lived; he feels at one with the trees.

Canetti compares conifer forests, with their orderly separation and vertical stress, with the tropical kind where creepers grow in all directions. "In the tropical forest the eye loses itself in the foreground," he notes, "there is a chaotic and unarticulated mass of growth, full of color and life." In line with Canetti, Liu and Konior take up the forest metaphor as a powerful symbol of safety, a place to hide and survive.

The dark forest is such an intriguing motif for Konior because it brings into play the possibility that communication as such is dangerous (an element of the so-called Fermi Paradox). Instead of compulsively chatting, why not take up the cosmic challenge to become a dark forest, a mirror that humankind holds up to itself? "An alien civilization might feel it is too dangerous to communicate," the Fermi Paradox article on Wikipedia states,

either for us or for them. It is argued that when very different civilizations have met on Earth, the results have often been disastrous for one side or the other, and the same may well apply to interstellar contact.

If communication is dangerous, we should consider this scenario as an option: everyone is listening but no one is transmitting. We can take this principle out of its original alien galaxy context and place it on the table as a design proposition. It's in the best interests of all if we shut up—and not just for a moment either, but in a structural way, transforming our shrieking blue planet into a dark forest.

Konior notices that we're never alone. In fact, it is noisy, clamorous, and crowded out there. She describes the forest as a

tangible space, yes, but also a mental expanse. Made for sleepwalking, for a mundane delirium. For sacrificial rituals. People get lost in it by shining light in all the wrong places, exposing too much about themselves, communicating impulsively, recklessly.

Even when we refuse to respond or like, our sheer presence is enough to produce tons of data. The truth is no longer a confession. We have already spoken by the sheer fact of logging in, walking on the street, being present.

Much like our past condition when humankind was confined to the tribe, village, and nation-state, the social has become our penitentiary system once again. "What is an online community if not a sophisticated form of mutually assured destruction," Konior asks, "suspended between neurosis and narcissism, tied to the unnegotiable need to communicate?" Entropy is not some extraterrestrial point where time-space disappears into the big nothingness. Instead "it flows through us," looking for the next object to sacrifice.

The dark forest is not about content, but about a particular condition. To be sure, the bright daylight of the "enlightened" mainstream platforms does not cover the entire internet. It quickly turns to twilight when we log onto the "dark web," the space that is not indexed

by search engines where users trade drugs, porn, leaked documents, and other illicit commodities inside peer-to-peer networks. But this is not the darkness Konior refers to. For many of us, the entire internet experience, reduced to hours of swiping through apps, has turned into a metaphysical sci-fi experience, albeit a numb one. The world has closed in on us.

> We are dispossessed of will. Our neuroses, emotions and attention are ordered by our computers. As if in trance, we follow the collective pattern of feeling transmitted to us. Online, all impersonal worldly events are experienced as intensely personal, even if we don't play a role in them.

While drawing on the forest metaphor, Konior refrains from dredging up the overused image of the rhizome. For Konior, it's no longer useful to identify with a distributed root system or some heroic tree model. Dark forest theory is no longer about the design of a (subversive) information strategy. We're both hunter and prey; no longer on the run for power, but surrounded by it. Konior's internet forest comes closest to Arthur Koestler's *Darkness at Noon*, a repressive, timeless totality in which we're jailed behind an invisible, digital curtain.

"I want to grasp the brutality of our situation: communication is a compulsion and yet it is also the source of conflict."

For Konior, communication is a sign of stupidity rather than intelligence. "As an isolated system, it tends towards the high-entropy option. Connection produces conflict." Humans hunt each other. "In the prison of interiority that is the internet, someone always has to be discarded: directing entropy away from the self, towards the other." In the nasty, brutish Hobbesian battle of all civilizations against all, "the smarter one stays silent or attacks first."

To become a dark forest is to shut up. The refusal to send out signals into the universe is a tactic—or perhaps more like a bitter lesson that we have to learn. Our daily social media indicates the exact opposite. Every move, touch, and input is recorded, transported,

and stored in multiple databases. All communication leads to friction and, potentially, conflict. "More sociality, more entropy." In this situation, the party logic is simple: the more, the merrier. As the all too human *Gutmenschen* cannot distinguish between sociality and survival, the faith of our planetary existence has been sealed. But what if we kept our thoughts, as experiences of the brain, to ourselves?

In the eighteenth century, the notion of society emerged in response to the rigid formality of the state. As Johan Heilbron explains in *The Rise of Social Theory*, the growing diversity could no longer be managed by the institutions of the state. "A society," he writes,

> was a system of groups of people and institutions linked to each other in a variety of ways. This linkage was many-sided and many-faceted; it did not stem from a "plan," was not stipulated in laws or rules and was neither purely "political" nor purely "economic."

Rousseau may have been the first to use the word social as the adjective of société, but today this link is no longer self-evident. Our quest, two centuries later, is to defend society against social media. We see that society is not a given and has similar constructs compared to today's social media: both are an interconnected system defined by links. As Heilbron concludes, "the idea that human beings can be understood from the social arrangements they form is a modern one."

Adrian Ganea:

> I am intrigued by the magic of the unreal and the intangible, I am drawn to the ethereal and the elusive, I seek the sorcery that incarnates the virtual into solid matter. I am fascinated by the ways the bodiless nonmaterial subject can materialize and transpire into the real world. In my work, I try to operate through these phenomena, aiming to put them into effect. While enacting the production of illusions, untruths, and fiction I am often reflecting on their increased automated fabrication.

The starting point in the design of new social media apps is the group and the social, not the user. The tools will be goal-driven. What needs to be done? Not sharing for the sake of sharing. In this way, we move from profile to project, from like to decision, from behavioral to social psychology.

On urgent publishing. There is a crisis of distribution. With bookshops closing and libraries going digital, it is becoming clear that the twentieth century Media Question is no longer about the what—content and ideology—but about the how. What is recursive publishing? Why do we speak about "care" in this context and contrast this with the random flows on social media? Our task is to design new figures that matter, new roles that venture beyond reader and writer, editor and designer. Care should not be reduced to careful. What does the art of curating and custodianship mean in terms of cultural content production? If concepts matter and images hurt, then how does this relate to the real existing nihilism of our experienced information overload? The utterly absent publishing practices of social movements such as

Extinction Rebellion, the Yellow Vests, and Black Lives Matter show that the gap between book and tweet is only growing wider. Does digital in this context mean that nothing but data matters?

On digitization. Whoever thought that digitization came first, followed by the connection of all devices, was way off the mark. After three decades of the internet, Western countries such as Germany officially proclaimed their national "digitization" agenda, including plans for a digital ministry. The titanic forces of industrialization once described by Ernst Jünger have been superseded by an even more powerful yet invisible revolution. Much like the neutron bomb, "designed to maximize lethal neutron damage near the blast while minimizing the physical power of the blast itself," digitization presents itself as a historical imperative—nothing short of a Hegelian totality on a planetary scale.

The digital whole is reached at the end of a process of digitization of all processes in both individual and society. This transformation, which is neither false nor fake, comes both from the inside and outside. In most cases, it is not even necessary to invade and replace thoughts, acts, and movement from the inside—remote capture will do. This bestows upon the digitization myth a kind of metaphysical or even magical status. In the case of Germany, the source of their digitization deficit is indeed puzzling. Should Brussels donate computers to Berlin? Is the situation so dramatic that top-down reeducation efforts are required? Or should psychoanalysts and therapists be called in to assist in overcoming the widespread tech fear and digital scepsis? If the startup model has really failed, does Germany need to roll out the ultimate weapon: a Four Year Plan?

Hardware and software require a complex infrastructure of underground cables, minuscule sensors, and data centers. But all of these cables and structures are buried, hidden from view: the material turns invisible.

This positive utopia is both an engineering dream and a totalitarian nightmare. As we can observe, the digital totality of productive forces does not translate into any form of awareness, let alone class consciousness.

The final frontier of digital totality is not society and its urban environments but the networked psyche. The promise of digitization is the optimization of all systems—first and foremost the working of the human brain. It's no longer space that is the final frontier. Are we able to capture its scale? Can we deal with the immensity of its nullity, its dead databases, stored videos, and useless backups? Don't we fight futile systems and get rid of them? Why, for instance, hasn't new materialism come up with a radical critique of our collective obsession with digital metaphysics?

Reading Achille Mbembe:

> Computational mechanisms, algorithmic modeling and the extension of capital into every sphere of life are all part of one and the same process. Whether operating on bodies, nerves, material, blood, cellular tissue, the brain or energy, the aim is the same: first, the conversion of all substances into quantities— the pre-emptive calculation of possibilities, risks and contingencies with a view to their financialization; second, the conversion of organic and vital ends into technical means. Everything must be detached from any kind of substrate, from all corporeality, from all materiality; everything must be artificialized, automated and autonomized. Everything must be subjected to quantification and abstraction. Digitization is nothing other than this capture of forces and possibilities and their annexation by the language of a machine-brain transformed into an autonomous and automated system.

Digitization, says Mbembe,

> is now driving an unprecedented unification
> of the planet. The planet itself is increasingly
> understood and experienced as a universal
> field of mediations. It is no longer a physical
> world so much as a reticular one. But this
> ubiquitous, instantaneous world, populated
> by connection devices and all sorts of pros-
> thetics, is confronted by another world, the
> old world of bodies and distances, materials
> and areas, fractured spaces and borders—
> the world of separation.

"It feels like a breakthrough when I make certain disclo-
sures. But then I regret them. The conversation ends and
I feel more alone." Eda Gunaydin on confession in the
age of the internet.

In a state of the visual arts report, Gergely Nagy writes
about the situation of the arts in Hungary:

> We are not able to talk about exhibitions and
> institutions because we always find ourselves
> talking about the circumstances instead:
> political positions, lack of opportunities, lack of
> funding, boycotts and anti-boycotts.

Take Latvia, for instance. Here "governmental support
for visual art has been poor and private patronage
explicitly conservative and almost non-existent." For the
Czech art sector "the year was dominated by protesting,
canceling, firing, fighting, but also accepting, attempt-
ing, reassembling." As directors get dismissed and
protests against "artwashing" play out, art scenes across

the region are fighting for their survival. There's institutional fatigue, including the independent initiatives. On the one hand there are endless cycles of austerity and poverty; on the other, new forms of nepotism by a cultural managerial class dominated by consultants, annual reports, excel sheets and revenue targets. The critique of the rotting corpse is justified yet ultimately pointless. The rot progresses deeper.

The art situation is compared with a barn. "The condition of the barn keeps deteriorating over the years, its roof leaks and no one repairs, reconstructs or patches it." Kyiv, for instance, is rapidly becoming "the European capital of cultural destruction." The problem is no longer boredom. The stagnation gets to a point where laws of dialectics kick in again and cause a whirlwind of protests, which then lead to open forms of reaction, leading to a next round of resignation and despair. As we hear from Bucharest, "a meeting with the minister revealed what we already knew: the state couldn't care less about the current cultural climate and the hardships of cultural workers." Switching to Toruń, Poland, where "controversial information appeared in the media about extremely low salaries for performers recreating Abramović' (and Ulay's) performances. This information was ignored by the artist and denied by the director."

For some, the situation is still ambivalent. Are the doors really opening or maybe closing forever? "When critical art is marginalized," concludes Nagy, "there is a chance that soon the art production itself will be marginal and insignificant as well." Once visual arts as a genre is solely defined as historical (a process that arguably already happened to opera and classical music), contemporary art practices get deinstitutionalized. They become exposed on the market, beholden to wealthy patrons— or alternatively, disappear underground, becoming self-funded amateur works that are almost invisible. After the disappearance of the critics (and related trade magazines), we will witness a redefinition of the curator.

From a radical Central-European perspective, the solution for the leaking barn is not to promote some false unity of a "warm" community, but instead to be uncompromising in questioning all forms of power and oppression—both inside and outside the group.

An example is Jan von Brevern's critique of the *lumbung* (barn), the central motif of the 2022 documenta ruangrupa curatorial collective that promotes "cosmopolitan communitarianism." According to Von Brevern, today's museums prefer to be cozy yet global barns that celebrate the idea of small communities.

> Art no longer sets the tone, rather it seems to be in tune with a melody that has long been trumpeted by chocolate bar producers and airlines. Today, every chemical giant, every major bank and every coffee house chain is eager to conserve resources, support local communities, and uphold "values such as collectivity, trust, transparency."

Von Brevern questions whether the barn is a suitable symbol if we want to critique imposed harmony. The class base behind the "urban neo-community of the new academic middle class" needs to be revealed, not celebrated. What's missing here is an explicit agenda that needs to be promoted instead. *Auseinandersetzung*, against toxic optimism aimed to silence critics, cherishing refusal, disagreement, dissident positions, organized networks, and other forms of negative energies channeled towards open conflict (free and viral), against a deadly consensus machine that is part of the problem. The task ahead is not to promote salvation of the community feeling but to design hybrid agonistics (in line with Chantal Mouffe). Let's bring together offline and online spaces and facilitate conflict through self-organization, self-defense, and confrontation.

> Once, the purpose of knowledge was to give form to reality; then its aim became the production of possibilities; now it has become nothing but a risk manager. Once, we were producers; then we became consumers; now we are products. Once, the body's strength

was exploited to produce goods; then the
energy of desire was exploited to consume
goods; now one's creativity is exploited to
produce the self as a commodity. Once, we
had children; then we desired children; now we
have become children. Once, love was a pact
of mutual support; then it was a desire; now it
is the price at which we sell ourselves. Once,
machines were a means to our ends; then they
were the ends for which we were the means;
now they are oracles that interpret signs and
whose prophecies we interpret. Once, we were
in a disciplinary society; then we were in a
society of control; now we are in a risk society.
        Anna Longo

To be a philosopher you need the ability to pay
attention: to be rapt by what is in front of you
without seizing it yourself, the care of con-
centration—in the way you might look closely,
without touching, at the green lacewing fly,
overwintering silently on the kitchen wall.

This quote from Gillian Rose stirs us to consider the role
of attention today. What are the implications of this for
the digital naive generations that face great difficulties
to focus? Can distraction become a force for good and
create mega intensive aphorisms? Or is philosophy
doomed as such?

In *Trick Mirror*, Jia Tolentino writes:
        The call of self-expression turned the village of
        the internet into a city, which expanded at time-
        lapse speed, social connections bristling like
        neurons in every direction. At ten, I was clicking

around a webring to check out other Angelfire sites full of animal GIFs and Smash Mouth trivia. At twelve, I was writing five hundred words a day on a public LiveJournal. At fifteen, I was uploading photos of myself in a miniskirt on Myspace. By twenty-five, my job was to write things that would attract, ideally, a hundred thousand strangers per post. Now I'm thirty, and most of my life is inextricable from the internet, and its mazes of incessant forced connection—this feverish, electric, unlivable hell.

The purpose of beautiful things is to be destroyed. This is why young people are closer to death than the old, why well-laid cities are always bombed, why history progresses by its bad side, and why revolutions fail.

Sam Kriss

Binge watching design. Niklas Göke asks how Netflix and YouTube are doing their hot-wiring magic on our brains. Netflix methodically A/B tests every screen, every picture and every word, down to the thumbnails. It tracks exactly by which episode we get hooked on shows. The company recently played with a feature that outright encourages binging by showing you how far you've gotten in a show. Technologically, Netflix consists of hundreds of micro-services that custom-tailor your video so it buffers as little as possible. Auto-play has become the default both there and on YouTube. These platforms study us like rats.

Online video turns out to be the ideal confession channel. Göke:

> This morning I checked how many hours I spent this week on YouTube, binge-watching doggies being saved, koalas being cute, American political news, plane crashes, music, celebrity news, motivational videos, the unicorn cult, vegan privilege videos. Yesterday I clocked 14 hours. I feared my nicotine addiction would be replaced by something else. And alas it happened. With great shame, I have to confess it turns out to be YouTube. I did feel I gave up on everything. It was so cozy, just sitting in my bed postponing everything, including getting a life.

The moment we sit down on the couch and start watching, we accept that none of the things we planned will ever happen. We don't need to "recharge." We need to escape from a more uncomfortable truth—we've become someone who accepts defeat rather than put up a fight. Binge-watching was the word of the year in 2015. It's such a widespread narcotic that it's become more socially accepted than smoking. In a study referring to binge-watching as the new normal, Netflix holds the mirror in our face, laughing: "76% of TV streamers say watching multiple episodes of a great TV show is a welcome refuge from their busy lives."

What complicates this problem is the fact that, like all things, binge-watching isn't entirely evil. It does have its benefits, like the ones we talked about earlier. The reason it's become such an uncontrollable beast for us is the role it takes in confirming this identity of resignation, the belief that we don't deserve more in life. Our adventurous days are over, we tell ourselves. We should just settle down and watch the adventures of others from our comfortable couch.

> The problem isn't that Netflix is addicting. It's that our lives aren't. I think I want to cut my internet cable from the router really. Anyways. Another day, another brick to save myself from this.

Silicon Eulogy. This is a lament for the dead, a tragic event that happened without anyone noticing: the passing of the élan vital of the virtual. The internet we were promised is no longer with us. The elusive force of the digital has dissipated before our eyes. This is the price we were willing to pay for its *Vollendung*. But do not expect any pensive poems here. We hardly noticed our willing suspension of disbelief and carried on, like zombies, until we noticed the death of all platforms.

What happens once we become disenchanted with our digital devices, apps, and platforms? It is not that we have obtained a supernatural force that makes all opaque, proprietary, and closed services suddenly transparent. Transparency may not be a mystical, post-political force to open the box. For decades, users have waited in vain for this technology to become ordinary, banal, dull. Yet the relentless manufacture of new models, services, apps—and the exhaustive iteration of existing ones—have thus far prevented this from happening. The never-ending production of coolness prevented the uprising of the youngsters against the establishment, until most of us had sunken so deep into the abyss that there was no way out.

English media scholar David Berry has proposed the concept of explainability.

> As a result of new forms of obscurity in the use of artificial intelligence, automated decision systems and machine learning systems, a new explanatory demand has resulted in a very fascinating constellation which we might understand as the social right to explanation.

Melancholy is the quicksand you sink into
when you can no longer believe in reality, and
no longer know what to look for in fiction nor
what to make it say. But it is also the sign of an
internal confrontation between the actual and
the potential, between what is and what is yet
to come.
        After Death

In *The Light that Failed: A Reckoning*, Ivan Krastev
and Stephen Holmes distinguish between two styles
of unmasking: "one in the service of Enlightenment
values and the other in the service of a cynical and
unprincipled abandonment of values." The authors are
aware this distinction is outdated. They remark that this
notion of tearing away of the mask "assumes a sharp
distinction between private motivations and public
justifications," and argue for a return of moral justifica-
tions in their fight against the cynical rule. They struggle
with the question of how to unmask liberal hypocrisy
while not switching to the illiberal side. But what if we
step outside of this political philosophy game altogether
and perceive the world as a game with variables between
radical openness and secrecy?

More on the network form. Sven Lütticken suggested
that I read Caroline Levine's *Forms*, in which an entire
chapter is devoted to the network-as-form. She considers
the altogether formless character of networks as "the
antithesis of form." Network aesthetics, those slick
scientific-looking visualizations, are enticing at first
glance. But the art lovers amongst us are instantly aware
of its trivial trash value. Levine notes that for some

theorists, it is the network's "resistance to form that
makes networks emancipatory—politically productive."
Networks have the "capacity to trouble and crack open
bounded totalities." Do networks have that quality of
invisible cohesion inside the cultural matrix?

For Levine, the network remains a discursive
construct of certain authors. We only speak of networks
as a web of interconnected textual references. Deleuze
states this and Latour says that; Greenblatt argues A
while Clifford contends B. Without drifting off into
vitalism we can state that networks are living entities.
One will find out about its dynamic nature soon enough
once maintenance has been withdrawn. Despite the
heroic language of networks being self-sustaining, auto-
nomous entities, when sys-ops disappear, the software
is no longer updated. Once roads are no longer kept up
and key maintenance personnel resign, things fall apart
very quickly indeed. This is why network visualization
has such a dark, morbid, obsessive side. A picture is the
ever-changing cluster of relations that needs to be taken
before the object disappears. In the meanwhile, it's good
to note that networks are snapshots of the real that defy
the claims of totality. In line with Adorno, we might say
the whole network is a lie.

Behind the Iron Curtain, dissident poets still produced
work with the certainty that their work would somehow
survive and be remembered. As Anne Boyer writes in
*A Handbook of Disappointed Fate*, this is no longer the
case. "Poetry, which was once itself a search engine,
exists in abundance now, as searchable as immaterial
as any other information." In line with Frances Yates,
Boyer notes that verse poetry once served a social func-
tion as memory structure and didactic aid. "Its songish-
ness was useful to memory." Alongside the rise of the
printing press, broadcast media, and the internet, we've
witnessed the collapse of the entire retention complex.
This condition was meticulously diagnosed by Bernard

Stiegler, and has reached a point where we cannot even recall our own address and telephone number. "Without the filter of prosperity," Boyer writes, "now a poet looks just as forgettable as everyone else. If poetry is revenge porn against the self by the self, so is, now, every other form of contemporary self-expression." What remains is the endless repetition of slogans, memes, icons, celebrities that appear like brands, like the author names that appear as part of an insurance claim, reduced to references in peer review journals.

What's the role of design in an age of chaos and complexity? What contribution does it make in times of economic crises and downturns? Is it the perfect tool to accelerate the collapse? This makes me wonder if design, as inherently speculative work, can only thrive when things are growing. Can we think against this tendency; can we design decline? We're not talking here about clever ways to promote zero growth. What does it mean to give shape to entropy? This is a Virilio meets Warhol question. Aesthetics of the incident. How can we design contradictions that become unlivable, surfacing the lie? Why be smooth and pleasurable when the mushroom cloud of crisis is erupting before our very eyes?

Complexification understood as the trade-off between stabilization and diversification, randomness and order, integration and variation, tantamount to the loss of the last vestiges of teleology.
Reza Negarestani

The desire for the deep against pleasures of the shallow.

Data, the raw material from which information is de-
rived, is being stored, copied, moved, and modified even
more easily than ever before. The data quantum leap
reaches levels outside of our imagination. Surrounded
by Internet of Things sensors, AI recommendation
systems, invisible algorithms, spreadsheets, and block-
chains, Bateson's "difference that makes a difference"
can no longer be identified.

We're facing a declining return on difference. With ever
more data—either good or bad—we don't gather new
insights. Peak data is ahead of us. Following the defini-
tion of peak oil, we can say that peak data is the moment
when the maximum rate of extractivism is reached and
the platform logic implodes. What happens next? A
steep decline sets in until systems and their users are
outside of the entropy danger zone. More data is not
going to turn into more information and better-informed
citizens, let alone critique. Once we reach peak data,
the presumption that better information = better deci-
sions can no longer be maintained. Meaningful units
no longer provide us with significant differences and
we are looking right into the abyss of bit rot. After the
peak, the degradation of data will grow exponentially
and databases will be compromised beyond repair. We
always knew that data never had intrinsic value. But
what happens when we can no longer gain a competitive
advantage from our data and the crisis of the "informed
decision" sets in? We've become increasingly aware that
data is manipulated, fuelled by subliminal behavioral
interventions and filtered through algorithms.

137

Much like the imperialist nineteenth century produced revolutionary nationalism, the globalist early twenty-first century is defined by regressive digitality.

As a result of current platform stagnation, indifference, cynicism, denial, boredom and disbelief are on the rise. We are caught in a turbulent whirlwind of dialectical forces and can no longer make a distinction between drastic techno-determinist forces (such as automation, AI, and 5G) and the collapse of human awareness. This leads to mass depression, refusal, and uprises driven by anger, fear, and resentment. In a good cybernetic tradition, the technical tipping point of peak data will be both attributed to AI's out of control army of (ro)bots and the rebel wisdom of a dissident intelligentsia that is both local and planetary.

This is not merely a problem of "overload" that can be solved with a periodic reset. In this context, Bartleby's dictum of "I would prefer not to" is the future. Reclaim time and space to decide. We have the right to refrain and do not need to be told to forget.

We are so terribly ill. Our ailment is enervating, though we are astir. It leaves us completely constricted, but perpetually frenzied and almost always restless. We do everything and go nowhere, do nothing and go everywhere.
RevoltingBodies

Let's return to David Riesman's *The Lonely Crowd*. Today's character can be described as a fusion reactor where inner and other-directed vectors collide. The resulting impact produces an endless chain of micro-interactions and massive amounts of data. This is our paradox: the inner-direction of a self that constantly relates to itself does not lead to solitary introspection, but to an ever-growing dependency on online others, "securing external behavioral conformity." The highly insecure self that constantly demands approval has taken stage. Inside out, outside in. What seemed to work as a sociological contrast in the victorious America of the late 1940s appears to social media users as a nostalgic comparison of historical phenotypes. In the age of accelerated dialectics, the role of "individual" engineers and entrepreneurs and "collective" bureaucrats and workers have emulsified. If only we could separate them again, like particles in a centrifuge. The other-directed type has not just been superseded by Lasch's narcissist personality. What we cannot come to terms with is the mass conformity of the unique individual. Social media symbolizes "Lonely Crowd 2.0," a decidedly busy form of loneliness. It is neo-feudalism, without the aristocratic class as ideal. Uneducated billionaires do not distinguish themselves through a sophisticated lifestyle, openly refusing to embody public values associated with enlightenment, high culture, ethics, and morals.

In retrospect, Bernard Stiegler's *The Age of Disruption: Technology and Madness in Computational Capitalism* reads like his last will and testament. Written three years before his untimely departure from this planet, the book is part personal biography and part summary of his key concepts, sprinkled throughout with dark foresight. It is marked by a deep form of despair that is driven by his spirit of non-submission. There's a belief here that Europe ought to reinvent the technology it has let drift away from it. Ergo, we should not conquer

the world but save it. The current cult of disruption can only lead to barbarism. On several occasions Bernard Stiegler called for a Cybernetics 2.0. The same sentiment was taken up by Felix Stalder, who posed a provocative question: "After 70 years of cybernetics, can we think of relationships, human and otherwise, that are not based on 'communication' or 'information exchange'?"

6

# Delete Your Profile, Not People

## Comments on Cancel Culture

"The best way to keep a prisoner
from escaping is to make sure
he never knows he's in prison."
Fyodor Dostoyevsky

"I do not identify as a boy or girl,
I identify as a nuisance, an irritant,
a fool, and a problem."
@Drilllknight (Simon (they/them))

"Guess who's getting X'ed? You made
a choice, that's your bad. I'll be honest,
we all liars. I'm pulled over and I got
priors. Guess who's going to jail tonight?"
Kayne West

"Den ich liebe alle die zu Grunde gehen."
after Nietzsche

The COVID-19 pandemic has stirred and heated, creating an optimal online breeding ground for "cancel culture," or the "removing of support for public figures in response to their objectionable behavior or opinions."[1] This buzzword emerges from the fusion of social media platforms, the celebrity news industry (previously known as "old media"), and the timeless urge of maturing communities to purify the ranks. Deviant members have to be expelled and sacrificed in order for the tribe to thrive. Once the dazzling machine comes to a stop, the induced shock creates a fresh wave of cancellation stories. This is bread and butter for the mainstream outlets, who survive by constantly trotting out a series of scandals. VIPs, stars, royals, and media personalities are provoked, show off their bad behavior, and are summarily condemned—only to reappear in the next cycle. Such scandals are neither exceptional nor a sign of crisis, but instead at the very core of a particular business model. If in the past, such unsavory characters had been "cancelled," there would be nothing to talk about.

Celebrities float above the masses. They are unconventional, outrageous, unique—modeling a lifestyle that is by definition not politically correct. In the old media model, the audience delegated (or better, outsourced) their own desires for excess to them. In this sense, they functioned as a proxy: it is through their extraordinary lifestyle that the norms of the ordinary life are defined and renegotiated. Until recently, celebrity role models (including intellectuals, writers, and actors), have performed in a fantasy world that both fascinates and disgusts ordinary folk, perpetuating the very notion of class, of masters and slaves. Is "deplatforming" going to fundamentally change the ways entertainment and distraction are organized?

What once started as a sign of discontent and debate inside communities spread via social media so quickly that it is now considered part of our digitally saturated culture.[2] In this platform age, "cancellation" means unfriending certain individuals, unfollowing particular companies, or boycotting specific products. "If you can't beat 'em,

1     www.merriam-webster.com/words-at-play/cancel-culture-words-were-watching.
2     For an introduction to cancelling see *ContraPoints*, January 2, 2020: *www.youtube.com/ watch?v=OjMPJVmXxV8* and Mark Fisher's classic 2013 text, "Exiting the Vampire Castle," *Open Democracy*, November 24, 2014, *www.opendemocracy.net/en/opendemocracyuk/exiting-vampire-castle/*. Fisher: "We must create conditions where disagreement can take place without fear of exclusion and excommunication."

ban 'em." It means terminating the communication once you've deemed their opinions, behavior, or comments to be objectionable. A breakup in the name of social justice. Staying true to the transactional nature of the word, it can be considered a total divestment. Once, reservations and credit cards were the objects of cancellation. Now, it is ordinary people. The social media deletion logic has spilled over into the real, with devastating consequences for activists and artists, causing a hysterical hype of witch hunt proportions in some circles. We need to make the distinction here between #MeToo/legitimate whistle blowing by abused women, versus a more "tokenistic" cancel culture trope in social media. While some rapists may have been convicted because of call-out culture, it is questionable if this would have happened without social media cancelling.

Fear that "cancel culture" may be here to stay has been demonstrated to us through its explanation of worthy goals, such as the need for open debate and disagreement, which tolerance is supposed to endanger.[3] In this accelerationist day and age, the paradox is that cancel culture can successfully shortcut discussion, consensus-building, and any sense of the public sphere.[4] Users respond with outrage in a split second—but before you know it, they've moved on. Dopamine-driven, impulsive users are known for their ignorance of the rules set by Habermas and cannot be bothered with the long hours it takes for a general assembly to reach consensus.

But the main fear around "cancel culture" often remains unspoken. The U.S. professional class is de facto locked-in and simply cannot think outside of the existing platform premises. They live haunted by a single question: "Will you still like me tomorrow?" Losing followers on Insta or Twitter means immediate loss of one's reputation, attention, and ultimately income. We're all influencers now. Less likes and retweets literally mean less money. This is the high price intellectuals and artists pay once they

---

3       See Alexander Beiner, "Sleeping Woke: Cancel Culture and Simulated Religion," *Medium*, July 17, 2020, *medium.com/rebel-wisdom/sleeping-woke-cancel-culture-and-simulated-religion-5f96af2cc107*.

4       "The way to defeat bad ideas is by exposure, argument, and persuasion, not by trying to silence or wish them away. We refuse any false choice between justice and freedom, which cannot exist without each other. As writers we need a culture that leaves us room for experimentation, risk taking, and even mistakes. We need to preserve the possibility of good-faith disagreement without dire professional consequences." Eliot Ackerman et al., "A Letter on Justice an Open Debate," *Harper's Bazar*, July 7, 2020, *harpers.org/a-letter-on-justice-and-open-debate/*.

have been sucked into the vortex and cannot see a way out. The Twitterati have zero imagination that a debate outside of social media channels is possible. In times of economic crisis, social media panic effectively leads to the closing of the American mind. There's no alternative, we're stuck on the platform.

Expulsion of individuals from the tribe or nation has always happened. So has destructive in-fighting inside decaying subcultures. It's not easy to stage the end of a movement (together). Aesthetics of disappearance sounds sophisticated, but the exit still hurts. What happens today, in the age of platform capitalism, is that millions of users are simultaneously presented with the same "outrageous" moralistic content. This rage-inducing material is selected by algorithms, who aim to provoke as much interaction (clicks, retweets, comments, likes) as possible, in order to keep us on the same service for as long as possible. In the age of social media, users are "paying" (with) attention. A "cancellation" can reach a critical mass within hours. This is the unpredictable part. It is a sign of protest from users when they wish to "delete" evil characters, but in the logic of the entertainment industry this is simply not possible. America loves a comeback. And in the digital age, your past can come back to haunt you anytime. At the moment, it is uncertain whose logic will win. Will it be "decentral-ized" social media and their supposedly clean algorithms or the "yellow press" methods of traditional publishing? If we look at current "cancel culture" examples, a hybrid picture emerges that blends the worst of both worlds. Print media feeds off social media and vice versa.

The "cancel culture" meme can also be read as an amputated, passive-aggressive version of what is known in geek culture as up or down voting. This is a part of internet culture that originated in forums that existed before the World Wide Web. The branding logic of platforms forbids the implementation of the downvoting principle, high-lighting the fact that they are not neutral. Social media in its current form is dominated by large marketing firms that organize brand campaigns, from politicians to pop stars and influencers. This global management class despises all things negative. They are not hired to organize, critique, and debate but to generate clicks and money. As we all know, we still do not have "dislike" buttons. Users are not

allowed to vote: they can only delete the post or exit the platform. As Heather Marsh notes, the result is the user-as-reflector, an individual only able to "reflect" current power relations.[5]

Here we see the criminal side of "organized positivism" hitting the surface. As a result of mood suppression, today's "cancel culture" is a wild beast that seems to leap out of nowhere, provoking moral panic with the ruling media elites, whose interest it is to keep the "bad characters" on-stage. This was not supposed to happen. The atmosphere has to remain positive—at all costs. Geek culture may be sexist, and celebrities may be sentenced, pay a fine and even go to jail, but they will reappear soon enough. After the remorse has been extensively covered, the cycle can start again. The spectacles without consequences go on, never seriously addressing underlying problems such as discrimination, social inequality, or climate change. The real issues stay under the surface until—surprise surprise—they burst out onto the streets, provoked by seemingly random events (such as the murder of George Floyd, which could have been another murder, a week before or after).

In theory we could say that when we cancel, we unfollow (in this case, followers or friends) and delete data. At the same time, new information is exposed. The collective deletion act is perceived as surprisingly negative and destructive. It's seen as a symbolic way to say "No, thanks, I don't like you anymore, get out of my life." To unfollow someone quickly becomes a statement. Cancellation may be an implicit sign that users desire change, a gesture that they want to abandon ship and call off a symbolic connection to the figures that have been given power. But this viewpoint may be too voluntary. Using notions from the vanished mass psychology discipline, it would be better to emphasize the hysteria group-think aspect, in which individuals "dissolve" into one giant mass act of denunciation, receiving pleasure from the knee-jerk reactions of an online mob that is usually non-existent and invisible.

From a European materialist media theory perspective, cancellation is not an armchair replacement of "real"

5    Heather Marsh, *The Creation of Me, Them and Us: Must Read Books* ([Vancouver]: Mustread, 2020), p. 108.

protest but a software effect. Let's put the cultural analysis of the "mass morality" (Achille Mbembe), identity politics, and religious aspects of "woke" culture aside. What's important to emphasize here are the global implications of this culture as it is embedded in code (both on the level of the visible interface design, and the invisible algorithms and AI). If anything, "cancel culture" is an expression of the limited ways we have to express ourselves through dominant social media and in the world in general. My "Sad by Design" research emphasized the ways in which behavioral scientists are working for Silicon Valley platforms to produce human emotions such as sadness, anger, and depression.[6] The techno-induced distractions, depressions, and resentment have so far produced an extraordinary profit for companies such as Facebook and Google. The good news is that more and more of us are finding out how all of this works. Compared to 2016, the year of Brexit and Trump, our awareness is much greater. However, despite this growing recognition, not much has fundamentally changed since then. "Cancel culture," understood as a sudden mediated response of the social media masses, has itself become a meme.

There's no doubt that certain norms are prevalent in this context, associated with American "political correctness." However, we need to be careful here, because what we often end up witnessing is a toxic clash between two rival male cultures that fight over the dominance of a shrinking, regressive empire. On the one hand, there is the op-ed culture of liberal-conservative media. On the other hand, there are algorithms written by geeks who often have right-wing libertarian or even white supremacist mindsets. Sudden waves of public shaming are never spontaneous, but are instead launched by influencers and only "go viral" when they trigger already-existing values.

As Lisa Nakamura suggested, it may be better to transform the individual focus of cancellation into collective "cultural boycott" campaigns that clarify who is acting and what the political context is. Emotional terms such as "humiliation" do not mean much. What should count is evidence. Record or film companies can decide to no longer

6    The essay: *www.eurozine.com/sad-by-design/*. The book came out with Pluto Press (London) in 2019.

work with an artist. Consumers can stop buying their products or related merchandise. Politicians can be voted out. And most important, investigative journalism should more frequently lead to actual prosecution and legislation changes. The problem with all of this, of course, is that it rarely happens. Instead we get stagnation and frustration, resulting in widespread resentment and rage. The endless production of scandals without consequences are the main reason behind the rise of public online shaming.

Cancel culture in its current form is a form of protest without consequences that limits itself to passive-aggressive acts such as unfollowing, deletion and unfriending. These clouds of sentiment blow over quickly. In fact, they can even have reverse consequences. When we see fires all around, we should not be surprised that a "woke" anti-racism movement erupts alongside increasingly stricter immigration laws and structural violence, particularly within the education sector and labor market. How can we surface the real problems? Discriminatory algorithms and domestic violence against women are both invisible. It is the duty of activists and researchers to make power visible. However, we need to recognize that alongside physical violence (that could in theory be photographable), we're increasingly fighting against abstract violence (code, borders, and other forms of structural separation).

Let's look into four examples from the Netherlands.

# De School

Considered the most progressive Amsterdam nightclub, De School was often compared to the iconic Berghain in Berlin. More than just a club, De School also featured a cafe, restaurant, gym, and gallery, where we held numerous INC events during the daytime. De School had an image as a safe space for various marginalized groups, a place where everyone was free to be themselves.[7] That was, until the middle of 2020, when the club managers took a hesitant position in their support of one of the first local Black Lives Matter protests, causing various stories about

---

7       Briefly before the pandemic and the closure of De School, the Institute of Network Cultures published a longform by Maisa Imamović, set in the cloakroom of the club, where Maisa the PPI (Pseudo Party Intellectual) used to work, "Club-Wise, a Theory of Our Time," *Institute of Network Cultures*, February 4, 2020, networkcultures.org/longform/2020/02/04/club-wise-the-theory-of-our-time/.

the club to pop up on Instagram.[8] Testimonies spanned from discriminatory door policy against ethnic minorities to sexual assault by security guards, criticism of the largely-white staff, and experiences shared in the club's comment section. One of the most vocal groups were electronic music lovers, a core part of the club's community that nevertheless seemed to be most critical in calling out the institution. The club made various plays at redemption, from statements on their Instagram account to a live podcast[9] promising reforms in policy. None of these apologies seemed to work—if anything, they only increased the criticism they were receiving online. The local nightlife scene was fractured into two camps: the "come on, they're the most progressive club in the country, give them a break" camp, and the "we need to hold them accountable" camp. The new policies promised by management never came through because the club shut its doors in August 2020 due to financial pressures caused by the pandemic.[10]

For cultural theorist Theo Ploeg, the closure of De School marked the loss of his belief in the inclusive power of electronic dance music culture. For Ploeg, hatred breeds hatred. "People that founded one of the coolest and most inclusive clubs in the world were portrayed as apparent racists. Cancel culture at its worst."[11] Ploeg sees isolation along identity lines as one of the most significant forces neoliberalism has. "When people are isolated in groups, they are easier to control and manipulated to turn on each other." What needs to be further investigated here is how the formation of such isolating "groups" happens under the post-network condition of social media platforms. Which techno-social architectures create coalitions of affinity? As Ploeg concludes: "We should be aware of our differences and never allow the system to use them against us."

8        Malou Miedema, "Hoe De School een slagveld werd in de strijd tegen racisme in de nacht," *vpro.nl*, July 13, 2020, *3voor12.vpro.nl/artikelen/overzicht/2020/juli/Hoe-De-School-het-slagveld-werd-in-de-strijd-tegen-racisme.html.*

9        *www.youtube.com/watch?v=WYpucKOnZbM&t=1867s.*

10       Rumours circulate that the same organization is opening a new club with a different name, inside a former traffic underpass at Waterlooplein in Amsterdam where the TunFun kids playground was based.

11       Theo Ploeg, "La Haine, De School and Systematic Violence," *Stasis*, July 27, 2020, *studiohyperspace.net/stasismag/2020/07/25/la-haine-de-school-and-systemic-violence/.*

# Dekmantel

One of the Netherlands' most popular festivals in the electronic music scene that also organizes editions around the world with the implicit aim of exporting Dutch DJs and music producers overseas. In 2019, one of Dekmantel's artists publicly made a statement against them on Instagram.[12] The statement claimed that the festival was failing to book Latin American talent at its 2019 edition, despite hosting a festival in São Paulo as well as multiple events in South America. Facing the pressure, the festival management responded with a public apology, agreeing with the criticism and promising to program more artists from outside of the Netherlands.

# Red Light Radio

An online radio station and celebrated international music platform based in Amsterdam's Red Light District, operational from 2010 until 2020. In January 2019 one of its residents posted a critical Tweet about artworks exhibited in the RLR office that were unfriendly to sex workers.[13] After this everything escalated quickly. The resident and another person shared their experiences publicly on Twitter and Instagram and in an interview with *Mixmag*.[14] Most interesting was the fact that RLR did not appreciate that the criticism was online and public, rather than shared privately. When it was suggested the station could support sex workers more, given their location and name, they claimed to be "proudly apolitical" and argued that hashtags like #sexsworkiswork did not suit their brand. What followed was widespread ambivalence: current residents wavered on whether they would play there, and fans were unsure if they still wanted to listen to the station. The situation resolved itself when the station had to close down anyway because of new apartments being built.[15]

12      Henry Bruce-Jones, "Dekmantel Festival Criticized over Lack of Latin American Artist at 2019 Edition," *Fact*, January 24, 2019, *www.factmag.com/2019/01/24/dekmantel-festival-criticised/*.
13      Malou Miedema, "Toonaangevend radiostation Red Light Radio international in opspraak," *vpro.nl*, February 17, 2020, *3voor12.vpro.nl/update~3f9242b5-ea27-49b5-a3a1-ff2d1f4fe928~toonaangevend-radiostation-red-light-radio-internationaal-in-opspraak~.html*.
14      Patrick Hinton, "Red Light Radio Accused of Failing to Uphold Community Values," *Mixmag*, February 10, 2020, *mixmag.net/read/red-light-radio-amsterdam-accused-community-values-news*.
15      "Red Light Radio stopt met het maken van radio," *Het Parool*, May 8, 2020, *www.parool.nl/amsterdam/red-light-radio-stopt-met-het-maken-van-radio~b1920d5c/*.

# Julian Andeweg

Dutch contemporary artist and painter, who was widely celebrated in the art world. Andeweg was exposed as a notorious rapist in an elaborate investigative article in *NRC Handelsblad*, a Dutch liberal newspaper, spanning sixteen years of abuse.[16] Soon after the scandal came out the @call-outdutchartinstitutions Instagram account opened where more #MeToo cases in the Dutch art scene were published.[17] After the expose, Andeweg was cancelled by his gallery, museums, and other art-related institutions. Feeling the pressure to respond, the Hague art academy KABK, where Andeweg studied and numerous incidents happened, published an internal investigation, after which the board resigned.

Some months later, a member of the anti-woke KIRAC (Keeping It Real Art Critics) collective made a video clip with Andeweg, saying he should be "uncanceled" and welcomed back into the art world.[18] The tumult culminated during the screening of a similarly controversial KIRAC video called #Honeypot in October 2021 at De Balie (an Amsterdam cultural centre for public debates that has been involved in similar controversies before). What followed were Black feminists calling out white feminists to do something about KIRAC's depiction of the rapist on a white horse (yelling "Hail the king"), issuing calls on various social media platforms to take action—as this was happening in the "white" art world. The Wonda Collective, a feminist group, took it up on themselves to organize a protest in front of De Balie during the evening of the event, which was coordinated in a Telegram group, where participants were scanned through a personal phone call before being able to join. As the event proceeded, the group then organized a boycott of De Balie, stating the venue was supporting rape culture.[19]

16      Lucette ter Borg and Carola Houtekamer, "Hoe een kunstenaar carrière maakt onder aanhoudende beschuldigingen van aanranding en verkrachting," *NRC Handelsblad*, October, 30, 2020, *www.nrc.nl/nieuws/2020/10/30/hoe-een-kunstenaar-carriere-maakt-onder-aanhoudende-beschuldigingen-van-aanranding-en-verkrachting-a4018047?t=1636715740*.

17      Tessel ten Zweege wrote an article based on 72 anonymous testimonials of sexual misconduct posted on the Instagram account: "Calling Out Dutch Art Institutions," February 26, 2021, *futuress.org/magazine/calling-out-dutch-art-institutions/*.

18      *www.keepingitrealartcritics.com/wordpress/about/*. See also their Wikipedia entry: *en.wikipedia.org/wiki/Keeping_It_Real_Art_Critics*. The KIRAC controversy coincided with the release of their #Honeypot video about the call of a female leftist student to have sex with right-wing males to "overcome polarization in society" in which conservative philosopher Sid Lukkassen took up the offer but midway into the filming withdraws his consent.

19      *en.geenpodium.nl/*. "There was no sign of self-reflection or any discussion about sexual violence, which ideologies and values uphold rape culture and how we can break out rape culture."

Dutch culture seems especially adept at staging provocative controversies, claiming to be progressive while also proud to cross any border. Alina Lupu, writing about another 2020 scandal, argues that there's

> a clash between those progressive values and the concept of absolute freedom and autonomy of the artist. In the narrative of "absolute freedom and autonomy of the artist" he/she/they seem to be held above any sort of criticism, implying that the title of artist offers them the possibility to play with any and every concept under the sun, with little to no need to justify their approach, being at once in the world, and outside of any system of moral reference.[20]

While this eternal clash of values is playing itself out, social media seem to be located in an entirely different universe. The good vs evil drama is overruled by technological cynicism, steering herd mentality with cheap and fast "like" and "follow" choices that are swiped away, left or right, up and down. Despite all of that, the Social Media Question is not an irresolvable problem.[21] We can get rid of social media-driven cancel culture. Jaron Lanier's 2017 call to delete your social media accounts still holds.[22] What's to be done is to steer Europe's big data and artificial intelligence billions into creating a multitude of social media alternatives, built by multi-disciplinary teams, not just geeks.

As Sam Kriss indicates, shutting up is not a resolution, and this is not what I am proposing here as a possible way out. Kriss summarizes the current pop doctrine like this:

> Silence is no longer the source of creativity. Digital systems can't compute an absence; if you refuse to speak, you're complicit. Post more, feed us more, empty yourself into the internet—or you're a racist.[23]

20    Alina Lupu, "Call-Out Culture/Cancel Culture," *Platform BK*, February 23, 2021, *www.platformbk.nl/call-out-culture-cancel-culture-2/*. There's even a special publication, compiled by Platform BK, bringing together material around the Breda *Destroy My Face/We Are Not a Playground* case: *Call-Out Culture Reader 6: De controverse rond* Destroy My Face van Erik Kessels (Amsterdam: Platform BK, 2021), *www.platformbk.nl/reader-6-call-out-culture/*.
21    Reference to the irresovability chapter of Matthew Fuller and Olga Goriunova, *Bleak Joys* (University of Minesota Press, 2019), in which they discuss the works of Christa Wolf.
22    Jaron Lanier, *Ten Arguments for Deleting Your Social Media Accounts Right Now* (London: Vintage, 2018).
23    Sam Kriss, "Appeasing the Gods of Posting," *The Bellows*, June 25, 2020, *www.thebellows.org/appeasing-the-gods-of-posting/*.

This is what happens when an accelerated culture descends into the abyss. Speak up and you'll be unmasked. Remain silent and you're part of the problem. The internet is a vast opinion collider, with billions of highly charged, circulating ideology particles. In this context, a post can potentially cancel us all, spreading a climate of paranoia and uncertainty. "Nobody is irreplaceable. Everyone is disposable. Anyone can be sacrificed in an instant. Guilt or innocence are unimportant." This is what happens when community and common contexts have fallen apart. As Bernadette Corporation once noted,

> One must be a militant element of the planetary middle-class, a citizen really, not to see that it no longer exists, society. That it has imploded. That it is only a case for the terror of those who claim to re/present it.[24]

   24   bernadettecorporation.com/How%20to.pdf.

# 7
# Crypto-Art Annotations

"One character asks the other what he likes. The answer is money. 'I can't believe you like money too!' the first character says without irony, 'We should hang out!'"
Idiocracy/Daniel B. Markham

"My ultimate dream job is to trade labor for capital."
@333333333433333 (Darcie Wilder)

"Capitalism is when I'm sad."
K-Gorilla

"At least you can eat tulip bulbs."
DC Beastie Boy

"Not everything that is faced can be changed, but nothing can be changed until it is faced."
James Baldwin

"Central banks say you can't have digital cash and anonymity. We say we will, whether they like it or not."
Nym

"Never catch a falling knife"
general saying

"Which artist was the wealthiest in Renaissance Florence? Neri di Bicci. Second wealthiest? Andrea di Giusto Manzini. Heard of either of them?"

@hragv (Hrag Vartanian)

"They throw money at every problem, except poverty."

Redford Herrington

"Bitcoin does not seem to be a good coin."

@CryptoCorbain

"Goal is to capitalize on exploitable weaknesses."

OK

"My value proposition? Communism. Open for hire, consulting VCs, Hedge Funds, Think Tanks."

@nckhde (Nick Houde)

"If you have a problem, use blockchain. Now you have two problems and a right-libertarian fan club."

@aral (Aral Balkan)

"Money is a meme and now that memes are money we don't need money, we just need memes."

@punk4156

"If you don't get it, have fun being poor."

Bitcoin saying

When the Homer Pepe NFT sold for $223,000, Barry Threw cheered: "The art world is a software problem now." Let's return to the early 2021 crypto art wave. Here, newly created speculative "assets"[1] are financed with lavish amounts of "funny money," superfluous cash that is spent on even more speculative ventures. The choice of the young crypto-millionaires not to stash their profits away in investment funds or real estate is the most likely explanation for the Non-Fungible Token (NFT) boom.[2] In line with 1990s start-up values, the newly acquired wealth should not be invested in fine art paintings or laudable charities, but continue to circulate inside the tech scene itself. The only aim of the virtual is to further expand the virtual: a boom that fuels the next boom. What else should one purchase after the Miami condo and the Lambo? It's easy, *épater les bourgeois*: refuse to be patrons. Unlike colonial and carbon money, the IT rich are not interested in living forever and becoming esteemed supporters of avant-garde fine arts, architecture, or classical music. The surprising twist here is their sudden interest in digital arts.

David Gerard explains how the hype, commonly known as Web3, started:

> Tell artists there's a gusher of free money! They need to buy into crypto to get the gusher of free money. They become crypto advocates and make excuses for proof-of-work. Few artists really are making life-changing money from this! You probably won't be one of them.[3]

As Brett Scott explains, crypto-hype promises artists they are destined for market greatness. But such hype, driven by males, can only take off if everyone buys into it.

> Far from saving you from bullshit jobs, trading is a bullshit job, and the only way to temporarily win at it is not to throw yourself into battle against "the market." It's to collaborate in swarms.[4]

1    As Finn Brunton describes it, "it is a project of making the future into an object of knowledge." In: *Digital Cash* (Princeton: Princeton University Press, 2019), p. 12.
2    Read about the possible collapse scenarios for crypto art hype here: Twitter thread started by @DCLBlogger (Matty) February 27, 2021, *twitter.com/DCLBlogger/status/1365651253422776321*. Market data can be found here: *cryptoart.io/data*.
3    David Gerard, "Attack of the 50 Foot Blockchain," March 11, 2021, *davidgerard.co.uk/blockchain/2021/03/11/nfts-crypto-grifters-try-to-scam-artists-again/*.
4    Brett Scott, "The Real Lesson of the GameStop Story is the Power of the Swarm," *The Guardian*, January 30, 2021, *www.theguardian.com/commentisfree/2021/jan/30/gamestop-power-of-the-swarm-shares-traders*.

The moment the hype takes off is the ultimate reward for the struggling pioneer. As Chelsea Summers quips:

> There is nothing as sweet as professional vindication after years of people rejecting your work, underestimating your value, and generally dismissing you. And by you I mean me. And by professional vindication I mean money.[5]

Take Hashmasks and Cryptopunk, fixed number storage places that make it easy to buy, sell, and compare similar images ("collectables"). Here the speculative game is most obvious. The top ten images sold on Cryptopunk during the February–April 2021 hype period were priced between $1.46 and $7.57 million, proving Mazzucato's thesis that value had become subjective.[6] It is telling that online details about the transactions fail to mention a description of the works, let alone their aesthetics, reducing the artworks to numbers such as #7804 or #3396. While "famous" NFT artworks may be handpicked by Sotheby's experts, gallerists, critics, and curators, it is not (yet) clear where buyers can go to resell such works. While the details are lacking, the overall logic is clear: artworks are stored value, that value is expected to rise, and these staggering prices will continue to be designated in fiat currency. While BTC or ETH may rise and fall and the blockchain could vanish altogether, the scheme assumes this will never happen and that these "rare" digital artworks will keep their value.

"Art history will be seen as before and after NFTs," says @Hans2024. What is art at the crossroads of the game, VR, bitcoin and social media experience? For some there is an element of magic in buying a piece of "rare art." For others, like Sybil Prentice, NFTs have a garage sale vibe: leftovers of an accelerated online life in which image production and consumption happens at a relentless pace.[7] Yet whether positive or negative, it's clear that crypto art and non-fungible tokens alter the landscape of art. As Derek

5        Chelsea G. Summers, "Confessions of an Angry Middle-Aged Lady," *Oldster Magazine*, October 7, 2021, *oldster.substack.com/p/confessions-of-an-angry-middle-aged*.
6        According to Mariana Mazzucato, value became what consumers were prepared to pay. "All of a sudden, value was in the eye of the beholder. Any goods or services being sold at an agreed market price were by definition value-creating." *The Value of Everything: Making and Taking in the Global Economy* (New York: PublicAffairs, 2018), p. 7. A particular NFT may sell at auction for $100 or $100,000, both valuations are real.
7        @nightcoregirl (sybil prentice) April 18, 2021, *twitter.com/nightcoregirl/status/1383654340674547715*.

Schloss and Stephen McKeon state, "in a natively digital medium, art takes on a more expansive role, intersecting with virtual worlds, decentralized finance, and the social experience."[8] Before digging into the tale of NFTs, let's look at the broader narrative around blockchain, crypto, and the future of digital money.

# A Lab for Money

The MoneyLab network was founded by the Institute of Network Cultures in March 2014. Let's recap where we are six years later. Between then and mid 2021, we've held twelve international conferences. Seven were in-person affairs, four of those in Amsterdam and the others in London, Buffalo, and Siegen. Five were virtual encounters due to pandemic conditions, held in Ljubljana, Helsinki, Canberra/ Hobart, Berlin, and Wellington. The project has a blog and email list, hosts online debates, runs its own Discord server and has published three text collections. MoneyLab considers, critiques, and intervenes within fintech and the digital economy with a special focus on the arts. It is a network of artists, activists, and geeks experimenting with forms of financial democratization, exchanging and debating crowdfunding, cryptocurrencies and the blockchain, cashless society, and universal basic income.

Let's state the obvious: creative workers are in dire need of money, whatever form it takes. In a situation of rapidly growing inequality, the world cries out for the redistribution of wealth. But alongside living wages and justice, there are many reasons to be interested in finance, from aesthetics to ethics and politics. MoneyLab questions deeply held myths, from Calvinist austerity to infinite growth and "trustless automated decision-making." It challenges persistent beliefs, scrutinizing right-wing libertarianism, anarcho-capitalist dreams, and that special sauce of neoliberal entrepreneurialism. MoneyLab explores what is happening outside of global finance, hedge funds, and high-frequency trading, peering beyond the status quo and consensual reality. As an "organized network," MoneyLab demonstrates what roles art, activism, and critical research can play in

8    Derk Edws and Stephen McKeon, "You're Sleeping on Crypto Art," *Medium*, September 10, 2020, *medium.com/collab-currency/youre-sleeping-on-crypto-art-7df920ec038e.*

the redesign of money. The aim here is the democratization of finance, expanding the ecology of radical alternatives in fintech, with a special focus on feminist economics, social payments, corporate crime, and crypto.

If crypto and blockchain are supposed to be at the core of a new decentralized economy, then why are they so absent from platform discourse? Maybe it's simply too early to know if there will be a synthesis between the platform economy and current experiments with crypto and tokens. Yet so far at least, the platform economy is not supposed to have its own finance system. While most platforms are modeled around deals and transactions, this is mostly done in fiat currencies, using the traditional payment systems of banks and credit cards giants. Companies such as Adyen, PayPal, WePay, Venmo, and Worldpay are specialists in smoothing smartphone and online payments.

So why aren't platforms associated with crypto transactions? We can only guess about possible reasons. Fueled by venture capital, the prime directive of platforms is hypergrowth, aiming towards monopoly status. This makes fast, frictionless payment systems in fiat currencies a prerequisite. Platforms are not interested in speculative currency experiments, but are instead financially conservative. While crypto may be associated with utopian/dystopian goals, using their services for actual payments is still cumbersome and often expensive, to say the least. Seen from the opposite side, platforms are anything but decentralized and do not subscribe to ideals such as decentralization. The reality is that the two cultures diverge. There is no integration on the horizon. While the monetization of online services is still on the rise, there's no similar synergy happening in regards to the integration of crypto-at-large.

## Mainstream Crypto, Dark Crypto

It may be good to quickly refer here to the Libra saga, the dominant theme just before the pandemic. This centered around Facebook's (aborted) launch of Libra, a proposal to create their own cryptocurrency for Facebook, WhatsApp, and Instagram. Libra may have failed for now, but the payments and income are vital for billions. Imagine you could be paid directly, peer-to-peer, for your artworks. What would Silicon Valley's copycat of China's WeChat Pay and Alipay

be, given the hegemony of Instagram in the art world? From micropayments to data trading and the normalization of subscription models (e.g. Netflix and other on-demand video services), new money systems are becoming mainstream overnight. With Libra, the whispers of a possible financialization of social media reached mainstream audiences for the first time. What are the implications of the convergence of personal social media data and money transaction systems? Many expressed ambivalent feelings: while it is urgent to create income streams for internet creators beyond the influencer model, the financialization of everyday life was deemed a step too far, if not a straight nightmare.

Putting naive start-up dreams of alternative finance aside, the real avant-garde of online payments can be found in the online porn industry, "pump and dump" schemes, and cybercrime. Wallet theft has emulated and overtaken classic bank robbery. A good decade into the story of fintech there's still a lot of speculation—both in terms of money and concepts—and not a lot of actual use cases. Is this about to change? The tragic move from the stage of tokenization and defi (decentralized finance) is yet another example of how to not go ahead. We need to ask how the elusiveness of cryptocurrencies is used to launder money, and what can be learned from these tactics?

These have been dark times for the economy all along. Offshore finance wreaks havoc in the very fabric of cities and communities. Crypto companies scour the world in search of new tax-havens. Information leaks from financial paradises made it clear that the wealthy, influential, and well-connected will still escape taxation. These are the same people turning places like Malta and the Bahamas into luxury apartment zones, while well-documented Dutch fiscal loopholes cost the world approximately €22 billion in lost taxes each year. Corporations like Shell tempt governments with scraps of their ill-gained revenues in exchange for legal residence in anonymous letterboxes. Global business and crypto-speculation have forced national regulations to stoop to the logic of the international tax marketplace, where the lowest bidder wins. In the face of rampant offshoring and privatization, local economies and communities struggle to thrive, often succumbing to a precarious freelance existence in the gig economy.

# Crypto for Good

Can we use crypto for more than just speculation and financialization? MoneyLab #8 was hosted in Ljubljana, our first in a post-socialist country, and featured examples far from the mainstream media spotlight. It zoomed in on the effects of offshore finance and explored counter-experiments in the realms of housing, care work, and blockchain technology.

At the cultural fringes, interesting debates are happening. Blockchain is no longer just another tool for capitalist growth obsessions. People are realizing radical visions for fairly-waged care work, redistributed wealth, equitable social relations, and strong grassroots communities. In our world of vanishing cash, corner-cutting multinationals, and weakened social support structures, can community currencies or self-organized care networks strengthen neighborhoods? Can there be tokens for the people, climate neutral NFTs or Distributed Autonomous Organizations for the good? What would fair and social housing look like if it was turned into the cornerstone of the economy? Who is building local systems that can stand up against the financialization of housing in the global platform economy? What are alternative strategies for self-organization, and how might these push toward radical new futures situated in resilient local communities? These are MoneyLab questions.

Beyond the cryptocurrency hype of the last decade, the underlying principles and technologies known as the blockchain have now become widely dispersed. From health to academic research, energy to governance, copyright law to fine art, companies and organizations across various social fields are exploring the blockchain. Unleashed from its niche origins in cryptography and electronic currency, the blockchain is now held up as the solution for every problem. Sustainable energy? Blockchain! Higher quality research? Blockchain! Fairer globalization? Blockchain! But just as important as its ubiquity is its perceived maturity. No longer the risky venture of the startup or the experimental tinkering of cypherpunks, blockchains are quickly becoming an IT backbone solution for large corporations and institutions. Blockchain technology has also found its way into civil society, grassroots initiatives, NGOs, and art institutions. In this domain there are clear tensions. "Trustless" transactions—secure, anon-

ymous, running on corrupt cryptocurrencies—quickly make any utopian initiative look like a rather shady affair.

MoneyLab started early with the Bitcoin debate and the community still has a keen interest in steering alternative blockchain or distributed ledger topic developments. Now that governments and banks have lost their ability to dictate what money is, there's a small window of opportunity to democratize its design. NFTs have been a good vehicle to bring these issues into the art context. Who isn't mesmerized by the alchemy of digital money? You, Doctor Faustus, summoned a demon out of thin air, magically making code work for you, digging the digital gold out the network. MoneyLab would be the last to take the moral high ground and condemn the criminal energy that defines the alt-fin era.[9] With Venkatesh Rao we state our demand: premium mediocre mansions for all!

# The Question of Money

What is money? What should it be? As crypto fantasies overflow with the same old biases, we want to put the question of money back on the table. Defining the architecture of money and payment systems cannot be left to libertarian male geeks that dream of autarky. With feminist economists and other irregulars, MoneyLab imagines, for instance, a crypto economy that values care work and focuses on equity and solidarity. Fueled by feminist theory and aimed at decolonizing existing power structures in the economy, MoneyLab looks at promising design strategies to counter the corporatization of digital money, from hyperlocal cryptocurrencies at techno festivals, to the "SheDAO" and self-organized exchange systems in refugee communities. The question remains: can technology be used critically to support cooperation and commoning in a world that is dominated by individualism and competition?

In this capital-centric system, time and time again the observation has been made that capital no longer matters. It is absent, lame, invisible. There is no capital without

---

9      Mainstream economists have gone beyond good and evil to describe "value creation" of the financial sector by all means. "By all means available we mean innovation, obstruction, undercutting, impairing, damaging, vandalizing and cheating—generally within the letter but not in the spirit of the law, and sometimes beyond the limits of the law altogether." In: Anastasia Nesvetailova & Ronen Palan, *Sabotage: The Business of Finance* (London: Allen Lane, 2020), p. 16. Both gift and labour-centred value theories resist the nihilist randomness of today's (crypto) valuation cult.

investment, workshops, factories. Many have noted a general strike of capital, refusing to invest in infrastructure and regional production, no longer creating "real" jobs, pushing the workforce into precarious conditions. Instead, capital invests in—or should we say mutates into—finance. Money generates more money. This is why (to say it with Horkheimer) anyone who wants to criticize capitalism without talking about finance should remain silent. Rudolf Hilferding's *Das Finanzkapital* has been described as the fourth volume of Karl Marx' *Das Kapital*. But that came out in 1910! Since then, no major Marxist-inspired finance theory has been published. While Marxist debates over the past decades certainly touched on the topic, their main concern circled around "value," not finance. For a century we've been waiting, in vain, for the fifth volume. In this meanwhile "financialization" has only further grown with "quantitative easing" becoming the official religion of both central banks and the financial sector.

The ascendancy of finance means that engaging with it is key. While the rise of derivatives, stock options, and collateral finance in the 1980s and 1990s coincided with the rise of PCs and computer networks, the post 2008 boom in crypto experiments has thrived off ubiquitous internet bandwidth, cheap hardware, and unlimited datacenter capacity. Given these conditions, MoneyLab is an exercise in "occupying" the space of financial abstractions. While the 2011 Occupy movement dealt with the devastating past policies of austerity, expulsions and accumulated debt, MoneyLab focuses on the critique of empty crypto-futures, aiming instead to create tools and policies to redistribute wealth.

# Crypto Art

We can define crypto art as rare digital artworks, published onto a blockchain, in the form of non-fungible tokens. Crypto art is not just any image, but comes with a distinct style, a particular aesthetic that goes with the territory. Let's therefore study the aesthetics of the pioneers back in 2014. The common cultural references here are not New York's *Artforum* or Berlin's *Texte zur Kunst* but the online pop culture of imageboards: memes, anime, Pokémon cards, and the like. Jerry Saltz:

> Most NFT so far is either Warhol Pop-y; Surreal-
> ism redux; animated cartoon-y; faux-Japanese
> Anime; boring Ab-Ex abstraction; logo swirling
> around commercial; cute/scary gif; glitzy screen-
> saver; late Neo-conceptual NFT about NFT-ism.
> All Of those are NFT Zombie Formalism.[10]

In short, what's striking is the overall retrograde style, as
if we're stuck in a loop, forever repeating *Groundhog Day*.
The settings are copy-pasted from American science-fiction
films and comic books and projected into today's games
environment.

   NFTs are based on the assumption that scarcity is a
good thing that needs to be reintroduced. Scarcity creates
the possibility of value skyrocketing and speculation,
which may in turn attract investors. The fatal destiny of
the artwork is to become unique. Ours is an anti-Benjamin
moment when digital art in the age of technical reproduc-
tion makes its big leap back into the eighteenth century.
At the same time we need to remind ourselves that
"decentralized finance" is an alternative reality, driven by
libertarian principles, fed by a temporary abundance of
specific free money and a religious belief in technology
that will save humankind. Digital reproduction and "pira-
cy" are no longer the default. Those who disagree with this
premise would need to become hackers (again), cracking
the code in order to enjoy the artwork. Is this the only way
of making a living, to become "rare" again?

   Back to the screen; @lunar_mining's tweets are re-
freshing. "I love stormy days when the market is dumping.
Feels healthy and cathartic—as natural as the seasons."
I contacted @lunar_mining because of a critical tweet:

> NFTs =! digital art. NFTs replicate the me-
> chanics of the art marketplace, but I've yet to
> see an NFT with meaning or soul or abyssal
> depth. There's an emptiness to NFT trading,
> a nihilism: it is a marketplace without ideas.

The person behind the address is the artist and former
Coindesk editor Rachel-Rose O'Leary. I asked her opinion

10   Jerry Saltz (@jerrysaltz), April 5, 2021, *twitter.com/jerrysaltz/status/1379056028969488390*.

about crypto art. Rachel-Rose:

> There's a low-level boyish signaling out there but also some nuance that is emerging. For example, you can see the early stages of meme culture fusing with collectibles, which is potentially a powerful combination.

For Rose, art ended with Sol LeWitt, who said that the idea becomes the machine that makes the art. This realization contains the key to art's exit from itself. Crypto is an idea turned into a machine. It is the crystallization of ideas into architecture. By binding narrative to a machine, crypto has the potential not simply to describe the world, but to actively shape reality.

> In a world of unprecedented political urgency, contemporary art has retreated into subjective delusions. In contrast, crypto offers a powerful regenerative vision. That's why I'm expending my energy here rather than the art world.

She observes a hollowing out of culture in general.

> Art on the art market shares the same over-priced, pop-culture feel as the current NFT market, related to a declining culture industry and the behavior of markets than NFTs or crypto culture itself.

Is the essence of art that it should appeal to (crypto)investors? "NFT platforms aren't competing with the auction house or gallery—they're competing with Patreon," tweets Tina Rivers Ryan. Are these patrons the medieval cardinals of today? Here we see how the perverse logic of the art market can become internalized into the mind of the artist. According to Robert Saint Rich,

> the influence of social media has created a perspective in artists that they need to produce masterful quality works in a large enough quantity so that they can be shared on an almost daily basis. This is an impossible standard that forces artists to create uninspired work.[11]

167      11      *twitter.com/fatherrich_/status/1343000927448535043.*

Artists create banal artwork for banal tastes, hoping to give their pieces popular appeal. But paradoxically, the aim of investors was never to collect art pieces. The crypto art system is a financial system, putting creators into peer-to-peer contact with the nouveau riche of today: the crypto millionaires. While we may critique this situation, it cannot be undone. A return to "normal" is no longer on the cards. This is a digital world; we've passed the point of "newness." Crypto art belongs to that moment in the history of contemporary arts when both painting and conceptual art forms are both becoming impossible.

# Where's the Art?

Let's define what we encounter here as "admin art" that solely exists on a ledger. These are meta-tagged images defined by their desire to become a record, to obtain a times-tamp, to embody a digital unit of value. The value is in-scribed inside the work, readable by machines. Crypto art is retrograde in that it wants to put the genie back in the bottle and create digital originals. Its innovation claims to fix past structural mistakes. What it shares with the avant-garde is its initial unacceptability. The discontent of crypto arts lies in the perverse obsession to get onto the ledger.

Admin art is what art becomes when it is defined by geeks. These geeks dress up as notaries and play-act at being lawyers, fastidiously policing "authenticity records." At the center of all this is the notion of ownership and the prom-ise of being "securely stored on the blockchain."[12] How is an artwork purchased and ownership transferred? First you need to setup a digital wallet on a smartphone and purchase some cryptocurrency (Ethereum in the case of crypto art). Then we visit the website with the art pieces. The interface is structured in typical fashion, with "top sellers" and "top buyers" conforming to the established "most viewed" influ-encer logic. We then have recently added works, followed by a section where you can "explore" the cheapest or highest priced NFTs. As in the case with any platform these days, the user design is profile-centric. Only after creating a pro-

12    More on the ownership question here: "What it means to own an artwork governed by an NFT is not some settled fact." Michael Connor, "Another New World," *Rhizome*, March 3, 2021, *rhizome. org/editorial/2021/mar/03/another-new-world/*.

file one is able to purchase and "mint" an artwork. Either there will be an instant sale price or one set by an auction.

Ownership of this virtual object depends on a chain of institutions or intermediaries, a dependency that is right in your face yet somehow remains unmentioned. The most obvious, of course, is your connectivity to the internet. But alongside this, there is a stack of necessities, from cloud services to browsers, operating systems, the Ethereum currency, the blockchain, the wallet, and platforms like OpenSea and Foundation, each with their own layers of services, networks, and transaction fees. So where exactly, in this soup of platforms and protocols, is the token ID?

If the production and distribution costs of digital art works tend toward zero, what does it feel like to produce worthless works? What are the mental costs, the "creative deficit" if one can freely copy-paste, steal motifs, and quote without consequences? While some celebrate the infinite amount of possible combinations, others lament the culture of indifference this entails. This culture is driven by the promise of opportunity, the excitement of being in on the game. We're on the payment train. Instead of underground aesthetics that need to be experienced first-hand, the focus of the artistic endeavor has shifted to storing value.

So the excitement for crypto art is fed by an unspoken desire to disrupt the old Silicon Valley order and its outdated obsession with free things and free ideas. However, what remains is the central role of the market, which is run by a handful of platforms and managed by curators. Jargon like "hotbids" and "drops" seem to come from nowhere. This is by no means a move away from post-digital art (or post-internet art values, for that matter). Crypto art is material as hell. It cannot exist outside of data centers, undersea cables, servers, wallets and the handheld devices of its traders. A substantial amount of crypto artists draw on paper. The maker's ideology and practice is never far away.

In the debates, NFTs claim to be possible sources of income that fight mass precarity amongst artists and creative workers. Selling crypto art as unique works (or in limited series) is claimed to be an additional income stream for most producers. The demand of a Universal Basic Income will remain in place though. Highflying artist Beeple is the exception to the rule. Overinflated prices merely say something about the Tulipomania state of crypto, the wealthy that need

to stash their money somewhere. Marketplaces for crypto art are, all too often, ways to temporarily store "funny money" elsewhere. What's prevented at all times is a sustainable financial solution. The ideology of speculative cryptocurrency hoarding[13] and the demand of artists for a living wage are inherently incompatible.

# From Cold Retromania to Creatively Weird

Ledger technologies are, at their core, boring, administrative procedures. There is no artistic potential in them, other than the "art and money" engagement described by Max Haiven in his *Art after Money* book, which plays around with concepts such as the gift, exchange value, and symbolic exchange. The blockchain is, in essence, a follow-up to the excel sheet. There's no Excel Art—and for that the world can be thankful. We suffer enough from the bookkeeper logic.

How many millions have been killed as a result of some cold spreadsheet calculation?

This is a question that, surprisingly, can unite the contemporary and crypto art worlds. The opportunity here is to be able to ignore, personally and collectively, the harsh selection mechanisms that are required in the first place. Without a rigid, closed, and interconnected culture of critics, curators, gallery owners, and museum directors, the real speculation cannot take off.

We should challenge the genre to become even more weird in a contemporary fashion and seek a dialogue with today's alienated condition of the platform billions. Crypto art is marked by an unreconstructed desire to return to a revolutionary period, before Thatcher and Reagan, when psychedelics were still possible doors of perception to overcome the narrow boundaries of the narcissistic Self. Rather than awarding this retromania, we should instead begin a fundamental makeover of the crypto-social imagination, one aimed at confronting our messy present. It's easier to drift off and time travel back to Ancient Mesa, Russalka, or Jakku than it is to radically rethink contemporary places such as Niamey, Karachi, or Osaka. It is lazy to define your basic aesthetics on work done by others. But there are also other ways of seeing.

13    Julius Mansa, "Hodl," *Investopedia*, December 18, 2021, *www.investopedia.com/terms/h/hodl.asp*.

During the pandemic's quarantines and lockdowns, countless hours were spent online. If crypto art has not benefited from that booming "attention economy," when will it? In order to make full use of the current situation, digital art needs to open up to a multiplicity of genres, schools, currents, aesthetics, and give them a distinct twist. Pull the virtual game worlds into our dusty urban wastelands and create real hybrids, not 2070 escape worlds. If crypto is so big and "disruptive," it should easily be able to shrug off the aesthetics of the past and create its own distinct style and visual language. Tell us how we should do crypto performances, dances, and dress up. Create an entirely singular style. It's not hard to leave behind the Pokémon card collectors. We can do it.

## Art of the Flip

The investor does not care about the art work itself. NFTs are bought with the sole reason to resell them. Investors track the growth of the artist's net worth, hoping to receive royalties each time a work flips. The difference with the traditional art market is that there are less intermediates and gatekeepers, fewer curators, critics, galleries, biennales, museums and auction houses. The market for crypto art is internalized and explicit. All romantic notions have been eliminated, replaced by a tightly integrated sales chain. According to curator and critic Domenico Quaranta, the NFT craze has been guided by interests,

> investment of wealthy crypto owners who wanted to demonstrate how certified digital scarcity can be crafted on the blockchain, and wanted to attract new crowds of creators and investors in the field; and the interested investment of auction houses, who wanted to open up a new market and attract huge amounts of cryptocurrency that could only be invested, so far, in other cryptocurrency and that can now be used to buy art and promote oneself as a visionary patron.[14]

The startup logic here is one that benefits early adopters,

14    Domenico Quaranta, "Code as Law: Contemporary Art and NFTs," *Digital Art, digitalart. kuenstlerinnenpreis.nrw/blog/code-as-law-contemporary-art-and-nfts*.

one not dissimilar from insider trading and similar venture capital tricks. Quaranta:

> The lucky ones are those who have been part of the crypto community for quite a while, who bought Ether when it was cheaper, who have connections in the field that are open to support them, bidding to launch the auction or to raise their quotations. This is why the NFT market has been often explained as a Ponzi scheme, where new investors are attracted—with promises that remain mostly unfulfilled—into the game in order to generate revenues for the early investors.

However, Quaranta's conclusion resonates with the Money-Lab consensus:

> Refusing to engage would probably be a bad choice, also considering the fact that this environment is very likely to be a test ground or a first prototype of what the internet would be, like it or not. Choosing the right mode to engage is key.

Geraldine Juárez expresses disgust about NFTs and why she is not interested in "technologies that leave people behind and make everything more difficult for everyone." She's tired of the "creepto" art scene's refusal to take things for what they actually are. NFT art would increase social inequality because it engages with a form of "financialized capitalism that emphasizes investment as a 'political technology' concerned with speculation more than with commodification." Digital artists, "situated at the bottom of the art market pyramid...are the lucky marginal customer selected by crypto-finance to justify the normalization of blockchain technologies and the deployment of the casino layer of the web." Net art is under pressure from all sides. Is this why so many digital artists willingly allow their work to be reduced to an "asset"?

Is crypto good for anything? Critics should be careful to repeat the obviously useless nature of the blockchain and instead attempt to understand the collective fascination with it. The irrational forces that drive the crypto bandwagon are not to be lightly pushed aside with

"rational" liberal arguments. Crypto may soon become a dominant twenty-first-century form of administration. To effectively oppose it, we need a radical software theory that is able to go to the core of this technology. Refusal and resistance should be based on autonomous intelligence gathering, not empty gestures.

# A Short History of Non-Payment

Let's take a step back, put good intentions aside and scroll back two decades to see why the original internet designs excluded the option of built-in payments. The pioneering work of David Chaum and his Amsterdam-based venture DigiCash, together with the cypherpunk movement, laid the groundwork for what was to become Bitcoin. Even then it was interesting to consider why there had been so little progress in the two decades of the IT revolution. If one wants to understand the orchestrated disinterest of the start-up class in digital money, crypto, and payment systems, look no further than Kevin Kelly's 1998 book, *New Rules for the New Economy.*

"The Net rewards generosity." With this phrase, Kelly summarizes what was expected online: to "share" your content. "The most valuable things of all should be those that are ubiquitous and free."[15] Read, comment, like, upload, share. The belief that "the free" would prevail can be considered the core of the 1990s dotcom orthodoxy. This core belief persisted, folded into the later premise of Web 2.0, and then social media platforms after that. The supposed "law" that the internet is bringing down costs lies at the core of this monetary blind spot. Add to this the inherent difficulties in processing credit card payments, and you start to understand how cyberspace-native currencies were deliberately kept beyond the tech horizon.

Kelly's underlying idea was that biological behavior would reign. "Biology has taken root in technology," he argued, resulting in self-regulating, self-optimizing processes. There is a "zillionic plentitude" and a desire for the return of scarcity was not at all anticipated. "Because prices move inexorably toward the free, the best move

15   Kevin Kelly, *New Rules for the New Economy* (London: Fourth Estate, 1998), p. 57.

in the network economy is to anticipate this cheapness." What comes after the disruptive period of the free is the great unknown. What we need to believe in is the dotcom dogma: "For maximum prosperity, feed the web first." In order to attain this lofty plateau, the economy should start behaving like a "biological community. War and battles were the allegories of the industrial economy. Coevolution and infections are more apt in the new economy." The belief was that the new organization would be flat, "spread out laterally, with nested cores, and swollen in the middle." In Kelly's utopia "companies will change shape more than they will change size." His electronic space encourages mid-size communities.

Kelly predicts that this new, highly technical economy, spanning the globe, will be one that "favors intangible things." The infrastructural turn embraced by later tech superstars such as Amazon, Airbnb, and Uber is completely overlooked here. Instead, it is seen as obvious that the virtual will come to dominate tangible goods and services. For Kelly, the end-game is clear: rather than messy digital/physical integration, we will see a total victory of those more enlightened elements, the immaterial and the spiritual. The lower castes will do the rest, we do not need to bother with the servants. In line with Barlow's 1996 "Declaration of the Independence of Cyberspace," bricks and mortar were supposed to be subdued by the power of invisible networks of "smart" objects and actors.

What do Kelly's vision in 1998 and crypto "wisdom" in 2021 share? Both have an unwavering belief in the inevitable victory of the automated machine. "No one can escape the transforming fire of machines," Kelly writes. Yet contrary to Kelly's predictions, the network is no longer the driving metaphor. Centralization has taken command. There has been no self-reinforcing success of the network. Swarms were merely tools to push aside the industrial economy while reinforcing the monopoly power of the digital rubber barons. Kelly's "future of business" asked us "to forget supply and demand." The irony is that this is precisely the Hayekian pillar of the crypto orthodoxy. NFTs are designed from the very beginning to be auctioned.

# New Money, New Models

Independent investigations are often the base of social movements. But it is not enough to critique this badly designed tech dreamed up by ignorant Western male engineers with zero environmental awareness. We need to understand how this technology came to attain its hype and sexiness. How did administrative procedures become so alluring that you can have heated debates with perfect strangers about it in a bar or on a bus? And we also need to talk about how to secure privacy-sensitive data in online databases and ledgers. Precisely which elements of the blockchain should be saved if we strip down the tech from its libertarian core?

Until Facebook's failed launch of Libra in 2019, crypto and social media platforms remained separate universes. "Snap and TikTok are great examples of next-gen alternatives to the current platform establishment but they still monetize in the same way as the incumbents," noted Ana Milicevic, "what new platforms may emerge if the main monetization engine shifts away from user attention into something new?"[16] We need new internet (aka social media) models in which peer-to-peer payments are an integral part. Communication should not be paid via ads and sales of user data. The attention economy as we know it has resulted in an army of influencers struggling to make a living. Most artists and designers are earning far less than a minimum wage, a situation that only became more acute during the pandemic. If the aim is to cancel the Silicon Valley "social contract" (data extraction in exchange for free services), we need another financial infrastructure underpinning digital services—with or without blockchain, Bitcoin, Ethereum tokens, or "proof of work."

We need to separate the technical possibility of generating and storing unique digital artworks from the question of price, currency, and method of payment. Causing an uproar, Akten showed that the current model of storing digital works of art on a blockchain is utterly unsustainable, calculating that the carbon footprint of an average single-edition NFT equals driving a car for 1,000 kilometers.[17] Art on the blockchain is only sustained by an abundance of subsidized data center capacity and cheap

16    pando.com/2020/06/29/trouble-platforms-google-amazon-facebook-apple-market-cap/.
17    See: github.com/memo/eco-nft.

internet bandwidth that somehow nobody seems to be paying for. Add to this the ever-growing computational/storage capacity on PCs, laptops, and smartphones at the receiving end and you get the infrastructural drive. As soon as one of these elements become scarce and expensive again, the whole blockchain scheme falls apart. In the near future, we should be able to safely store works ourselves offline and then verify them online. But we do not need this baroque 24/7 networked blockchain structure for that.

As it took decades to start to see derivatives as a social form, how do we value "the social" in an age of platforms? Can there be something like a collective form of value creation? Fully automated luxury communism is entirely possible. Mutual aid exists. Cooperation is real. What's urgent in this never-ending pandemic period, from the perspective of creative workers, is an easy-to-use payment system, based on public standards, not controlled by corporations (read: exchanges) that are peer-to-peer, with the least possible implicit intermediaries (no mandatory BTC or ETH and their "gas" fees). Crypto is now too much a goal in itself, ruled by an invisible "pump and dump" mob. After a decade of rampant speculation on the currency side it's time for a general switch to the user side. Rather than geeky males hoarding "digital gold" for the sake of it, we need to reconsider the real use value of crypto. Creative workers and artists urgently need revenue models so that they can focus on their own work.

And what about the gatekeepers? It is hypocritical to demand the dissolution of curators, galleries, and auction houses, while simultaneously introducing new technological gatekeepers, from the Winklevoss brothers and Elon Musk to Tether-backed investors. Douglas Rushkoff suggests that the elite NFTs function as micro social networks[18] and create their own "channels," "making so much revenue that they can call the shots, admitting or dismissing artists based on their revenue, making 'suggestions' about content or casting."[19] And Rushkoff concludes:

18      Nick Casares, "NFTs as Micro-Social Networks: The Path to Crypto Adoption," *Cointelegraph*, November 27, 2021, *cointelegraph.com/news/nfts-as-micro-social-networks-the-path-to-crypto-adoption* "NFTs are providing a glimpse into a new layer of social interaction. When framed as micro-social networks, NFTs could lead the way to a new form of social media based on creativity, ownership and contribution."

19      Douglas Rushkoff, "How NFTs Will Kill Netflix," *OneZero*, November 15, 2021, *onezero.medium.com/how-nfts-will-kill-netflix-62f9a3f03e87*.

"Oops, we're back where we started. Aggregation leads to disaggregation. Disaggregation leads to aggregation. Inhale. Exhale." We need to break this vicious cycle and insert radically different logics.

"Bitcoin is what you get when you'd rather see the world burn than trust another human being ever again," says Aral Balkan. Black box algorithms and right-wing libertarians are hegemonic givens here. Despite all the "democratic" promises, the crypto business is anything but decentralized and deeply dominated by racist right-wing techno-libertarians. This is out there, in the open, for everyone to see. Unless this is properly addressed, nothing will move on, certainly not in the art world. If the crypto community cannot discuss its own power, race and gender issues, then why bother? The world is not in need of more billionaires, but is instead crying out for a radical redistribution of wealth. Unless crypto starts to sabotage its own speculative dream machines, things will inevitably collapse.

8

# Principles of Stacktivism

"One of the last frontiers left for radical
gesture is the imagination."
David Wojnarowicz

"Don't be satisfied with stories
of how things have gone with
others. Unfold your own myth."
Rumi

"There is always room for the worst and that is why we must not lose hope."
Radu Aldulescu

Those that define internet standards shape our thinking and hold the key to our freedom of communication—no trivial task. Yet tech policy is seen as boring, a yawn-inducing issue offloaded to engineers, corporate lawyers, research universities, and government ministries. In the previous age of global internet governance, regulations and protocols were outsourced to technocrats (and a few "civil society" NGOs agitating on the margins). However, in this age of "techno sovereignty," where everything from 5G to TikTok is capable of causing geopolitical conflict, there is no more consensus. In short, we demand protocols, not platforms.[1] But who's going to get us there? Meet the stacktivists.[2]

Thirty years into the internet saga, we can state that stacktivism is the new hacktivism. We finally understood our Hegelian destiny to connect the dots. We have to face and embody the real existing Technological Totality. While still longing for a new suite of local technical tools, we also have to consider our technical condition at the planetary or even cosmic level. A first step to get there would be to envision a "conceptual" meta-techno activism that goes beyond the legal restraints of the law. If there ever was a planetary mission to reclaim ownership, it is to design a Public Stack, dismantle monopolies, fight both state and corporate surveillance censorship, and build infrastructures for all. A public service internet with public service media inside could be a good start.[3] That's the agenda, for now. This cannot be done without a deep understanding of what Hui calls cosmotechnics.[4] In this urgent infrastructural turn, we're making visible what's absent and articulating the invisible. This means taking into account an epistemology of the non-rational, as Hui calls it, a "dark forest" poetry that helps us to imagine a new nomos and takes us back from "platformation" to form.

1       See: Mike Masnick, "Protocols, Not Platforms: A Technological Approach to Free Speech," *Knight*, August 21, 2019, *knightcolumbia.org/content/protocols-not-platforms-a-technological-approach-to-free-speech*.
2       The term stacktivism was arguably first used for an unconference in London in 2013 and defined as "a term that attempts to give form to a critical conversation & line of enquiry (infra-spection?) around infrastructure," *stacktivism.com/unconference*.
3       More on this in the #PSMIManifesto: *bit.ly/psmmanifesto*. A Dutch example would be Public Spaces, initiated by a coalition of public broadcasters with the aim to build a new internet infrastructure, reclaiming the internet as a public domain (*publicspaces.net/english-section/*). Another one could be the Reclaim Your Face campaign: "Reclaim our public space. Ban biometric mass surveillance!" *reclaimyourface.eu/*.
4       Yuk Hui: "We must constantly ask what happens to our sensibilities when the sky is covered with drones and the earth with driverless cars, and exhibitions are curated by artificial intelligence and machine learning software. Is this futurism really something that speaks to us?" *Art and Cosmotechnics* (Minneapolis: e-flux, 2021), p. 214.

# The Stack

Benjamin Bratton's *The Stack* can be useful to bounce
ideas against when we want to define the state of the art
in technology, urbanism, design, and activism.[5] As is often
the case with today's speculative thinking—from accelera-
tionists to Reza Negarestani—Bratton's proposed scenarios
can go either way. The book stacks layers, one on top of the
other, starting with Earth as the foundation. The first layer
is occupied by Cloud, then City, Address, and Interface,
with the User on top. As Marc Tuters notes in a review of
the book,

> The Stack model is intended to include all
> technological systems as part of a singular
> planetary-scale computer, a kind of Spaceship
> Earth 2.0, updated to reflect the demands of
> the Anthropocene era.[6]

Grand designs such as *The Stack* can be read as a proposi-
tion to connect the dots[7] while also containing encrypted
insights for the few "careful readers."[8] What's the purpose
of obfuscated theories if not attracting groupies, creating
an avant-garde cult aka lifestyle sect that's only accessible
to initiated members who can decode the messages? Are
we dealing with meta-Marxism[9] here or a decidedly U.S.
globalist conspiracy theory that covers up its own interest
and techno-power in innocent universal terms? What
if the planetary dreaming is nothing but a "retropia," a
backwards-looking utopia that nostalgically wants to return
to the self-evident command enjoyed in the Clinton, Bush,
and Obama years? In the regressive, confused, and turbu-
lent times of Trump and Biden, no one seems to be sure
about U.S. world domination and its "protocolistic" hegem-
ony. Obscure language and behavior in the fields of politics

5        Benjamin Bratton, *The Stack* (Cambridge, MA: MIT Press, 2016). I would like to thank Pit
Schultz for the many conversations and email exchanges, with whom first notes for this essay were
made. Also thanks to Antonia Majaca and Ned Rossiter for the conversations and feedback, and Jack
Wilson for the copy-editing of the first version.
6        Benjamin H. Bratton, "The Stack: On Software and Sovereignty", *Computational Culture 6*
(November 2017), *computationalculture.net/scenario-theory-review-of-benjamin-h-bratton-the-stack-
on-software-and-sovereignty/*.
7        For example, Safiya Umoja Noble, "A Future for Intersectional Black Feminist Technology
Studies," *Scholar & Feminist Online* issue 13.3-14.1 (2016), *sfonline.barnard.edu/traversing-
technologies/safiya-umoja-noble-a-future-for-intersectional-black-feminist-technology-studies/*.
8        See Leo Strauss, *Persecution and the Art of Writing* (Chicago: The University of Chicago Press,
1952), p. 25.
9        Brent Cooper, "The Abstraction of Benjamin Bratton: Software, Sovereignty, and Designer
Sociology," August 19, 2017, *medium.com/the-abs-tract-organization/the-abstraction-of-benjamin-
bratton-756c647ab6ec*.

and aesthetics can be interpreted either as a courageous refusal to conform to the dominant retrograde discourses or be read as straight out evidence of the status quo.

Stacktivism is not Anti-Bratton (as in Friedrich Engels' *Anti-Dühring*), but rather non-Bratton as in non-fascist. Beyond good or evil, *The Stack* should be considered a worthy follow-up to Lev Manovich's 2001 book, *The Language of New Media*. Both are classics that are attached to, but not necessarily conceptualized and written at UC San Diego. And both are inspiring to disagree with. One can read *The Stack* as a Foucauldian toolkit that lifts out the useful parts, leaving the critique of Bratton's unreconstructed love for Carl Schmitt to others. It's easy to take apart Bratton's naive dream of "planetary computation" populated by sci-fi species-beings, while still enjoying the vast theory landscape he offers in this Magnum Opus.

# Grand Visions

Benjamin Bratton's role as Program Director of the Moscow-based Strelka Institute included grand visions such as *The Terraforming*, an education project that is purposely designed with unclarity as the main feature.[10] At Strelka, the hyper-speculative overdrive tactic is used to overrule the pressing political topics of our time, including the financing of the center itself by oligarchs and their alliances with the Kremlin. According to Wikipedia, the program deals with "long-term urban futures in relation to technological, geographic, and ecological complexities."[11] What we do not need is yet another Realpolitik or more violent globalist neoliberal consensus. Our crumbling world is in urgent need of new vocabularies and visions. There will be no return to the new normal. But what happens when grandiose vistas block our view of the real existing interest groups and ideologies that feed—and feed off— contemporary theory production? What kind of politics of abstraction are going on here? There's a fine line between empowerment through knowledge and techno-obfuscation of a planetary engineering class in the making.

10    *theterraforming.strelka.com/*.
11    *en.wikipedia.org/wiki/Strelka_Institute*.

Stacktivism starts and ends with the desire to reclaim the internet. To get there, we need to speak truth to power, to kick against platform realism. Bratton argues that we "have to build a politics capable of engagement with the full complexity of reality."[12] OK, but how much of this is ordinary dealmaking in some hotel conference room with Big Tech engineers and lobbyists, and how much is driven by open and inclusive forms of self-organization? Dealing with the technical and legal language of protocols and standards is a profoundly dirty and long-term business that is crying out for a new generation to take up the task. In this age of geopolitics, is it a lie or an act of liberation to call for a "deliberate plan for the coordination of the planet," as Bratton does? Who's speaking, in an era where political representation through nation states was supposedly ditched decades ago? Is there any legitimacy to speak on behalf of billions of users? What claim can a critical, oppositional, commons-driven movement make in such an instance?

What type of speculative thinking do we need in this disaster era of climate change, growing inequality, and real existing geopolitics? Where are the radical think tanks and collectives that go beyond the institutional limitations of scenario thinking? What's subversive and poetic weirdness today? This is a question for both Hui and Bratton. Do we really have to wade into the muddy waters of Heidegger and Schmitt in order to get anywhere? Can post-colonial and post-gender futurism possibly help us to liberate ourselves from the dark reactionary thought systems of the European twentieth century? What happens when all contingency planning of the past is shoved aside and institutional prediction industries are so easily unsettled by the intrusion of the unpredictable? In a turbulent world, where the administration of the present is delegated to the dazed and confused, ideology design is up for grabs. Let's refine the art of strategic forecasting in these times of collapse while not being naive about the collective power of "making worlds."

12    Benjamin Bratton, *The Revenge of the Real: Politics for a Post-pandemic World* (London: Verso, 2021), p. 9.

# Rereading and Misreading the Stack

Lately, "the stack"—once only a technical term used by engineers and geeks[13]—has jumped context and transformed into a general container concept, placing it in danger of becoming an empty signifier. As a meta-concept, the stack has been detached from its author and his Californian-nihilist program for the aspirational cool crowd and turned into a tool for bringing together interrelated crises: climate change, inequality, AI and automation, and COVID-19. In Bratton's world, you sign up for the program and carry the card, otherwise the entry sign points to exit. No affect, behavioural noise, or regional ambiguities please, we're performing Important Theory here. Perhaps this is a form of group therapy for the insecure? That's fine if you like the taste of testosterone in your milkshake.

Yet it's all too easy to unmask Bratton as a Californian techno-solutionist. How much is gained by planting this (now effectively empty) label on him? The grand spectacle of clashing egos should not distract us. In our hyperconnected world, we have too much of that anyway. To determine, to think technologically, remains of utmost urgency. It is precisely the "stacking" of issues, factors, and contexts that will bring us further into the constitutive force of technical systems.

This is the time to design one, two, three, indeed many stacks, and not to dismiss the ambitious efforts of others because, after all, where are the European antidotes to Bratton or Shoshana Zuboff? Europe tragically fails in the production of contemporary reference texts, both at the speculative and the critical level. While the late Bernard Stiegler comes to mind, a lot of translation work is still to be done in order to transform his philosophy of technology into workable programs decoupled from his often-obscure neologisms. Where, for instance, are the counter proposals to the blockchain? The Bratton Bible, written in the quasi-authoritarian voice of a Master Designer, can also be read from a grassroots perspective and should be praised for its multidisciplinary analysis of techno-social

---

13      See for instance *techterms.com/definition/stack*. A classic description of a stack can be found in the *Life After Google*, written by right-wing techno-evangelist George Gilder, who comes up with a "seven-layer model of a hierarchical stack in which lower functions are controlled by higher functions" (Washington DC: Regnery Gateway, 2018, p. 162) with a physical layer, the datalink, the network layer, internet protocols, a session layer and schemes for presentations and applications.

(power) practices. Why not be ambitious? There's a lot at stake. As a proposal, Bratton's reading of the stack should be compared to Dante's hell, Sloterdijk's spheres, Deleuze and Guattari's *Mille plateaux*, Hui's cosmotechnics, and Stiegler's *The Age of Disruption*. But instead of conducting hermeneutic exercises, the proposal here would be to transplant the term into the hacktivist context and define the principles of "stacktivism:" dancing stacks.[14] Project Gay Science: *die Verhältnisse zum Tanzen bringen!*

We can also read *The Stack* as a pedagogical framework within the Bauhaus tradition as a proposal for a general design principle. John Thackara has done just that, updating the Bauhaus foundation course for the age of global warming.[15] As an abstract model describing the architecture of the internet, the stack provides us with a useful spatial division of layers such as protocols, data, applications, and user interfaces. Bratton's notion of The Stack comes out of the U.S. postmodern literary tradition of cognitive mapping (Jameson), which seeks to make intelligible (and containable) complex processes. Bratton combines this approach with other forms of mapping. We might think, for instance, of the decade-long attempts to visualize the vertical integration of technologies, or classic network maps that aim to capture relations between different players. In a sense, he strives to transform 2D tech engineering plans into 3D models that provide a portrait of planetary transformation. His aim is to produce a general network theory able to provide deeper insights into the dynamics of power.

Bratton also invites us to think through technology in relation to geopolitics and location. In this sense, *The Stack* can function as a kind of method or approach. However, the book is purposefully vague about how material infrastructure and ideology relate. In the light of Trump, Putin, and Xi Jinping, Bratton's global engineer seems a tragic, retrograde figure. At best *The Stack* works well as a multidisciplinary guideline of past globalist techno-social prac-

14    This essay can be read as a continuation of the Media-Network-Platform chapter in my 2019 book *Sad by Design*, where I defined the vertically-thinking stacktivism as "infrastructural activism that is aware of multiple interconnected layers. This is hacktivism with a holistic awareness of the levels that exist above and below code" (p. 74).

15    John Thackara, "Re-wilding the Bauhaus: What Its Foundation Course Should Be Like Today," *thackara.com*, May 18, 2021, *thackara.com/notopic/what-should-a-bauhaus-foundation-course-be-like-today/*.

tices that, ironically, have become outdated since 2016, the year of its publication and the year of Brexit and Trump. For all its ambition to delineate the geopolitical contours of techno-operations at the planetary scale, the book resigns itself to an oddly depoliticized aesthetic imaginary.

# The Messy Totality of the Stack

How can we free up the stack concept from its current confinements and turn it into an improvised dance? Let's define stacktivism as an active and reflective reading of stacks-on-the-move. This definition is not afraid of the subject (formerly known as the user). And this definition involves action committed by confused, selfish, or messy players. This messiness provides space for grassroots interventions that refuse to accept the current configuration of "the stack" as a given. Such interventions flip the gun around, turning the Will to Totality of the engineering class and their financial backers against itself. In comparison with hacktivism and (tactical) media activism, stacktivism is indeed Hegelian in scope. It is confronting "das Ganze" and can be considered counter regressive as it takes into account the real-existing totality of today's interrelated tech-architectures, as opposed to the shrinking paranoid world of the online self that is in constant danger of collapse under the weight of its own self-image, surveillance, precarity, and depression.

Following Caroline Levine, we can state that the stack must be whole and complete, holding in unity the different parts, from protocols, interfaces, routers, cables, and antennas, to content and metatags.[16] The digital has brought on a seamless and subconscious unity of technics and life. A critical emphasis on the invisible technical wholeness helps us to fight naive and romantic gestures of resistance and face contemporary forms of abstract violence. Totality comes with closure, followed by enclosure. We need to be alert that any proposed power to unite comes with the capacity to imprison and expel. It is not an exaggeration to talk in public about (the possibility of) extermination. As Saskia Sassen explains, expulsions from

16    Caroline Levine, *Forms—Whole, Rhythm, Hierarchy, Network* (Princeton: Princeton University Press, 2017).

life projects and livelihoods, from membership, and from
the social contract at the center of liberal democracy, are
now a reality.[17] However, the stack as a unity of contra-
dictory, heterogeneous elements is never entirely closed.
Systems turn out to be unstable, temporary, and open,
not out of idealism but simply as a result of their flawed,
all-too-human design. This is a basic notion that can be
adapted from hacking and cyber warfare. Stacks may be
totalizing but are ultimately never total and have a consti-
tutive outside.

Niels ten Oever, Amsterdam-based internet govern-
ance researcher and activist, emphasizes the importance of
linking contexts and levels:

> The stack never was and never will be. The
> stack always was an abstraction, a story that
> was told to keep people working in an isolated
> manner, ensuring engineers stuck to their own
> layer. As long as you worked within your own
> parameters and delivered what the layer above
> and below you expected of you, you would
> not get into trouble. Stacktivism, on the other
> hand, works across the stack: it is a cross-
> stack collaboration, an attempt to realign and
> redesign the interfaces. Looking for inter-
> connections and associations that cannot be
> drawn from above, that defy standardization.
> Interconnections that escape abstractions
> and stereotypes. They are established through
> dynamic and unpredictable handshakes:
> questions, answers, and re(-)cognition.[18]

Stacktivism is ambivalent and struggles with totality, the
global scale, and the planetary whatever. "Think big but
act in small steps," that's the motto. We Are Infrastructure.
Stacktivism fights against the comfort of ignorance and
tries hard to overcome drifting-off-by-design, the tendency
to blissfully float above it all. While defining what stack-
tivism could become, it is good to keep in mind that we're
free to use Bratton's *The Stack* as a theory toolbox and not

17      Saskia Sassen, *Expulsions, Brutality and Complexity in the Global Economy* (Cambridge, MA:
Harvard University Press, 2014), p. 29.
18      Private email exchange, September 20, 2020. More on his work and PhD thesis here:
*nielstenoever.net/*.

interpret it as a hermetic belief system. Designs can inter-mingle. In line with Bratton, stacktivism claims to oversee all levels. It grasps the politics of code, algorithms, and AI. It is aware of the behavioral science manipulation of moods through careful interface design choices. It is alert to 5G electronic smog, phishing emails, fake news, and other sleazy suggestions from your "friends." How good are your bot detection skills? This hyperawareness comes at a high price. Not everyone is a stacktivist. ☹

## Stacktivism for the Good

Traditionally, direct action was placed in opposition to the gabfest. Acting = stop talking and start doing. In the con-text of hacktivism, this means that we stop consuming and start coding, hacking into systems to make real, tangible changes in society. Let's define what stacktivism-for-the-good could look like. Who is today's digital Robin Hood? How do we build rhizomatic links between global govern-ance, protocol design, the ethics-without-consequences industry, code writing, and investigative hacking? Who will be in charge of subversive foresight? Can we dream aloud together? How can we delegate trust to our think tanks that work in the public interest?

Stacktivism is a sovereign attitude. It is distinctly human but not frantically searching for a "correct" form of representation. In that sense it could be considered post-democratic and post-identity. Inside Douglas Rushkoff's *Team Human*, stacktivists take up the task of creating missing links: they are the meme producers, idea connec-tors, intercultural fellow travelers, and poly-disciplinary networkers. The social creation of new protocols remains an act of common decision. We are fighting at the concep-tual forefront of tech. Nobody needs to give us permission. Unlike the tactical media interventions of the 1990s, stacktivism is—by definition—abstract and conceptual in nature, recognizing that code is power and power is code. How to dismantle invisible power? Do we fight abstrac-tions with abstractions, design with counter-designs?

According to internet and civil society researcher Corinne Cath, we could see stacktivism as a playful human evolution of Bratton's concept of The Stack. It critiques its modular con-

ception of the world into discrete layers. To
remedy this flattening, it calls for the inclusion
of the inherent messiness of the Internet: the
entangled basement wires, packets lost in
translation, rugged governance cultures and
the idiosyncratic usages of the humans who
rely on it to function flawlessly.

Francesca Musiani states that
Decentralization often becomes a technical,
political, economic and social aim in and of
itself, reaching outside the "hacker" circles of
the early p2p systems. However, this has had
side effects. Decentralization has become an
objective in and of itself, with little understand-
ing of intent or assessment of actual effects.
I love Phil Agre's 2003 observation in this
respect when he said: "Architecture is politics,
but should not be understood as a substitute for
politics." Decentralized protocols are too readily
assumed, because of their technical qualities,
to bring about decentralized political, social
and economic outcomes. A more fine-tuned
appreciation of the social dimensions of the
stack is likely to improve things in this regard.[19]

Media historicism (aka archaeology) has so far failed to de-
velop critical concepts to understand the current situation,
also known as platform capitalism. There is more to the
internet than the politics of the senses. Notation systems
and perception are so twentieth century. What matters
now is who owns the internet in terms of data centers,
cables, and PR—and that question must be investigated,
first and foremost, through a material analysis. If I had to
locate a relevant precedent, it would be the Roman road
system described in Innis' *Empire and Communications*.[20]
What would that kind of analysis look like today? It might
be investigating the relation between the modernist stack
and the fuzzy "cloud" buzzword.

19       Private email exchange, October 16, 2020. See also Mélanie Dulong de Rosnay and Francesca
Musiani, "Alternatives for the Internet: A Journey into Decentralised Network Architectures and
Information Commons," *triplC* 18, no. 2 (2020), *www.triple-c.at/index.php/tripleC/article/view/1201*.
20       Harold A. Innis, *Empire and Communications* (Toronto: Dundurn Press, 2007).

# The Fragmenting Stack

How does Bratton's design relate to recent proposals by stacktivists for a European "data sovereignty"? The stack is breaking up, splintering into fragments. The consensus about needing to have global standards and global infrastructures seems to be fading. In the wake of this fragmentation, does it still make sense to speak of a singular stack? Should we instead speak of a thousand stacks or a rainbow of stacks? After all, we have the "red stack" from Tiziana Terranova,[21] the ancient "blue stack" of IBM, and the "green stack" proposal that wants to tackle the massive energy use of the blockchain, our data centers, and even our own digital devices.

Is a fear of the internet's "balkanization" justified? Right now, open architecture is the one principle that is in most danger. Open standards and protectionism do not go together. What would it mean if we gave up on the planetary level and narrowed our collective imaginary to the geopolitics of competing regional empires? In a regulatory wave, platforms can be forced to fork, and, as a result of this, other layers of the stack can be dragged with them. Many apps are already implicitly regional. Take the Anglo-Saxon bias of Google Books and contrast this to the (Siberian) multipolar Libgen library. The liberal consensus of some kind of harmonious multi-stakeholder alliance between "global civil society" and the "global governance as code" of tech giants has long lost any credibility. We're not just talking here about China's Great Firewall but also the latest efforts in Russia, Turkey, and Iran. And let's not forget American exceptionalism, which was one of the many causes of this development.

Bratton's Stack lacks the society layer, preferring the Greek city state or metropolitan area as the ideal civil unit. We can only guess that his traditional U.S. "globalist" upbringing is the cause of this mishap. A Thatcherite neoliberal position perhaps lurks within his framework: there are only users, no society. Or should we rather think

---

21      According to Tiziana Terranova, the red stack "is a new nomos for the post-capitalist common. Materializing the 'red stack' involves engaging with (at least) three levels of socio-technical innovation: virtual money, social networks, and bio-hypermedia. These three levels are to be understood as interacting transversally and nonlinearly. They constitute a possible way to think about an *infrastructure of autonomization* linking together technology and subjectivation." "Red Stack Attack! Algorithms, Capital and the Automation of the Common," *Effimera*, February 12, 2014, *effimera.org/red-stack-attack-algorithms-capital-and-the-automation-of-the-common-di-tiziana-terranova/*.

of an anarchist disgust with the state? Or even the enlight-
ened artist-engineer, hovering above the plebs like a Jesuit
priest? Infrastructure does not equal society. Any attempt
in the twenty-first century to reduce infrastructure to the
physical borders of the nation state has failed and will fail.
A contemporary techno-Maoist slogan could be: there is
no society, only infrastructure. There is no place either for
the user as a civilian actor. What do we draw from this? As
long as key layers are missing in such analyses, we can't
really draw new relations between them. This is why some
in the context of art and hacktivism have proposed rede-
signing Bratton's scheme as a "public stack."[22]

A public stack brings us to forms of commoning
and collective action. How might we develop systems that
provide us with new abilities to act together? The key design
question is what comes next after the model of social net-
works, which has been so compromised and overshadowed
by the social media monopolies. This is a digital commons in
which collective forms of money are included, a redistribu-
tion of wealth that has been produced together and should
never again be expropriated. Here it will pay to learn from
previous mistakes in this space. We might think of projects
like Wikipedia and Creative Commons, but also of the
self-centered notion of free software promoted by Richard
Stallman, who could only think in terms of individual
freedom of the single-user-as-programmer. We need to col-
lectivize our knowledge and create compelling alternatives.

# Refining the Stack

What Bratton's static metaphysical view particularly
lacks is the role of actors (along with their interests and
ideologies). Instead of trashing the stack, the proposition
here is to make the model more dynamic (or dialectical)
by introducing stacktivism. Let's define stacktivism as a
form of internet activism that no longer bothers with the
distractive noise on social media channels and dares to dig

22      Public stack was the name of a boat trip workshop, held in Amsterdam, June 2018, organized
by Waag: *waag.org/nl/event/public-stack-summit*. See also 'Redefining the European Stack,' *Trust,
trust.support/watch/redefining-the-european-stack*, a lecture from Arthur Röing Baer (from the
Berlin-based trust_support collective) from November 2019 on the European Union, which set itself the
mission to claim digital sovereignty. "Does this open up new possibilities for technological infrastructure
beyond the American and Chinese models? Or does it merely enable deep-rooted colonial fantasies to
take new form?"

deeper in order to make a real difference. Instead of talking only about upload filters or the deployment of cheap online moderation armies, we are working on the next internet. The charm of protocol-driven direct action or stacktivism is that it goes both up (from network to platform to stack) and down (protocols, data centers, cables), at the same time. The internet is more than social media, more than you and your app. This may sound like a simple, self-evident slogan but the integral practice-based vision of stacktivism is a promising one, beyond techno-solutionism and its critics.

In *The Revenge of the Real: Politics for a Post-pandemic World*, written during the 2020 lockdown, Bratton refines some of his earlier claims. He sees "platform technology assume real structural agency in political life in ways that usurp the supposedly natural authority of laws and law-yers." The stack theory gets updated with short reflections on 5G, automation, mask wars, and the "social economy of touchlessness" that defined the COVID-19 era. In line with *The Stack*, Bratton's motivation remains to work on a "deliberate plan for the coordination of the planet." He begins with global comparisons between countries like Brazil and Germany, and then moves into a rather easy polemic against Giorgio Agamben's misplaced comparison of lockdown measures with concentration camps.

Bratton enters more interesting territory when he asks what Michel Foucault would have made of the different pandemic policies. What would a "positive biopolitics" look like? Not one of "vitalism, Being, ritual, and disciplinary capture, but instead of demystification, animate sensing, reason and care?" The important step forward here would be to integrate our bodies, healthcare, the politics of health tech, and the uneven distribution of medicines and treatment. In effect, it would be to combine the abstract Foucauldian concept of "biopolitics" and population control with the IT infrastructure focus put forward by the stack. Bratton extends this pandemic insight by introducing the term "biopolitical stack" as "an integrated, available, modular, programmable, flexible, tweakable, customizable, predictable, equitable, respon-sive, sustainable infrastructure for sensing, modelling, simulation, and recursive action."

This is a pro-science program. Confronted with a global political culture that is deeply suspicious of govern-

194

ance, Bratton reaffirms a belief in science. "The culture of data matters" he states simply. The pandemic, but also climate change, "has made clear that the present anarchic state of geopolitics must give way to forms of governance that are equitable, effective, rational and therefore realist." Yet if it's urgent to join the Bratton tribe in its resistance against populist incoherency, it is unclear how this differs from the current U.S. hegemony of "global governance" and the Russian or Chinese counter strategies to it. On the national and online levels, it seems logical to rise up against "demagoguery, folksy scapegoating, simplistic emotional appeals, fear mongering and boundary policing, empty theatrics, sham symbolism and charisma-driven grifts." However, such a movement has yet to be translated into political rules for cosmo-technics, or what Bratton terms "planetary competence."

## Towards a New Stack

But let's return to our stacktivism, defined here in the "narrow" internet context as protocological activism. Stacktivism is an attempt to embody Adorno's critique of (planetary) totality as a lie, while climbing up the abstraction ladder in order to get some overview. The "stacktivist dilemma" is a classic one: How can the multitudes gain power while pulverizing power at the same time? The digital is now an encompassing global sphere. Is this dark enlightenment in action? In this light, how should we judge the Will to Stack? Dare to think in terms of political strategies when talking about cosmotechnics (or cosmic networks, for that matter). We've left the era of technology-as-tool far behind us. The nasty feedback machines strike back and try to corner us, suppressing our desires and needs, even without us noticing the closing down of communication and expression.

Can the stack (formerly known as the internet) only be understood in its totality once it has fallen from its unity and been reduced to fragments (read: geopolitical blocks and national webs)? Can we be global in scope on the protocol level, yet act locally in networks of strong-ties? Is it productive to consider cosmotechnics for good—stealing code from the rich and inserting it into networks for the poor, in the spirit of Aaron Schwartz and Anonymous'

SkyNet? Do you also believe that another WikiLeaks is possible, this time without the celebrity cult?

Let's upgrade and broaden the vision, considering what the fight against moral injustice might look like in the age of geopolitical cyber warfare and attacks on our critical infrastructure (not just the internet but water, gas, electricity, bridges, and hospitals). These are The Stacks of the People, and better not be naive about their vulnerability. We depend on The Stack. Making visible and defending critical public infrastructure could be one of the many tasks of stacktivism.

This leaves us with the question of how to organize strategic forecasting in times of extinction and collapse. How can we bring together new forms of collective intelligence that are truly planetary in nature, which is to say conflictual and variegated, and not merely designed to replicate Western policy production? Call them organized networks or think tanks, we're gathering in closed forums on Telegram, Mastodon, or Signal, in order to overcome divisions and get things done. In theory we have all the communication skills, tools, and ideas, yet we often do not know how to organize ourselves outside of surveillance capitalism and state control. Ni Zuckerberg, ni Xi Jinping.[23]

Let's apply Sven Lindqvist's famous "Exterminate All the Brutes" quote to tech criticism. "You already know enough. So do I. It is not knowledge we lack. What is missing is the courage to understand what we know and to draw conclusions." There is always more to find out, links to make and stories to tell. But the challenge now is to unleash political tech movements, design campaigns, and establish many think tanks. The task is to raise new code-loving generations for whom autonomy and techno self-determination are as natural as the seamless 24/7 smartphone connectivity is for us. Refusal and exodus are one, together with alternative tools. Forgetting and deprogramming are one part of this exit plan. As Jenny Odell proposed, doing nothing in the attention economy is an act of political resistance, a strategy "for any person who

---

23      "If internet users form a community with its own interests, incipient identity, and modes of living together, it doesn't matter whether existing sovereigns currently have the power to impose their rules on them. What matters is whether they can be organized to assert, and gain, their independence from those rules, or to force concessions and adjustment upon the old order." Milton Mueller, *Will the Internet Fragment?* (Cambridge, MA: MIT Press, 2017), p. 150. For stacktivists, the old order is symbolized by Silicon Valley and the Chinese Communist Party with Foxconn factories as synthesis.

perceives life to be more than an instrument and therefore something that cannot be optimized."[24]

Stacktivism is ready to understand the entire picture after the defeat of "small is beautiful" software alternatives. The app for good can no longer match the deep infrastructural take-over. The ultimate test is how to relate to the current monopolies. It's never too early to draw up new specs. How can this be done in a situation where Western do-gooder "global society" NGOs that claim to promote alternatives are too weak to win, yet too strong to die? How can we redistribute critical resources and talents? The need to bring together different and messy idioms of knowledge (technical, spiritual, cultural, political) is widely felt.

What we will do next is to act together. The starting point in designing the new techno-social must be the group rather than the individual user—the social not the individual. Tools will be temporal and goal-driven, focused on what needs to be done now, not sharing for the sake of it. In this way we move from profile to project, from merely liking to collective decision making, from behavioral to social psychology, from influencers to cooperation, from shitstorms to debates.[25] In this sense, stacktivism is only one of many options. Distributed forms of collective design will remake life from the swamps.

24     Jenny Odell, *How to do Nothing: Resisting the Attention Economy* (Brooklyn: Melville House, 2019), p. xi.
25     This proposal is also featured in Pit Schultz' May 2018 non-Facebook proposal, which offers a radical pragmatist set of strategies out of the stagnation, both in terms of the inability of regulators and those that believe in alternatives that have proven "dead-end devolutions," *nettime.org/Lists-Archives/ nettime-l-1805/msg00030.html*.

# Reconfiguring the Techno-Social

## Conclusion

"There's a point when you go with what you've got. Or you don't go."
Joan Didion

"A lot of people think the internet started good and just became bad, but I was there and it was always terrible."
Ian Bogost

"We are limited only by our dreams."
RRF

"What is to be undone?"
Dominic Pettman

"I thought I silenced you."
Sevdaliza

"What if...Google isn't nearly big enough?"
@bratton (Benjamin Bratton)

"What is most difficult is to love the world as it is, with all the evil and suffering in it."
Hannah Arendt

"Just fucking leave me alone."
Billie Eilish

200

"Was taking selfies and then suddenly noticed water damage in the corner of my living room."

@nadiadvv (Nadia de Vries)

"The way to respond to crisis is to practice compassion and change the cycle of suffering."

Xiaowei Wang

"I've seen wojaks you people wouldn't believe."

Jung Lacanian

"Don't ignore stupid things or you will stay at the motherfucker level."

Brad Hollande

"Life begins on the other side of despair."

Jean-Paul Sartre

"We need to be weird, unsettling monsters."

Gary Hall

"The problem is not that there are abstractions— the problem is that we are not abstract enough."

Brian Massumi

"We want to make love with drones. Our insurrection is peace, total feeling. They say crisis. We say revolution."

Paul B. Preciado

We need to escape, to find a way out. At the end of *Atlas of AI*, Kate Crawford finds traces of an emerging movement that aims to go beyond the current configuration of capitalism, computation, and control.

There are sustainable collective politics beyond value extraction; there are commons worth keeping, worlds beyond the market, and ways to live beyond discrimination and brutal modes of optimization. Our task is to chart a course.

In this concluding chapter we take up the challenge of the Platform Question, a question that needs to be resolved before we can start thinking about the "next internet." As Tiqqun writes:

Rather than new critiques, it is new cartographies that we need. Not cartographies of Empire, but of the lines of flight out of it. How to? We need maps. Not maps of what is off the map. But navigating maps. *Maritime* maps. *Orientation* tools. That do not try to explain or represent what lies inside of the different archipelagos of desertion, but indicate how to join them.[1]

First mapping, then strategies, and lastly tactics.

In these remaining pages, I will explore ways to deplatform the platform paradigm and what profile-free social media alternatives might look like after learning from their earlier mistakes ("free!" "open!" "decentralized!"). To put it in policy terms: how do we place a public digital infrastructure at the core of a tech sovereignty strategy and migrate from a platform to a protocol-based digital economy?[2]

## From Regulation to Prevention

In 2004, I renamed my newly established applied research chair from *Interactive Media in the Public Domain* to the *Institute of Network Cultures*. The term network cultures was

1      Tiqqun, "How Is It To Be Done?", *Voidnetwork*, July 12, 2012, *voidnetwork.gr/2012/07/18/how-is-it-to-be-done-by-tiqqun/*.
2      See Katja Bego, Public digital infrastructure should be at the core of Europe's tech sovereignty strategy, July, 14, 2021, *https://research.ngi.eu/public-digital-infrastructure-should-be-at-the-core-of-europes-tech-sovereignty-strategy*.

less pretentious and was not constrained to the academic social sciences. In changing the name, I made a clear commitment to arts, design, and activism. For one, network cultures emphasized the social community aspect and the mapping of real existing uses. For another, it highlighted the role of aesthetics and made space for experiments by artists and activists that went beyond the engineering paradigms. If asked now, would I rename the center into *Instituting Platform Exodus?* Instituting is described as "social improvisation, a process that remains incomplete and fugitive, inseparable from emergent imaginings and imaginaries of a livable life."[3] The idea would be to prevent the establishment of inherently problematic technologies instead of trying to regulate them after the fact.

I am explicitly excluding platform "governance" (aka regulation) as a viable short-term strategy. This is not just because of the proven inability of lawyers and NGOs to curb the power of the existing platforms, despite massive waves of do-gooder energy and slow progress. Exhibit A here would be the "Stop Hate for Profit" campaign against Facebook, something that made corporations look virtuous, but was largely symbolic. While neoliberalism and market solutionism may be on their way out as dominant ideologies, this does not imply that current (Western) states have the willpower to take radical measures and effectively dismantle and close down platforms. To ask corporations to please not collect data is naive. We will not see a revolution based only on regulation and fines.

In an opinion piece, Mariana Mazzucato and others call for the public sector to start investing in itself again.

> Governing online platforms requires more than just "gov-tech," McKinsey consultants, or advisers from Silicon Valley. The fact that Big Tech itself is driving the public sector's digital transformation does not bode well for the state's future regulatory and operational independence.[4]

Those who regulate Google use Google products and infra-

---

3        See: *newalphabetschool.hkw.de/category/instituting/*.
4        Mariana Mazzucato et al., "Reimagining the Platform Economy," *Project Syndicate*, February 5, 2021, *www.project-syndicate.org/onpoint/platform-economy-data-generation-and-value-extraction-by-mariana-mazzucato-et-al-2021-02*.

structure, from Gmail and Docs to Google data centers. How can regulators and governance structures have any teeth when their internet is heavily reliant on these products and services? No wonder many do not know where to start.

One place to start breaking the social media barrier is the design of "internet prevention." The aim here is to go beyond offline therapies.[5] We do not just need less internet.[6] We're talking about the collective ability of reality-making here. How do we jump the airgap from prototype, to scaling for the billions? Is it possible to alter this encapsulated social reality through the power of the collective mind? In the fluid context of the online self, where billions depend on the silent approval of other billions, it is the common imagination that will make things real. Thoughts can—and will—change reality.[7] A consumer boycott of the obligatory "smart" fridge that talks to your supermarket may be obvious but how about a sudden demand for analogue cars? How about self-destructive apps? Where are our promised repairable phones and laptops? Backwards compatible operating systems? Ever dreamt of a device that is so simple and stable that it simply no longer needs to be upgraded?

Prevention means questioning where technology should be implemented. In line with the 2018 *Data Prevention Manifesto*,[8] Kate Crawford poses a question that comes close to an AI prevention strategy: "Are there places where AI should not be used, where it undermines justice?"[9] What is important here is to sabotage the inevitability of technology-first approaches and work on a politics of refusal, the topic of the transmediale 2021–22 festival.[10] Prevention means probing the assumption that

the same tools that serve capital, militaries
and police are also fit to transform schools,

5          More on this can be found in Jess Henderson's *Offline Matters, The Less-Digital Guide to Creative Work* (Amsterdam: BIS Publishers, 2020).
6          Michael Dieter comments that we should not be left with less as the alternative. There are ways of inhabiting less as zen minimalism or modernist utopianism, but in the online discussion it seemed more like less theory, less ambition, less idea of what to do—it's a classic tactical media dilemma, but it also dovetails with other crises like economic downturns, the pandemic, climate crisis" (private email exchange, November 17, 2021).
7          Recontextualization of Gary Lachman, *Dark Star Rising, Magick and Power in the Age of Trump* (New York: Penguin, 2018), pp. 168–178.
8          *dataprevention.net/*.
9          Kate Crawford, *Atlas of AI* (New Haven, CT: Yale University Press, 2021), p. 226.
10         Refusal was the 2021 theme of the Berlin transmediale festival, *https://transmediale.de/theme*. "For some, refusal is a luxury that stems from an advantage; for others, it manifests from regressive, reactionary politics. Too often refusal is a stance adopted after years of exile, exclusion, or oppression."

hospitals, cities, and ecologies, as though
they were value neutral calculators that can be
applied everywhere.

# Platform Exodus

How do we organize the social media exodus? "All
mankind is divided into three classes: those that are
immovable, those that are movable, and those that move,"
Benjamin Franklin once said. It is sadly us, users, that be-
long to the immovable category. For decades Silicon Valley
monopolized and stifled the innovation of communication
and business. Users are trapped in "virtual cages," clueless
how to escape and move on. Virtually all activists, artists,
and geeks can no longer imagine how an exodus could
be organized. Let's not even talk here about academics,
NGOs, and the cultural sector that cynically continue their
dependencies despite "knowing better."

 In order to free our minds from both crippling
depression and organized optimism, let's start sketching
how we can leave behind the dominant platforms. First
of all, there are cultural techniques to forget social media.
Once notifications have been switched off, apps can easily
disappear and no longer catch our attention. This is the
most likely scenario. The online herds are simply too busy
to follow complicated instructions on how to delete ac-
counts. No, what we'll likely see are apps being abandoned,
passwords being forgotten, phones being lost. No longer
bothering is a subconscious act, done out of self-interest.
Anthony Nine:

> Add all your problematic family members,
> annoying co-workers, people that you went to
> school with, randos you met one time, creating
> the illusion that you are "friends"—and then log
> out and never look at it again.[11]

Drowned in noise, the masses get bored and log off.

 Delete your profile altogether, don't just cancel certain
"friends." Yes, this also implies that we cancel and reclaim
the algorithms, contacts, and databases of the dominant

11     Anthony Nine (@spaceweather9), October 6, 2021, *twitter.com/spaceweather9/status/*
*1445784088078471172/*.

platforms, as it was us, the people, who provided them with that data in the first place. Freeing the world from the venture-capital start-up model, driven by hypergrowth and related "free" services, could potentially lead to a renaissance of social networking tools that are non-profile centric and driven by affinity. Dialogue and discussion, not comments and likes. Who's afraid of adversarial design? The decentralized app landscape may seem chaotic at first, but it will inspire former "users" to become actors again, instead of tragic zombie consumers.

Whether platforms are an all or nothing proposition is a question I have long asked myself. If we do not want to go back to network nostalgia and refuse to praise harmonious, identity-centered community beliefs, how can we move on from platform logic and invent new forms of the techno-social for a media inhabited by five billion users? In order to get there, we need to start experiments while politicizing the Platform Question. In a universe built and owned by right-wing libertarian geeks, appeals to ethics have fallen on deaf ears. There is no liberal-progressive consensus on the horizon yet. With regulatory regimes weakened for decades and a political class relying on platforms for the next elections, the question becomes urgent, if not desperate. "Internet architecture" has rapidly fallen off the global agenda—if it was ever there in the first place. My thesis: platform socialism should abolish the platform, not embrace it.[12]

Already we're starting to see signs of discontent, from the October 2021 global Facebook outage to the "sad by design" evidence of whistle-blower Frances Haugen.[13] Scandals no longer surprise us. In *An Ugly Truth*, two mainstream US journalists describe the Facebook scandals between 2016 and early 2021, based on more than four hundred "insiders."[14] The disappointing account fails to go beyond the description of personalities and their PR moments such as press conferences, hearings and interviews. The book fails to come up with new evidence and sums up

12    *www.plutobooks.com/9780745346977/platform-socialism/*. I am questioning if it is possible to "reclaim the emancipatory possibilities of digital platforms," as James Muldoon seems to suggest here.
13    See the 60 Minutes interview in which the identity of the Facebook whistle-blower, Frances Haugen, was revealed: *www.cbsnews.com/news/facebook-whistleblower-frances-haugen-misinformation-public-60-minutes-2021-10-03/*. A selection of documents published by the Wall Street Journal here: *www.wsj.com/articles/the-facebook-files-11631713039*.
14    Sheera Frenkel and Cecilia Kang, *An Ugly Truth, Inside Facebook's Battle for Domination* (New York: HarperCollins, 2021).

what's already widely known, adding further to the growing evidence fatigue.

The proof of platform harm has been piling up for years and no longer makes a difference. What's needed is a comprehensive roadmap. Would it be possible to dismantle data centers, rack by rack, as Chinese bitcoin miners have done when closing down their operations? How will we achieve techno diversity under planetary protocols? I am concerned by the biblical or even messianic undertones of the word "exodus," yet I appreciate the movement aspect of it. We're on the go, leaving the imperial designs behind. It is no longer enough to create a consensus about the urgency that "another internet is possible." Actions speak louder than words. If we can pull this off, the agony will finally be over.

Exodus is no longer a utopian motive. Millions of users have already experienced mass migration, leaving behind web ghost towns such as LiveJournal, Tumblr, GeoCities, Hyves, and Blogger. But then something happened and this practical skill was lost and forgotten. Today the online herds seem inert, simply too big. We need to remember how to desert the platform, together, and reclaim digital self-determination. Let's build unknown #WeToo forms of collectivity, not another "me me me" version. What movement can break through the boredom and make us instantly forget the misery? You want the event to happen but where does it take place? We're just looking for something, anything, anxious to get to the next thing that never arrives. So, mind the gap, take profile reduction measures, and join the critical mass of lost souls.

# Alternative Platforms and Minor Networks

"The only thing that can displace a story is a story," asserts George Monbiot's in *Out of the Wreckage*. This is also the case with platforms. According to Monbiot, "the chattering multitudes create an unintelligible cacophony. Without a coherent and stabilizing narrative, movements remain reactive, disaggregated and precarious, always at risk of burnout and disillusion." The question here is how to turn platform alternatives into a "compelling narrative."[15]

15    George Monbiot, *Out of the Wreckage: A New Politics for an Age of Crisis* (London: Verso Books, 2017), p. 6.

The development of alternatives extends well beyond the strategic social media realm. We don't need Airbnb or Uber to find a rental or call a taxi. New services can be based on data prevention, not protection. Give peer-to-peer a chance. Let's find other ways that we can search for information, and each other.

The urgency is there. In the COVID-19 crisis, we saw tracing apps emerge almost overnight. If that could be done, then European alternatives to the dominant social media platforms no longer based on advertisements and hidden data extraction are entirely possible—and could be built within months. From the perspective of change, a lot of our institutions will have to be closed down as they are beyond repair. Silicon Valley tops this list. New business models are sorely needed. If we just keep being polite and not questioning anything or anyone, nothing will ever happen.

Too much hand-wringing and theoretical diagnosis overload may block the action that is needed. There are too many scandals and not enough stories about alternatives and their progress. We need to reflect on our own blind spots and vicious circles concerning tech-related stagnation. What stopped us from building the next internet, platform, or alternative app over the past decade? It is one thing to see that data leads to more data, obscuring even further its ideological premises. But can we say the same thing about therapy leading to more therapy? We can easily get lost in an affective hall of mirrors.

There are a few options on the table—but we need more. In all cases radical imagination is the starting point, followed by the will to start experiments, no matter how small or conceptual. The first one is what net artist Ben Grosser called platform realism,[16] fighting out our struggles there on the platforms themselves. This is, more or less, the status quo. The second would be to campaign for exodus and migration to already-existing alternatives such as Fairphone, DuckDuckGo, Jitsi, and Etherpad. The third would be to leave the platform question aside altogether and fully focus on the development and mainstreaming of platform alternatives. This is the strategy of the Varia scene,[17] who are focused on the "fediverse" ecology of

16    *networkcultures.org/blog/2021/06/29/platform-realism/.*
17    *varia.zone/en/mastodon-and-fediverse.html.*

Mastodon, combined with Discord, Signal, Telegram, and autonomous autopoietic post-blog community websites. The fourth would be the "offline matters" strategy that concentrates on the poetry and aesthetics of (self)organization. These radical reinventions go beyond political parties, local initiatives, coops, and the traditional model of trade unions.

Minor networks cannot come into being in the bright spotlights of a platform. Applied autonomy is both a skill and a basic right. Without it, self-organization becomes random, short-lived and—most of all—reactive. Leaving the platform is one option. Hopefully we migrate to a better one. For most, the alternative is found in dispersal, away from one-size-fits-all solutions, towards a range of diverse, contextual tools that are local and assist in doing a particular job. Grosser adds:

> Decentralization undoubtedly holds some promise for dreams of exodus from big tech platforms. But decentralization on its own is not a panacea. We only need look at speculative finance and libertarian crypto dreams to find clues about who feels most excited about decentralization and why.[18]

# New Values

Over the past years I have found no way to politicize online sadness. No doubt, there were, and still are, plenty of people that recognized themselves in my texts and performances. And it's certainly important to know how power operates so we don't just replicate their models, either willingly or subconsciously. But after a three year tour doing (virtual) roadshows, I had to experience what I knew all along. Empowering depression or anger is a dangerous game. Mutual recognition is short lived and doesn't lead to collective action. This is also the case with social media criticism. By itself, merely understanding the "twittering machine" lacks a political program and roadmap to change. Radical media have other beginnings: not in problems but desires. There are strange encounters, random connections, irrelevant contexts, often paired with

18    Quote from a private email exchange with Ben Grosser, June 28, 2021.

outdated tech. The new emerges from weird remixes. Is this also the case with platforms? A focus on the fastest, most expensive and complex often leads us nowhere: think of VR, quantum computing, or AI.

The negatives we contend with on big tech's platforms are rooted in their alignment with the ideologies of capitalism. Global platforms reflect the same profit-focused business values that drive Big Tech to build those very platforms in the first place: growth, scale, more and more at any cost. This inevitably leads Big Tech to treat users as resources, ready to be mined, manipulated, and transformed into profit. These foundations are doomed from the start. "Without a private profit motive, many of the problems with big tech platforms would fall away," argues Grosser,

> What would a platform look like if it actively worked to defuse compulsive use rather than to produce it? Or if it wants less from users rather than more? Or if it encourages conceptions of time that are slow rather than fast?

Together with Grosser, I see a shared set of values when working to dismantle the control of Big Tech:

> SLOW: we need media that actively and intentionally works against the platform capitalist idea that speed and efficiency is always desirable and productive.

> LESS: we need new alternatives that advance an anti-scale, anti-more agenda. Facebook's answer to the negative effects of platform scale post 2016 was to foreground Groups to "give people the power to build community." Four years later that platform-produced power has propelled racism and authoritarianism to new heights.

> PUBLIC: social media infrastructure for over 3 billion users should not be driven by profit or controlled by single individuals. Ditto goods distribution (Amazon) and information access (Google).

> DECOY: to help produce a culture of platform
> refusal we need new projects that infiltrate
> the platforms and help users turn themselves
> away from them.

How else can we counter platform logics? To explore alterna-
tives, I talked to artist and researcher Joana Moll. "The main
problem is that we are trying to configure the platform, or
the internet at large, playing with the same variables that
enable corridors of power to exist," she responded.

> We are trying to shake those variables and put
> them upside down in the hope that this will
> reverse the established power structures. We
> are trying to gain sovereignty over physical
> infrastructures, blocking tracking technologies
> and expect alternative technologies to do what
> we're doing on the mainstream platforms. In
> order to reverse or shake up power, we need
> to add new variables that are not present in
> the corridors of power such as limiting their
> use of energy and the exploitation of natural
> resources. Such limiting variables could force
> companies to change their modes of oper-
> ation and give up some of their power. In the
> end, tech companies are incredibly dependent
> on electricity usage, so it would be interesting
> to see how this could play out.[19]

We need a multitude of platforms with different values.
Emanuele Braga wants us to invent new digital platforms
capable of taking away the monopoly of big capital platforms.

> The pandemic future will increase the role
> of digital platforms in determining our social
> behavior. The only alternative to this concentra-
> tion of power is to increase democratic control
> of social platforms, in the many possible ways
> of placing them in the hands of democratic
> states. At the same time, we need to develop
> cooperative models of digital platforms. From
> knowledge archiving, to logistics, distribution,

211          19      Quote from a private email exchange with Joanna Moll, July 5, 2021.

> welfare services, food and energy chains,
> we must develop self-organized cooperative
> platforms that decentralize governance and
> federate reproductive and productive alliances.

He sees a double movement:

> Strengthen the role of democratic states in the
> development and control of digital infrastruc-
> tures as a welfare and non-business oriented
> service, and, at the same time, develop coop-
> erative and independent bottom-up platforms.
> Only one of these two directions can reveal
> to be weak or authoritarian, which is why we
> must promote their synergistic and coexistent
> proliferation.[20]

As I have tried to prove, the platform has eclipsed the internet and we'll have to wait till we can properly separate the two. In the meanwhile, there is plenty of time, energy and desire around to create what we could call the Bandung Protocols.[21] We need organized networks that develop and implement internet alternatives beyond Silicon Valley and Beijing.

As one brief example, let's look into the develop-ment of a new monetary protocol, one way to help end the regime of the free, pay artists for their work, and redistribute wealth. How do we get back to the authentic societal information function of money? Ruben Brave has suggested returning to the Money over Internet Protocol, which immediately caught my attention. One advocate neatly summed up the rationale: "While stablecoins are likely part of the solution, a successful blockchain-based architecture must implement currency as protocol through consumer-facing applications that provide a seamless bridge to legacy fiat technologies."[22] The idea is simple: stop concentrating crypto assets in apps and blockchains that can easily be monopolized. Monopolization has further driven the platformization of the internet into the

20        Emanuele Braga, *Gestures of Radical Imagination*, April 2020, *instituteofradicalimagination.org/2020/04/16/gestures-of-radical-imagination-a-program-for-the-useful-revolution-by-emanuele-braga/*.
21        Reference to the 1955 conference, held in Bandung, Indonesia, where the idea of a non-aligned movement was launched, excluding the Cold War antagonists and their satellites. Lately, the Bandung spirit has come alive again, as in the case of this 2021 conference about the present decolonization of Africa: bandungconference.com. In the cosmotechnics case the Bandung spirit would have to resist a great deal more imperial and regional powers.
22        *https://www.researchgate.net/project/Money-over-IP*, posted March 19, 2019.

hands of the few, from VCs and whales to crypto founders. Of course, it is all too easy to say that Bitcoin is right-wing libertarian and unsustainable. It is much harder to specify exactly what a commons-based system would look like. There are numerous related technical issues that need to be resolved, from self-sovereign ID, to quantum crypto, and a timestamp protocol. Yet, despite these challenges, Ruben Brave has brought a viral concept back into circulation. The project starts to show how a safe and publicly owned money-over-IP, absent of fees, can be developed that belongs to everyone and no one.

# Roadmap for the Future

It's often said that researchers, theorists, critics, designers, artists, and activists are trapped in the perpetual now. While conservative think tanks plan years out, we tend to lack long-term vision. Let's therefore end with a roadmap, a Five Year Plan in six steps. Let's try to go beyond the tactics of making claims. This is an invitation to make steps together.

One possible way: Make the Internet Sexy Again. Take the Public Stack, a concept developed by Waag in Amsterdam that brings together a collection of open, fair, and safe alternatives. Their question is not phrased in legislative jargon, but in the simple terms of repair. "How do we fix a broken internet?" The emphasis here is on tech as a collective design act: after failure comes the process of unmaking and remaking. Stack in this context refers to

> different layers of the internet, which cannot work without each other. It is useful to view the internet in this way, because it allows us to parse the layers to investigate where it is wrong and which layers can be replaced with alternatives.[23]

Unlike Bratton's modernist notion of the stack, Waag's conception is not a layer cake but an iceberg where only the tip is visible: the app layer used by citizens. Most of the underlying technology stack remains invisible and outside of the public debate.

213          23          *https://waag.org/en/project/public-stack-alternative-internet.*

While such a constructive proposition includes a variety of values and rights, it remains unclear how a participatory inclusive stack design can be enforced on large players that have zero interest in change. How to take the toys away from the boys? This will be the tactical challenge for the next Public Stack round. Much like Bratton, Waag's Digital Future Roadmap sketches the difference between layers such as firmware and drivers, data and protocols, apps and operating systems. In the next phase, a dialectics of oppositional politics will need to be included. Irresistible alternatives will not be enough. How do we take geopolitical power plays, political lobbying, and a tired and largely indifferent public into account? In other words, how do we do antagonistic design in an age of disillusionment?

The discontent with social media platforms needs to be cherished and nurtured. Here, work on refusal and work on alternatives go hand in hand, feeding off each other. To be sure, the ultimate aim should be collective exodus. But at the same time, we also need alternatives, ways for ordinary people to move on. Refusal always needs a catalyst, a starting point. Rosa Parks stepped off the bus and many followed. So-called herd behavior is important during the long journey of exodus. This is the key of network dynamics. What happened to MySpace may one day also happen to Facebook and Google. Silicon Valley's fear is that this latent memory of the network effect will one day be resurrected and reactivated. So their aim is to erase that collective memory from the crowd. We're locked-in and firmly believe there's no way out. This is why the migration of small art and tech avant-garde has been a stagnating strategy for the past decade. We haven't been able to solve the chicken-egg conundrum, despite the many alternatives now on offer.

# Let's end with the six step program:

1          It all starts with assembling a techno-social exodus movement, much like Black Lives Matter or Extinction Rebellion. But how do movements come into being? Here we can learn a thing or two from earlier projects like Indymedia, Global Voices, Creative Commons, and Wikipedia. These days we know more about

the "rest of the world."[24] Autonomous network effects may still work, but the fortification walls around the platform are thick and need to be eroded from within. However, old school email lists and even blogs no longer work. Change will only come via self-experimentation from below, assisted by powerful memes.

2    Campaigns to break up monopoly platforms.[25] This is a topic Silicon Valley oligarchs really do not like discussed in public. All their lobby work in Brussels and Washington is ultimately aimed at preventing this. Breaking up conglomerates has been a utopia and a taboo for years, well beyond the event horizon. Even in the aftermath of the 2016 Cambridge Analytica scandal, this was never on the table. Now it is. We need to reverse the trend of Big Tech becoming invisible infrastructure and make their power visible. While there are no doubt legal aspects here, break-up campaigns have to be distinguished from calls for regulation and "governance."

3    Preparations for the building of the internet as a public infrastructure. Here we need more gathering of the tribes and serious brainstorm sessions, as we're not very far into this. Of course, we can sketch the outlines of a public stack. And we'll definitely need to get a better understanding of how intertwined data centers, protocols, and fiber providers are. But what will really count is to make local beginnings. A public sphere in the digital age can only grow if it starts as a living entity. This means political tech awareness across the board, from health care and education to logistics.

24    For example *https://restofworld.org/*, an international non-profit journalism organization "that documents what happens when technology, culture and the human experience collide, in places that are typically overlooked and underestimated."
25    The opening sentence of An Ugly Truth reads: "Mark Zuckerberg's three greatest fears, according to a former senior Facebook executive, were that the site would be hacked, that his employees would be physically hurt, and that regulators would one day break up his social network," Sheera Frenkel and Cecilia Kang, *An Ugly Truth: Inside Facebook's Battle for Domination* (London: The Bridge Street Press, 2021), p. 1.

4    One breakthrough would be the removal of
Google, Facebook, and other corporations
from internet governance bodies such as IETF
and ICANN, as their supposedly "neutral"
engineers have real political power at that
level, blocking structural change. Such a
move would mean reconsidering the naive
multi-stakeholder ideology and recognizing
the real power relations at play. We need to
reverse the silent takeover of these governance
bodies. Such a palace revolution will be the
real fight; followed by the even bigger quest
to socialize vital infrastructures such as cloud
services, data centers, and fiber networks,
including undersea cables. In a similar move,
Google and Microsoft products should be
banned from public education and replaced by
open source non-profit alternatives.

5    A federated, decentralized web will never hap-
pen inside Amazon Web Services (AWS). While
decentralization may sound like a worthy goal,
the current "nodism" will be fake because it
takes place inside a centralized cloud. Is it
realistic to bring servers back to the people, the
villages, the neighborhoods, and schools? Or
is that just wishful thinking, some romantic
notion? Should we instead socialize the exist-
ing datacenters and build public ones? This
debate is urgent.[26] If we want social networks
to be local again, where do we actually situate
them? Let's not shy away from conceiving
decentralized solutions within broader levels
of the stack and implementing them at scale.

6    Delegitimization of the globalist dream is well
under way. Europe and the US have been drift-
ing apart for years. The geopolitical division of

---

26      Again, Brussels is not the place to look for policies and alternatives in this context, with the
Gaia-X European cloud project, being the latest disaster, with Silicon Valley being prime partners at
the table. See *www.politico.eu/article/chaos-and-infighting-are-killing-europes-grand-cloud-project/*
("Amazon, Microsoft, and Google's cloud services have been flourishing, cementing their dominance
over Europe, accounting for 69 percent of the market. Europe's biggest cloud player, Deutsche Telekom,
accounted for only 2 percent").

the world is a fact, with distinct techno-social regions such as Russia, China, EU, UK (and its satellites Australia and New Zealand), India, and Turkey. The list is growing. We can skip the Balkan "fragmentation" debate here, this is not the point. The question is how to subvert new enclosures, organizing exchanges and debates beyond the regions with allies. Let's cultivate localities and facilitate encounters with (online) others, all with a royal gesture of hospitality and respect. This organized grace and warmth could even be formalized into code. All of the above is useless if we're not able to break the "global governance" consensus. From Lagos to Lahore and Bandung to Berlin, we need to come together and collectively create a future cosmotechnics that is able to sabotage the planetary destiny.

# Acknowledgments

The three years following my previous book, *Sad by Design*, have been overshadowed by the pandemic. Overall, this has been a period of missed opportunities. Tech giants have seen an unprecedented growth in revenue, profit, and power, while states have tightened their digital grip, dictating the conditions when it comes to health and freedom of movement. Tech critical movements have failed to gain political momentum, proving once again that even in this "virtual" arena it is vital to come together in real life and conspire, person to person. With overall levels of anxiety and paranoia skyrocketing, the lack of true dialogue, discussion and strategizing—despite Zoom and Teams—has been widely felt. Despite the frequent scandals that reveal the dark side of social media, we've seen no substantial changes. Internet usage only grew further. It seems intellectually tempting to move on, but none of the issues have been resolved. I decided to further confront the mess and not walk away from it in favor of lavishly funded topics such as smart cities, artificial intelligence, big data, or virtual reality (recently rebranded as the metaverse). The societal cost of abandoning the Internet Project will be high.

Since 2004 I've been based at the Institute of Network Cultures at the Amsterdam University of Applied Sciences, a place that continues to support my work. During the 2020 lockdown, a change of generations took place. I was proud to see that three members of my production team moved on to better jobs: Patricia de Vries, Inte Gloerich, and Miriam Rasch. I am very grateful for the many years of collaboration with them. In October 2020 I welcomed Sepp Eckenhaussen and Chloë Arkenbout as new members of INC's core team. Personal appreciation goes to John Longwalker who read and commented most of the chapters. We Are Not Sick is our band and together we proudly produced the music theory performance and album: www.wearenotsick.com (which launched in September 2020 and thus ran into COVID-19 restrictions).

I wish to thank Pia Pol and Astrid Vorstermans at Valiz publishers for their warm response to my request to publish this book with them. The support of their team was crucial in the smooth production. Simone Wegman was particularly helpful in this process. Also many thanks to Irene Stracuzzi for the beautiful visual identity and graphic design.

I would like to thank Réka Kinga Papp and her Eurozine team where "The Network Psyche," "Delete Your Profile," and "Zoom Fatigue" texts first appeared. "Requiem for the Network" was first published in a publication of the 2020 Berlin transmediale festival. The text benefitted from the preparatory discussions with director Krystoffer Gansing and other contributors. tripleC journal published a first version of the stacktivism text in their non-peer reviewed section, thanks to the efforts of Christian Fuchs. I would also like to thank all the members of the MoneyLab network and its board members for their direct and indirect contributions to the crypto-art chapter, in particular the organizers and speakers of the (virtual) conferences in Siegen, Amsterdam, Ljubljana, Helsinki, Canberra/Hobart, Berlin, and Wellington. All other texts appear for the first time. Online news inspiration came from New Models, nettime, Hacker News, Rest of the World, Cointelegraph, and the always disturbing Zerohedge.

For this book my Berlin dialogues were once more of crucial importance, in particular Pit Schultz, Alexander Karschnia, Cade Diehm, Michael Seemann, Antonia Majaca, Stefan Heidenreich, Anna-Verena Nosthoff, and Felix Maschewski. Thanks to all the "chorus" members that were so kind in answering my questions. Gratitude goes to Franco Berardi, Mieke Gerritzen, Miriam Rasch, Tiziana Terranova, Florian Schneider, and MoneyLab tribe members Ela Kagel, Max Haiven, Jonathan Beller, and Akseli Virtanen. I also wish to thank the DMCI faculty dean Frank Kresin for his support of my work and all INC researchers, interns and sympathizers such as Maisa Imamović, Jess Henderson, Gianmarco Cristofari, and Silvio Lorusso, along with Tommaso Campagna for technical support.

Editorial support and comments on chapters came from Tripta Chandola, Sepp Eckenhaussen, Michael Dieter, Donatella Della Ratta, Theo Ploeg and Nate Tkacz. Chloë Arkenbout went through the entire manuscript with me. A special mention here goes to my friend Ned Rossiter in Sydney for his continued support on all levels in making this book. And to Linda and Kazimir (who got his high school exam in this period) for their daily love and support. This is the second time I've been blessed to work with language magician Luke Munn (Tāmaki Makaurau/Auckland) as copy editor. My gratitude is priceless.

*Stuck on the Platform* is a Book of Desperation, dedicated to the memory of Bernard Stiegler, who passed away on August 5, 2020, on the other side of Forêt de Tronçais.

Amsterdam, April 2022

222

# Bibliography

Adorno, Theodor. *Critical Models: Interventions and Catch-words*. New York: Columbia University Press, 2005.
Alizart, Mark. *Cryptocommunism*. Cambridge: Polity Press, 2020.

Baudrillard, Jean. *Impossible Exchange*. London: Verso, 2015.
Beller, Jonathan. *The Message is Murder: Substrates of Computational Capital*. London: Pluto Press, 2018.
Berardi, Franco. *The Second Coming*. Cambridge: Polity Press, 2019.
Boyer, Anne. *A Handbook of Disappointed Fate*. Brooklyn: Ugly Duckling Presse, 2018.
Bratton, Benjamin. *The Stack: On Software and Sovereignty*. Cambridge, MA: MIT Press, 2015.
—. *The Revenge of the Real: Politics for a Post-pandemic World*. London: Verso, 2021.
Brunton, Finn. *Digital Cash*. Princeton, NJ: Princeton University Press, 2019.
Bullough, Oliver. *Moneyland: Why Thieves & Crooks Now Rule the World & How to Take It Back*. London: Profile Books, 2018.

Catlow, Ruth et al. *Artists Re:Thinking the Blockchain*. London: Torque Editions & Furtherfield, 2017.
Crawford, Kate. *Atlas of AI*. New Haven: Yale University Press, 2021.

Deleuze, Gilles. *Spinoza: Practical Philosophy*. San Francisco: City Lights Publishers, 2001.
Dijck, José van, Thomas Poell & Martijn de Waal. *The Platform Society: Public Values in a Connective World*. Oxford: Oxford University Press, 2018.

Fisher, Mark. *Postcapitalist Desires: The Final Lectures*. London: Repeater Books, 2021.
Frier, Sarah. *No Filter: The Inside Story of Instagram*. London: Random House Business, 2020.

Frenkel, Sheera & Cecilia Kang. *An Ugly Truth: Inside Facebook's Battle for Domination.* New York: Harper-Collins, 2021.

Gansing, Kristoffer & Inga Luchs, eds. *The Eternal Network: The Ends and Becomings of Network Culture.* Amsterdam: Institute of Network Cultures; Berlin: transmediale, 2020.

Gerard, David. *Attack of the 50 Foot Blockchain: Bitcoin, Blockchain, Ethereum & Smart Contracts.* [London:] David Gerard, 2017.

Gerritzen, Mieke & Geert Lovink. *Made in China, Designed in California, Criticized in Europe.* Amsterdam: BIS Publishers, 2020.

Gießmann, Sebastian. *Die Verbundenheit der Dinge: Eine Kulturgeschichte der Netze und Netzwerke.* Berlin: Kulturverlag Kadmos, 2014.

Gilder, George. *Life after Google.* Washington, DC: Regnery Gateway, 2018.

Gloerich, Inte, Patricia de Vries & Geert Lovink, eds. *MoneyLab Reader 2: Overcoming the Hype.* Amsterdam: Institute of Network Cultures, 2018.

Haiven, Max. *Art After Money, Money After Art: Creative Strategies Against Financialization.* London: Pluto Press, 2018.

Hayles, N. Katherine. *Unthought: The Power of the Cognitive Unconscious.* Chicago: The University of Chicago Press, 2017.

Heidenreich, Stefan. *Geld: Für eine non-monetäre Ökonomie.* Berlin: Merwe Verlag, 2018.

Heilbron, Johan. *The Rise of Social Theory.* Cambridge: Polity Press, 1995.

Henderson, Jess. *Offline Matters: The Less-Digital Guide to Creative Work.* Amsterdam: BIS Publishers, 2020.

Hilferding, Rudolf. *Finance Capital: A Study of the Latest Phase of Capitalist Development.* London: Routledge, 1981 (1910).

Hui, Yuk. *The Question Concerning Technology in China: An Essay in Cosmotechnics.* Falmouth: Urbanomic, 2017.

—. *Art and Cosmotechnics.* Minneapolis: e-flux/ University of Minnesota, 2021.

Innis, Harold. *Empire and Communications*. Toronto: Dundurn Press, 2007.

Kelly, Kevin. *New Rules for the New Economy*. London: Fourth Estate, 1998.

Lachman, Gary. *Dark Star Rising: Magick and Power in the Age of Trump*. New York: Penguin, 2018.
Levine, Caroline. *Forms, Whole, Rhythm, Hierarchy, Network*. Princeton: Princeton University Press, 2015.
Levy, Steven. *Facebook: The Inside Story*. London: Penguin Business, 2020.
Liu, Wendy. *Abolish Silicon Valley: How to Liberate Technology from Capitalism*. London: Repeater Books, 2020.
Lorusso, Silvio. *Entreprecariat: Everyone Is an Entrepreneur, Nobody Is Safe*. Eindhoven: Onomatopee, 2019.
    —, Pia Pol & Miriam Rasch, eds. *Here and Now? Explorations in Urgent Publishing*. Amsterdam: Institute of Network Cultures, 2020.
Lovink, Geert. *Social Media Abyss: Critical Internet Cultures and the Force of Negation*. Cambridge: Polity Press, 2016.
    —. *Sad by Design: On Platform Nihilism*. London: Pluto Press, 2019.
    — & Ned Rossiter. *Organization after Social Media*. Colchester: Minor Compositions, 2018.
Lowenhaupt Tsing, Anna. *The Mushroom at the End of the World*. Princeton: Princeton University Press, 2015.

Manovich, Lev. *The Language of New Media*. Cambridge, MA: MIT Press, 2001.
Marchert, Oliver. *Neu beginnen*. Vienna: Verlag Turia + Kant, 2005.
Massumi, Brian. *99 Theses on the Revaluation of Value: A Postcapitalist Manifesto*. Minneapolis: University of Minnesota Press, 2018.
Mazzucato, Mariana. *The Value of Everything: Making and Taking in the Global Economy*. London: Allen Lane, 2018.
Mbembe, Achille. *Critique of Black Reason*. Durham: Duke University Press, 2017.
    —. *Necropolitics*. Durham: Duke University Press, 2019.

Minichbauer, Raimund. *Facebook entkommen.* Vienna: Transversal Texts, 2018.

Monbiot, George. *Out of the Wreckage: A New Politics for an Age of Crisis.* London: Verso, 2017.

Mouffe, Chantal. *Agonistics: Thinking the World Politically.* London: Verso, 2013.

Mueller, Milton. *Will the Internet Fragment?* Cambridge: Polity Press, 2017.

Nassehi, Armin. *Muster: Theorie der digitalen Gesellschaft.* Munich: C.H. Beck, 2019.

Nesvetailova, Anastasia & Ronen Palen. *Sabotage: The Business of Finance.* London: Allen Lane, 2020.

Odell, Jenny. *How to Do Nothing: Resisting the Attention Economy.* Brooklyn: Melville House Publishing, 2019.

Oever, Niels ten. *Wired Norms.* Amsterdam: University of Amsterdam, PhD thesis, 2020.

Pessoa, Fernando. *The Book of Disquiet.* London: Allen Lane, 2001.

Portanova, Stamatia. *Whose Time Is It?* London: Sternberg Press, 2021.

Preciado, Paul B. *An Apartment on Uranus.* London: Fitzcarraldo Editions, 2019.

Rasch, Miriam. *Frictie: Ethiek in tijden van dataïsme.* Amsterdam: De Bezige Bij, 2020.

Riesman, David. *The Lonely Crowd.* New Haven: Yale University Press, 1950.

Rushkoff, Douglas. *Team Human.* New York: W.W. Norton & Company, 2019.

Sassen, Saskia. *Expulsions: Brutality and Complexity in the Global Economy.* Cambridge, MA: Harvard University Press, 2014.

Seymour, Richard. *The Twittering Machine.* London: The Indigo Press, 2019.

Srnicek, Nick. *Platform Capitalism.* Cambridge: Polity Press, 2017.

Steinberg, Marc. *The Platform Economy: How Japan Transformed The Consumer Internet.* Minneapolis: Univer-

sity of Minnesota Press, 2019.

Stiegler, Bernard. *The Age of Disruption: Technology and Madness in Computational Capitalism*. Cambridge: Polity Press, 2019.

—. *Nanjing Lectures 2016–2019*. London: Open University Press, 2020.

Stikker, Marleen. *Het internet is stuk: Maar we kunnen het repareren*. Amsterdam: De Geus, 2019.

Strauss, Leo. *Persecution and the Art of Writing*. Chicago: University of Chicago Press, 1952.

Vogt, Joseph. *Kapital und Ressentiment: Eine kurze Theorie der Gegenwart*. Munich: C.H. Beck, 2019.

Vries, Patricia de. *Algorithmic Anxiety in Contemporary Art*. Amsterdam: Institute of Network Cultures, 2020.

Wang, Xiaowei. *Blockchain Chicken Farm*. New York: Farrar, Straus and Giroux, 2020.

Whitman, Walt. *Leaves of Grass*. Oxford: Oxford University Press, 2005.

Wiener, Anna. *Uncanny Valley: A Memoir*. London: 4th Estate, 2020.

Winkler, Hartmut. *Switching – Zapping: Ein Text zum Thema und ein parallellaufendes Unterhaltungsprogramm*. Darmstadt: Verlag Jürgen Häusser, 1991.

Wojnarowicz, David. *Close to the Knives: A Memoir of Disintegration*. New York: Vintage Books, 1991.

Zabala, Santiago. *Being at Large: Freedom in the Age of Alternative Facts*. Montreal: McGill-Queen's University Press, 2020.

Zuboff, Shoshana. *The Age of Surveillance Capitalism*. London: Profile Books, 2019.

227

228

# Index

234

# About the Author

Geert Lovink is a Dutch media theorist, internet critic and author of *Uncanny Networks* (2002), *Dark Fiber* (2002), *My First Recession* (2003), *Zero Comments* (2007), *Networks Without a Cause* (2012), *Social Media Abyss* (2016), *Organization after Social Media* (with Ned Rossiter, 2018) and *Sad by Design* (2019). In 2004 he founded the Institute of Network Cultures (www.networkcultures.org) at the Amsterdam University of Applied Sciences (HvA). His center organizes conferences, publications and research networks such as Video Vortex (online video), The Future of Art Criticism and MoneyLab (internet-based revenue models in the arts). Recent projects deal with digital publishing experiments, critical meme research, participatory hybrid events and precarity in the creative sector. In December, 2021 he was appointed Professor of Art and Network Cultures at the Art History Department, Faculty of Humanities of the University of Amsterdam for one day a week.

236

# Colophon

AUTHOR
Geert Lovink

EDITOR
Luke Munn

PROOFREADING
Els Brinkman

INDEX
Elke Stevens

GRAPHIC DESIGN
Irene Stracuzzi
*www.irenestracuzzi.com*

TYPEFACES
STIX Two Text, Suisse Int'l

PAPER
Munken Premium Cream 90 g/m² 1.95 (inside)
Munken Pure 240 g/m² (cover)

PRINTING
Wilco Art Books, Amersfoort

PROJECT MANAGER
Simone Wegman, Valiz

PUBLISHER
Pia Pol, Astrid Vorstermans,
Valiz, Amsterdam

This publication was made possible through
the support of:

**Amsterdam University
of Applied Sciences**

INTERNATIONAL DISTRIBUTION

— BE/NL/LU: Centraal Boekhuis,
*www.centraal.boekhuis.nl*
— GB/IE: Consult Valiz,
*www.valiz.nl*
— Europe (excl GB/IE)/Asia: Idea Books,
*www.ideabooks.nl*
— Australia: Perimeter,
*www.perimeterdistribution.com*
— USA, Canada, Latin-America: D.A.P.,
*www.artbook.com*

INDIVIDUAL ORDERS
*www.valiz.nl*; *info@valiz.nl*

ISBN 978-94-93246-08-9
Printed and bound in the EU

Amsterdam, 2022
Valiz, Amsterdam, *www.valiz.nl*

# Making Public Series

The series *Making Public* investigates "the public", the civil domain where space, knowledge, values and commodities are shared. What does this notion of "public" mean? How does this domain change under the influence of technological, political and social tendencies? Where are the boundaries of "the public" and how are they determined? What forms of responsibility and solidarity does "the public" invoke? And how do artists and culture critics shape the debate on these issues?

Explore digital content related to *Making Public*: *valiz-makingpublic.net*

From 2021 onwards the series is designed by Irene Stracuzzi.

2017     Authenticity?: Observations and Artistic Strategies in the Post-Digital Age
Barbara Cueto, Bas Hendrikx (eds.)
Contributors: Erika Balsom, Franco 'Bifo' Berardi, Jazmina Figueroa, Bas
Hendrikx & Barbara Cueto, Holly Herndon & Mat Dryhurst, Rob Horning,
David Joselit, Oliver Laric, Timotheus Vermeulen, Beny Wagner
With Impakt Foundation
Designed by Template, Lasse van den Bosch Christensen & Marlon Harder
ISBN 978-94-92095-23-7

2017     Being Public: How Art Creates the Public
Jeroen Boomgaard, Rogier Brom (eds.)
Contributors: Barbara Alves, Jeroen Boomgaard, Rogier Brom, Anke Coumans,
Florian Cramer, Eva Fotiadi, Maaike Lauwaert, Gabriel Lester, Steven ten Thije
With LAPS Rietveld Academie
Designed by Template, Lasse van den Bosch Christensen & Marlon Harder
ISBN 978-94-92095-28-2

2017     Compassion: A Paradox in Art and Society
Jeroen Boomgaard, Rini Hurkmans, Judith Westerveld (eds.)
Contributors: Jesse Ahlers, Nick Aikens, Sarah van Binsbergen, Jeroen
Boomgaard, Pascal Gielen, Rini Hurkmans, Susan Neiman, Leonhard de Paepe,
Judith Westerveld
With LAPS Rietveld Academie
Designed by Template, Lasse van den Bosch Christensen & Marlon Harder
ISBN 978-94-92095-29-9

2017     Lost and Living (in) Archives: Collectively Shaping New Memories
Annet Dekker (ed.)
Contributors: Babak Afrassiabi, Dušan Barok, Tina Bastajian, Nanna Bonde
Thylstrup, Özge Çelikaslan, Annet Dekker, Olia Lialina, Manu Luksch, Nicolas
Malevé, Aymeric Mansoux, Michael Murtaugh, Josien Pieterse, Ellef Prestsæter,
Robert Sakrowski, Stef Scagliola, Katrina Sluis, Femke Snelting, Igor Štromajer,
Nasrin Tabatabai
With Piet Zwart Institute
Designed by Template, Lasse van den Bosch Christensen & Marlon Harder
ISBN 978-94-92095-26-8

2021     Curating Digital Art: From Presenting and Collecting Digital Art to
Networked Co-curation
Annet Dekker (ed.)
Contributors: Pita Arreola-Burns, Evelyn Austin, LaTurbo Avedon, Paul Barsch,
Livia Benedetti, Bob Bicknell-Knight, Elliott Burns, Tom Clark, Marco De
Mutiis, Constant Dullaart, Madja Edelstein-Gomez, Rebecca Edwards, Amber
van den Eeden, Rózsa Farkas, Marialaura Ghidini, Manique Hendricks, Tilman
Hornig, Florian Kuhlmann, Kalle Mattsson, Anika Meier, Marie Meixnerová,
Laura Mousavi, Katja Novitskova, Domenico Quaranta, Stefan Riebel, Ryder
Ripps, Sakrowski, Katrina Sluis, Lilian Stolk, Systaime a.k.a. Michaël Borras,
Gaia Tedone, Jon Uriarte, Miyö Van Stenis, Nimrod Vardi, Marcela Vieira,
Zhang Ga
Designed by Irene Stracuzzi
ISBN 978-94-93246-01-0